Berthe Morisot

Acknowledgments

We warmly thank Yves Rouart, Hugues Wilhelm, the Hopkins-Custot gallery, the Fondation Pierre Gianadda, Martigny, for all their help, as well as all the collectors whose works are reproduced in this book.

Translated from the French by Louise Rogers Lalaurie

Design: Dune Lunel

Copyediting: Penelope Isaac

Typesetting: Anne Lou Bissières with François Dézafit

Proofreading: Sarah Kane

Color Separation: IGS, Lille

Printed in Italy by Zanardi

Simultaneously published in French

© Flammarion, S.A., *Berthe Morisot: La Belle Peintre*, Paris, 2010

English-language edition

© Flammarion, S.A., Paris, 2010

editions.flammarion.com

10 11 12 3 2 1

ISBN: 978-2-08-030168-0

Dépôt légal: 09/2010

Berthe Morisot

Jean-Dominique Rey
Foreword **Sylvie Patry**

Flammarion

Contents

"I love only extreme novelty or the things of the past."

Berthe Morisot

"Berthe Morisot's uniqueness was to 'live' her painting, and to paint her life … she took up, put down, returned to her brush like a thought that comes to us, is clean forgotten, then occurs to us once again. It is this that gives her work the very particular charm of a close, almost indissoluble connection between the artist's ideal and the intimacy of an individual life."

Paul Valéry

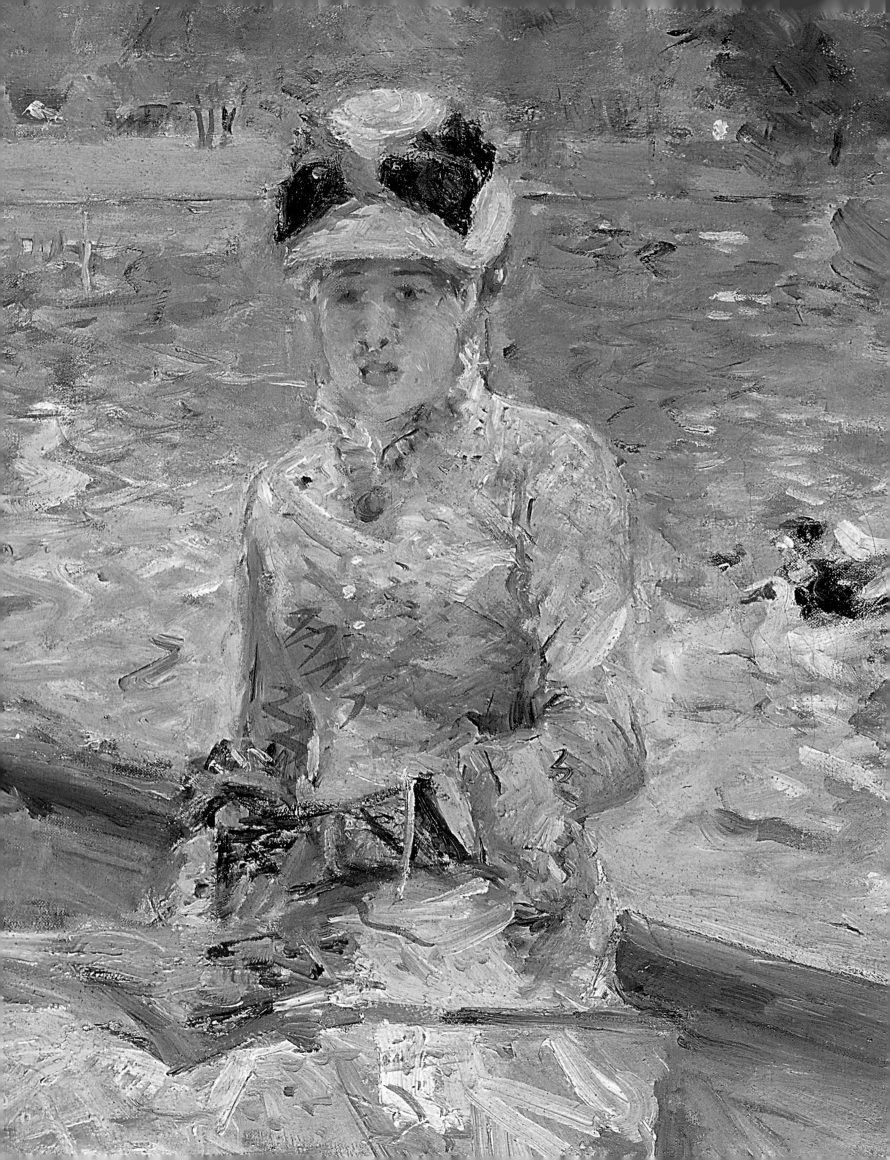

"This Singularly Painterly Painter"[1]

Foreword by Sylvie Patry

For Sylvie Patin

"I wanted to instill the notion that a life dedicated to colors and forms is not a priori less profound, nor less admirable than a life spent in the shadows of the 'interior.'"[2] (PAUL VALÉRY)

"Depth must be hidden away. Where? On the surface"[3]: in his introduction to the catalog of a retrospective in 2002, marking Berthe Morisot's reinstatement among the first rank of impressionist painters, Jean-Dominique Rey cited this description by the Austrian poet Hugo von Hofmannsthal as the best definition of her art. Rey's study, *Berthe Morisot: La belle peintre*, which appeared in French that same year, and is now republished along with this new English edition, distinguished itself from a critical tradition that saw nothing but charm and refinement in Morisot's work:

> The touch, sure and light / Offsets the fine palette / The satisfied eye alights / On the touch, sure and light / Toilettes, flowers, sea, shore, azure-bright / Hint at a feminine art / The touch, sure and light / Offsets the fine palette.[4]

1. Paul Valéry, "Tante Berthe," preface to the catalog of the *Exposition de Berthe Morisot*, Paris, Galerie L. Dru, May 31 June 25, 1926, 2.
2. Ibid., 9.
3. Jean-Dominique Rey, "La belle peintre," in *Berthe Morisot 1841–1895*, exhibition catalog (Lille: Palais des Beaux-Arts, and Martigny, Fondation Pierre Gianadda, 2002; Paris: RMN, 2002), 19.
4. Silvius, "Gazette rimée, triolets d'actualités: bouquets d'impressionnistes," *La Vie littéraire*, April 13, 1876; quoted by Hugues Wilhelm, "La fortune critique de Berthe Morisot," in *Berthe Morisot 1841–1895*, 71.

Detail of **Summer's Day,** (page 90).

11

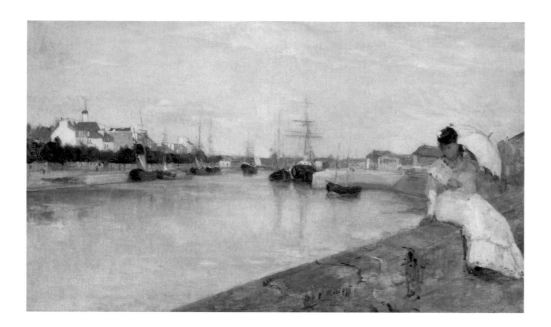

Composed in 1876, when attacks against the impressionists were at their sharpest, this "triolet of the news of the day" summarizes, in questionable but not ineffective verse, the most general, lasting characteristics attributed to the art of Berthe Morisot: lightness, finesse, delicacy. Almost twenty years later, on the occasion of the artist's first solo exhibition at a major Paris gallery, Boussod et Valadon, her friend Louise Léouzon-le-Duc (née Riesener) wrote warmly: "I have been to see your exhibition, and came away full of enthusiasm.... What ravishing art is yours, dear Madam! What distinguishes it is its grace and liveliness, it expresses every possible charm, the countryside, childhood, feminine charms above all."[5] Today, these same qualities remain very much a part of the powerful attraction exerted (in Mallarmé's fine words) by Morisot's "bright, iridescent pictures, here, exact, spontaneous...." But they are not the sum total of the significance and enduring fascination of an oeuvre that has, thanks to them, been frequently categorized, over and again, as "feminine art" full of "feminine charm."

5. Paris, June 12, 1892, unpublished letter, Paris, Musée Marmottan Monet, Rouart family gift, inv. I-8-82.

Vue du petit port de Lorient (The Harbor at Lorient), 1869.
Oil on canvas, 17 × 28 ¾ in. (43.5 × 73 cm). National Gallery of Art, Washington, D.C.
Ailsa Mellon Bruce Collection.

Refinement, elegance, lightness: the essence indeed of the ladies of the Parisian haute bourgeoisie in the second half of the nineteenth century, the milieu into which the artist was born. Qualities expressed nowhere better than by Théodore Duret, in the 1906 edition of his *Histoire des peintres impressionnistes*, one of the very first surveys of the impressionist movement: Berthe Morisot "was to conjure, thoughout the whole impressionist oeuvre, alongside the qualities of forceful strength and power proper to men, certain traits belonging solely to women—a delicate charm, a kind of grace suffused with carefree abandon, a distinction that is both natural and sophisticated,"[6] in short "the most appreciable of feminine qualities," in the words of another leading critic of the day, and a close associate of the impressionists, Georges Lecomte.[7]

There is, clearly, a reductive quality to these compliments—however sincere and well-founded they may be—defining and confining an artistic oeuvre, in terms of both subject matter and execution, to the narrow, strictly regimented sphere of women's lives in the late nineteenth century: family, children, ladies "at their toilet," and flowers; in other words, the private, "intimist," enclosed world of domestic life that emerged and defined itself throughout the nineteenth century in opposition to the public space and the world of work, both essentially masculine. Indisputably, this world provided Morisot with most of her subjects and, in this sense, as Paul Valéry reminds us, "her work puts us in mind of the private journal of a woman choosing to express herself through color and drawing."[8] By the same token, Berthe Morisot's highly personal technique is often described using metaphors derived from the world of flowers, traditionally associated with the celebration of womanhood. For Charles Ephrussi, the infuential editorial director of the *Gazette des Beaux-Arts*, Morisot "crushes flower petals on her palette, spreading them on the canvas in spectral touches, blown, scattered almost at random, and which harmonize, combine, and finally produce something lively, vivid, and charming, intimated by us the viewers, rather than seen."[9] Ephrussi was, nonetheless, a genuine admirer of the painter's "fleeting lightness,"[10] for which Édouard Manet was quick to congratulate his "dear Berthe": "I have just come out of the [impressionists']

6. Théodore Duret, *Histoire des peintres impressionnistes* (Paris: H. Floury, 1906), 136.
7. Georges Lecomte, "Mme Berthe Morizot," *Art et critique*, January 23, 1892, 29.
8. Paul Valéry, "Au sujet de Berthe Morisot," in *Berthe Morisot 1841–1895*, iv.
9. Charles Ephrussi, "Exposition des artistes indépendants," *Gazette des Beaux-Arts*, May 1, 1880; quoted in *Les Écrivains devant l'impressionnisme*, ed. Denys Riout (Paris: Macula, 1989), 235.
10. Ibid., 235.

exhibition, at which you are a great success.... Ephrussi has bought the *Woman with a Muff....*"[11] (**page 15**). The picture is emblematic of Morisot's work at the beginning of the 1880s. The artist presents one of her favorite subjects, an elegant young woman, whose fashionable grooming and accessories (the toque headpiece, the muff) personify one of the seasons: winter. Morisot embraces this traditional theme—the representation of the four seasons as female figures—in her own way, clearly inscribing the figures in the context of her own time, with the accent on their costume, which gives meaning to a picture with no subject as such, and no narrative. *Femme au manchon* (*Woman with a Muff*) recalls the engraved fashion plates first seen in the 1860s, a central feature of the modern world as perceived by the impressionists, but also Manet, Baudelaire, and Mallarmé, who was himself editor of a fashion magazine, the *Journal des Modes*, for a time. In the case of Morisot, the writer Joris-Karl Huysmans saw only "worldly elegance,"[12] although he later amended his opinion: "Berthe Morizot [sic] shows us ladies at their toilet ... a silk stocking is glimpsed beneath dresses styled and made by renowned couturiers," in what seems to him a "scumbled froth" of colors, "the frothy, vanilla-scented meringue of a painterly dinner."[13] As for so many other critics, her characteristic "touch, sure and light," remains on the surface barely brushing the canvas like the touch of a petal (the verb "*effleurer*," meaning "to touch lightly, brush against," so often applied to her technique by French critics).

Berthe Morisot was conscious of, and often saddened by, the implicit limits of such praise, to say nothing of the violent attacks also directed at her work. As Théodore Duret recalled, she "constantly saw her activity as an artist obscured by her position as a woman in bourgeois society."[14] Writing, at the age of forty-nine, in a long-unpublished notebook, she noted: "I do not think any man would ever treat a woman as his equal, and it is all I ask because I know my worth."[15] Morisot never wanted to produce "women's paintings," but simply to be a painter in her own right. When she began exhibiting after 1865, she measured

11. Letter from Édouard Manet to Berthe Morisot, Paris, Bibliothèque de l'Institut, Rouart family gift, inv. II-1-1.

12. J.-K. Huysmans, *L'art moderne. Certains*, Paris, 1975, 114.

13. Ibid., 233.

14. Duret, *Histoire des peintres impressionnistes*, 146.

15. Notebook of Berthe Morisot, Mézy, 1890, 34, Paris, Musée Marmottan Monet; quoted in Marianne Delafond and Caroline Genet-Bondeville, *Berthe Morisot ou l'audace raisonnée. Fondation Denis et Annie Rouart*. Paris, Musée Marmottan Monet, 1997, 50.

Femme au manchon or **Hiver (Woman with a Muff** or **Winter), 1880.**
Oil on canvas, 29 × 23 in. (73.5 x 58.5 cm). Dallas Museum of Art.
Gift of the Meadows Foundation Inc. in 1981.

herself not against Nelly Jacquemart—who collected an exceptional crop of prizes (for a woman artist) at the Salon during the same period—but looked instead to Manet, Degas, Monet, and Renoir.

Like her impressionist friends, who were similarly accused of cleaving to the surface appearance of things, she showed herself (in Albert André's words, describing Renoir) to be a "difficult artist," in whose work the improvised quality and apparent spontaneity of touch harbored their share of mystery and depth. Like the young women who inspired around three-quarters of her pictures, and whom the great novelist Octave Mirbeau saw (in complete opposition to Huysmans) as "engimatic." Through them, Morisot was writing not only "a modern woman's novel of the modern woman" but also a key chapter in the history of the avant-garde, in exclusive dialogue with the greatest and most innovative artists of her day, imposing "an inexplicable distance upon all the others who approached her." [16]

16. Valéry, "Tante Berthe," 2.

Portrait de la mère et de la sœur de l'artiste or **La Lecture**
(The Mother and Sister of the Artist), 1869–70.
Oil on canvas, 39 ¾ × 32 ¼ in. (101 × 81.8 cm). National Gallery of Art, Washington, D.C. Chester Dale Collection.

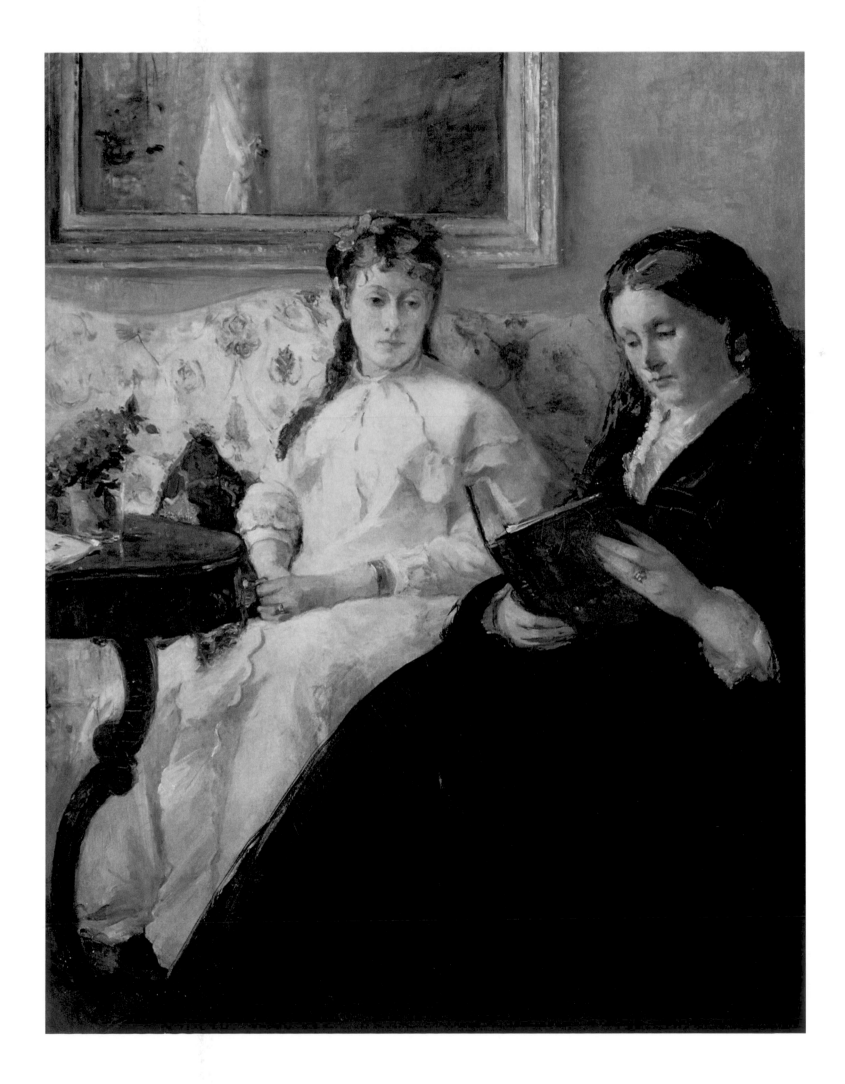

"Everything in her habits and looks spoke of careful choice" (Paul Valéry)[17]

With foresight, determination, and an independence of mind that draws our admiration even today, Berthe Morisot did indeed stray from the paths of tradition and convention. In 1857, at the instigation of her mother, Cornélie, who wanted to give her husband a gift of drawings by his daughters, on his saint's "name day", Berthe began taking painting classes with her sisters Yves and Edma, as part of the usual education granted to young ladies of her class, along with music and dance. Very soon, however, Edma and Berthe showed unprecedented interest and ambition, asking for a new teacher. In place of their tedious tutor Geoffroy-Alphonse Chocarne, they preferred Joseph Guichard, who encouraged them to discover the world of color and took them to copy the Old Masters in the Louvre. "With natures like those of your daughters," he warned Cornélie, "my teaching will not confer the meager talents of genteel accomplishment, they will become painters. Do you have any idea what that means? In your milieu of the grande bourgeoisie it would be a revolution; almost, I would venture, a catastrophe."[18] Above all, showing a keen awareness of the issues current in the world of painting at the time, the two sisters wanted to paint in the open air. Painting from life out of doors was already common practice among amateur women painters, notably in watercolors, but the approach took on a quite different dimension with Berthe and Edma, who saw it not as a pleasant, relaxing adjunct to the picture-making process, but an instrument of truth and observation, the very starting point of the picture itself.

The sisters now took advice from Camille Corot, beginning in 1860. The future impressionists sought no other master, with Pissarro—a great admirer of Corot—leading the way. Since the 1830s, Corot and the other proponents of realist landscape painting—Théodore Rousseau and the other Barbizon painters, Achille Oudinot and Charles-François Daubigny (an acquaintance of Berthe)—had embodied the renewal of painting. Starting in 1864, Berthe Morisot's submissions to the Salon—the official exhibition that could make or break an artist's career—clearly acknowledged the master's role and influence. Berthe was claiming not only her artistic pedigree, but her status as an artist

17. Ibid., 2.
18. Quoted in *Correspondance de Berthe Morisot*, ed. Denis Rouart (Paris: Quatre Chemins-Editart, 1950), 10.

Edma Morisot
Portrait de Berthe Morisot peignant (Portrait of Berthe Morisot Painting), 1865.
Oil on canvas, 39 ¼ × 28 in. (100 × 71 cm). Private collection, Paris.

in her own right, as depicted by Edma in a portrait dating from this period **(page 18)**: "The entry into competition of a young girl from a distinguished background is both a salutary example, and a singular encouragement.... You see, ladies, one may be an artist and take part in public exhibitions of painting, and remain, as before, a very respectable and very charming person."[19] Morisot took this reasoning to its logical conclusion: far from being content to follow convention and exhibit at the official Salon, itself a potentially compromising choice for a woman, as suggested above, she boldly chose a quite different, uncompromising path as a co-founder—with Renoir, Monet, Cézanne, Sisley, and Pissarro—of the *"Société anonyme coopérative d'artistes peintres, graveurs etc."*, in December 1873. The society organized its first exhibition (derisively termed "impressionist") in 1874, followed by seven others until 1886; Berthe took part in them all, apart from that of 1879. Guichard wrote once again to warn Cornélie: "My heart was seized to see your daughter's works in this deleterious company, I said to myself: 'one cannot hope to consort with madmen unscathed,' Manet was right to oppose her participation."[20] These demonstrations of independence were matched by Berthe's efforts to sell oil paintings and watercolors, deposited with art dealers from the 1860s onwards. Berthe Morisot was driven less by economic necessity than by a quest for the kind of aesthetic and professional recognition that would eradicate the charge of amateurism besetting women's painting.

And so Manet supplied Berthe's address to "a very rich gentleman who wished to have his children's portrait in pastel, [saying that] he should be handsomely charged if I want to be treated with consideration."[21] We may detect a certain insistence on Manet's part, when dealing with Berthe, who was never at ease with the commercial aspect of her work and ultimately sold little, when we reflect that more than half of her 423 catalogued oil paintings are recorded again in the collection of her daughter Julie.

Recognition and consideration, then, but compromise, never. Even when Cornélie exhorted her daughter "not to disdain ordinary, popular subjects so ... when it is after all a matter of pleasing the unpracticed eye, that registers the first impression only."[22] The pleasing charm with which Berthe Morisot's art is so much credited tends to eclipse her unflinching artistic rigor. Berthe

19. According to the *Compte-rendu des travaux de la Société du Berry à Paris*, tenth year, Paris.
20. Rouart, *Correspondance*, 76.
21. Letter to Edma, [Paris, around 1872], in ibid, 73.
22. Ibid, 15.

Édouard Manet
Le Repos (Repose), 1870.
Oil on canvas, 58 ¼ × 43 ¾ in. (147.8 × 113 cm). Rhode Island School of Design Museum, Providence.

Édouard Manet
Le Balcon (The Balcony), 1868–69.
Oil on canvas, 67 × 49 in. (169 × 125 cm). Musée d'Orsay, Paris. Gustave Caillebotte donation.

Édouard Manet
Portrait de Berthe Morisot étendue (Berthe Morisot Reclining), 1873.
Oil on canvas, 10 ¼ × 13 ½ in. (26 × 34 cm). Musée Marmottan Monet, Paris, Denis and Annie Rouart Foundation.

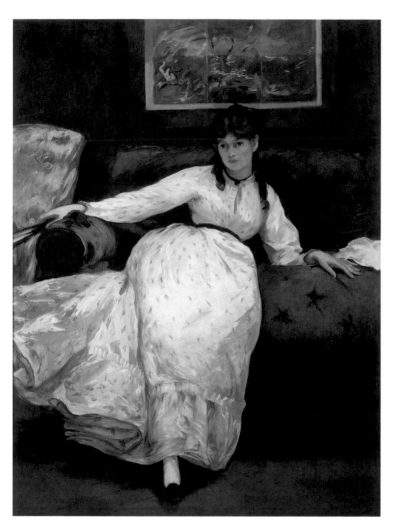

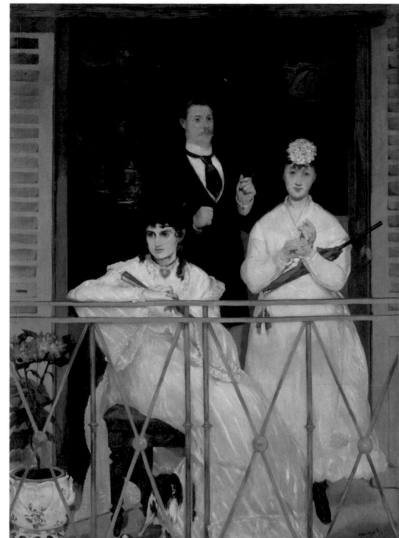

did not adopt the strategies described to her by her mother: "There are works for exhibition, others for the studio, you need to follow the public's taste if you want to succeed ... with some works you make your reputation with the artists, with others you do good business if possible."[23] Berthe seems to have favored the first category, and her artistic development reflects the figures she admired and with whom she associated. Félix Bracquemond, Henri Fantin-Latour, Carolus-Duran, Alfred Stevens, James Tissot, but above all Edgar Degas and Édouard Manet were all part of her circle, forming the "realist" avant-garde, with Manet as their acknowledged leader following the exhibition of his *Chanteur espagnol* (*Spanish Singer*) in 1861. And it is with Manet, in particular, that Berthe established a close artistic dialogue that continues to fascinate us to this day. "Everything speaks of careful choice," indeed, but not without sacrifices and personal doubts, as seemingly expressed by the young women in interior paintings dating from the late 1860s, such as Berthe's picture of Edma, (*Young Woman at Her Window*) (**page 23**).

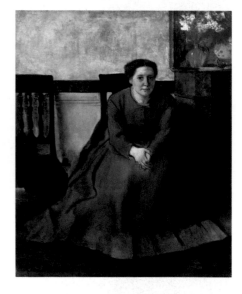

23. Cited in a letter from Cornélie to Berthe Morisot, July 23, 1867, in ibid., 18.

Edgar Degas
Victoria Dubourg, c. 1868–69.
Oil on canvas, 32 × 25 ½ in. (81.3 × 64.5 cm). The Toledo Museum of Art, Toledo, Ohio.

Portrait de Madame Pontillon or **Jeune femme à sa fenêtre**
(Portrait of Madame Pontillon or **Young Woman at Her Window), 1869.**
Oil on canvas, 21 ½ × 18 ¼ in. (54.8 × 46.3 cm). National Gallery of Art, Washington, D.C.
Donated by Mrs. Ailsa Mellon Bruce.

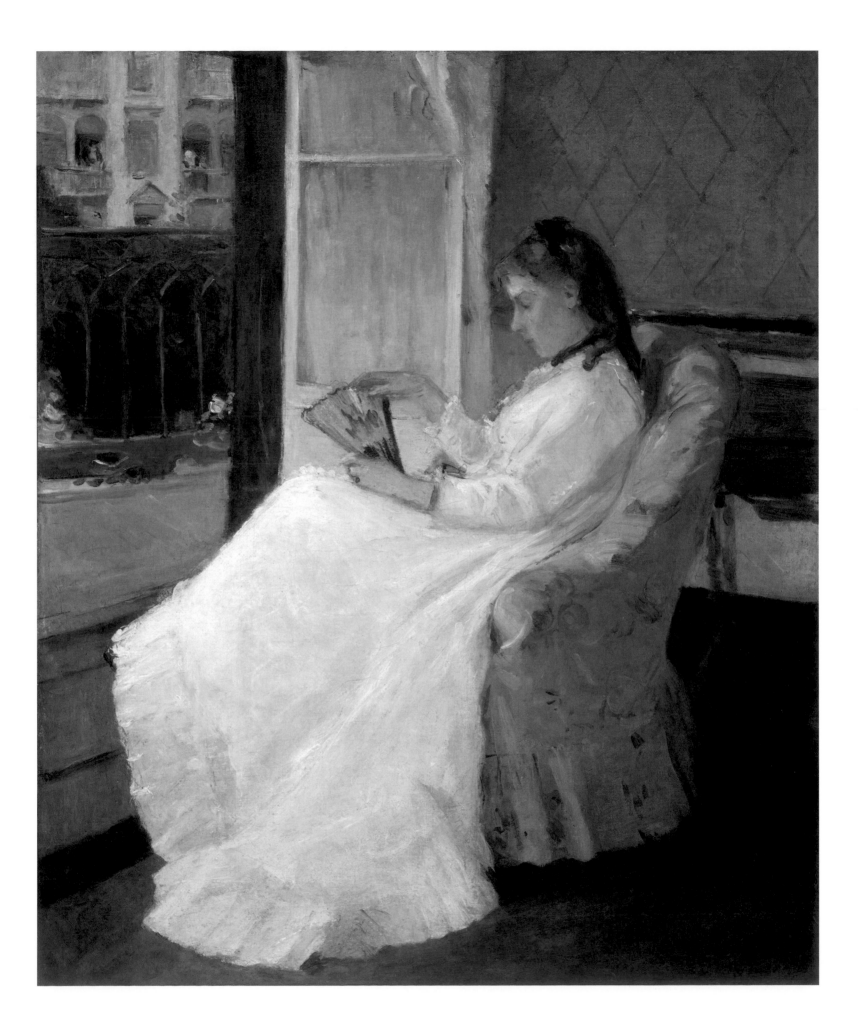

Melancholy

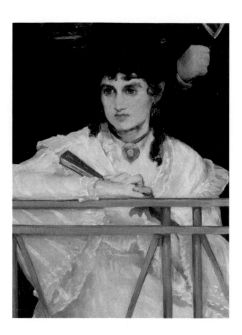

In 1869, the two sisters went their separate ways: Berthe remained in Paris, working at her painting, while Edma married a naval officer, Adolphe Pontillon, on March 8, and settled in Lorient on the southeastern coast of Brittany. With *Young Woman at Her Window* Berthe represents her sister in her new life: "I am often with you, my dear Berthe, in thought; I follow you around your studio and I should like to escape even for a quarter of an hour, to breathe the atmosphere we experienced for so many years."[24] The break with the brilliant artistic circles of Paris left Edma listless and unoccupied, as is underscored in the painting by her hands, toying aimlessly with a fan: "I can say this to you, my dear Berthe—I have been ferociously bored so far in Lorient.... I am alone for part of the day, and for two days now I have felt as if I were at the ends of the earth. Before going out, Adolphe handed me a shirt whose cuffs need changing, I have put one back but the work keeps dropping out of my hand...."[25] Useless hands indeed, if we compare them to those of Victoria Dubourg (albeit similarly devoid of a paintbrush), another woman painter of the sisters' acquaintance, and the future wife of Fantin-Latour, in her almost exactly contemporary portrait by Degas (**page 22**): the young artist strikes a decided pose, leaning forward and confronting the spectator, with her joined hands prominently depicted. In *Young Woman at Her Window*, Edma's hands are the object of careful study by Berthe, who reworked them together with the white dress, before exhibiting her picture.

In an ironic reversal, Edma, who painted the only portrait of Berthe in her role as an artist (if we discount the later self-portraits, **pages 48**; **135**), provides for her sister an image of the renunciation of painting—although she did continue to paint sporadically, as an amateur, because the "urge to paint hasn't abandoned me yet."[26] Berthe presents an image of isolation, and a sense of emptiness, in an atmosphere evoking the ennui of provincial life in *Madame Bovary,* which both sisters read during the summer of 1869: "And all that time the snow on the roof of the market hall cast a still, white light in the bedroom; after that, it was the rain that fell. And daily Emma awaited, with a kind of dread, the unerring recurrence of the smallest events...." Edma, for her part, confided to her sister: "Always the

24. Letter from Edma to Berthe, [March 15, 1864], in Rouart, *Correspondance*, 230.
25. Letter from Edma to Berthe, unedited extract, [1869], Paris, Bibliothèque de l'Institut, Rouart family gift, inv. I-5-63.
26. Letter from Edma to Berthe, [September 10, 1869], in Rouart, *Correspondance*, 34.

Édouard Manet
Detail of **The Balcony,** (page 21).

same life, here, the fireside and the falling rain." Berthe and Edma recognized in Flaubert's novel "a very remarkable work... and very interesting as a study in realism. Decidedly, this is the superior aspect of the art of our day, and its value will be recognized sooner or later."[27] This "realist aspect" is clearly expressed in *Young Woman at Her Window*, in a quite different way from *Madame Bovary*, and without the whiff of scandal that brought the novel before the courts upon its appearance in 1857: this is truly a painting of modern life, as conceived at the same time by Degas, Whistler, or Manet, taking as its subject a well-to-do young girl in a white muslin dress, in an interior. "Muslin was *very modern* at the time," recalled the painter Jacques-Émile Blanche.[28] Added to which was the equally modern motif of the street and balcony, treated in compressed plains of perspective that redefine the construction of pictorial, painted space.

In several ways, *Young Woman at Her Window* appears as an echo—transposed to an intimist, cosseted register—of Manet's *Le Balcon* (*The Balcony*) (**page 21**), completed in the spring of 1869. For the first time, Manet had Berthe pose for one of his pictures. She is dressed in white, her neck graced by a black ribbon, and holds a fan—all elements seen again, together with the contrast between the white dress and the green window fittings, in *Young Woman at Her Window*. But while Edma sits back from the window, in her apartment, wearing a tea dress (for wear indoors), her gaze downcast and sad, removed from the spectacle of the street, Berthe leans her elbows on the balcony rail, looking outwards. Edma's white tea dress is a recurrent motif in Berthe's work, an essential accessory and metaphor for the private world she depicts. Edma's face, captured in profile, evades the viewer's gaze, while Berthe's "magnetic" features[29] stand out forcibly, earning her description as a "femme fatale."[30] The two paintings were exhibited in successive years at the Salon: *The Balcony*, with its ambitious, large format and strident green—"his pictures always produce something of the impression of a wild or unripe fruit," Berthe would say[31]—met with incomprehension and rejection in 1869; *Young Woman at Her Window*, reworked on Manet's admiring advice, passed unnoticed at the Salon of 1870—"the small portrait done in Lorient is hung so high up that

27. Letter from Edma to Berthe, [after August 13, 1869], in ibid., 34.
28. Jacques-Émile Blanche, *Mes Modèles*, Paris, 1984 [1928], 213.
29. Valéry, "Tante Berthe", 2.
30. Rouart, *Correspondance*, 27.
31. Ibid., 26.

Detail of **Young Woman at Her Window,** (page 23).

it's impossible to come to any sort of judgment about it," wrote Berthe.[32] In *The Balcony*, as in *Young Woman at Her Window*, Berthe and Edma's gaze is distracted, absent, leaving us in some doubt as to the meaning of the scene. This may be a deliberate choice—a rejection of narrative and anecdotal detail shared by Morisot and Manet alike. In this, both are distinguished from the likes of Tissot and Stevens. Both pictures are also dominated by Berthe's characteristic sense of melancholy, expressed as a painter in works like *Young Woman at Her Window*, and as a model in her portraits by Manet, such as *Le Repos* (*Repose*) **(page 21)**.

Despite *The Balcony*'s lack of success, Berthe agreed to pose for Manet once again, inspiring a series of ten pictures revealing a genuine collaboration between the artist and his model. *Repose* was painted in 1870, one year after *The Balcony*, but not exhibited in public until 1873, to thunderous disapproval from the critics, who dismissed Berthe as a "drab, puny creature."[33] In what may be her studio, the young woman, fan in hand, sits stretched out almost at full length on a red sofa, her gaze detached and pensive. The pose was casual but carefully studied, almost impossible to hold, and shockingly artificial. In a moment of relaxation and repose, Berthe abandons the conventional carriage and bearing of a respectable young lady of good family. Her pose breaks with accepted social norms, harking back to traditional representations of melancholy, reinforcing the "profound, dreamy, almost pained"[34] quality of her countenance, and "anxious, unhappy" air often deplored by her mother.

In this sense, *Repose* resembles Whistler's "Arrangements" of the 1860s, showing young women dressed in white, in interiors decorated with Japanese accessories (like the Kuniyoshi print on the wall here), which seem to be suspended between dreams and reality. There is the same "somewhat cloudy" aspect,[35] so much admired by Fantin-Latour in his friend Whistler, and which we find again in certain portraits by Manet, Degas, Monet, or Morisot herself, around 1870. For Théodore Duret, who was also the happy owner of this magnificent picture, *Repose* is indeed an idealized representation of the modern Parisienne, the modern woman.[36] By offering a modern translation of melancholia, widely seen at the time as the nineteenth century's defining malaise, the picture loses its status as a portrait, and becomes a type, described by Manet in these terms when seeking

32. Ibid., 39.
33. Quoted in Adolphe Tabarant, *Manet et ses œuvres* (Paris: Gallimard, 1947), 207.
34. Paul Jamot, "Études sur Manet," *Gazette des Beaux-Arts*, January 1927, 31.
35. Letter from Fantin-Latour to Whistler, February 12, 1867, Glasgow University, Whistler Archive, 14.
36. Théodore Duret, *Histoire d'Édouard Manet et de son œuvre*, Paris, 1906, 138.

Cornélie's permission to exhibit it, in a letter dated May 20, 1871. When the picture was finally shown in 1873, the title preserved the model's anonymity and played on its ambivalent character as a generic scene of modern life, and a portrait. The picture's history is similarly ambivalent: sold in January 1872 by the dealer Paul Durand-Ruel, it was clearly not bought by, or gifted to, its model, as was generally the case for a portrait. It subsequently appears in the prestigious collection of Théodore Duret, and finally slipped away from its model at the Duret sale in 1894: the picture fetched 11,000 francs, more than Berthe had planned to spend, or could afford.

Some commentators, like Théodore de Banville, saw the picture as a representation of Baudelarian "spleen," but *Repose* is no less a reflection of the personal, moral crisis faced by Berthe. Like Edma, she felt a sense of "emptiness": "Your disappearance has left a great void. Here I am, relegated to my studio once again, the cold, the rain, the wind have returned so that your stay here is beginning to take on the quality of a dream," she wrote to her sister.[37] Boredom is a recurrent leitmotiv in the correspondence between Edma and Berthe: "I think I am fitted more than anything else for boredom, and I'm afraid you may resemble me in this."[38] "I tell myself I'm bored a good twenty times a day,"[39] repeats Berthe. Because, despite what Edma may have felt, the "air of the studio" and painting were no certain remedy. Berthe judged her own paintings "mere daubs"[40]:

> This painting, this work you miss so much, is a cause of much trouble and concern, you know this as well as I do and yet, child that you are, you are already weeping for the loss of the very thing that darkened your mood only recently. Think of it, yours is not the very worst lot: you have real affection, a devoted heart that is yours and yours alone, do not be ungrateful for the dealings of fate, think of the great sorrow that is solitude; whatever anyone says or does, womankind has immense need of affection; to want to retreat into yourself is to attempt the impossible.

And she writes again to her sister: "This diet is unhealthy, through it we will lose what remains of our youth and beauty, for me a matter of no importance, but for you, it's different."[41] In addition to these personal doubts and sorrows, the Franco-

37. Unpublished letter, private collection.
38. Unpublished extract from a letter quoted in Rouart, *Correspondance*, 24.
39. In ibid., 30.
40. Letter from Berthe to Edma, in ibid., 29.
41. March 19, 1869, in ibid., 24.

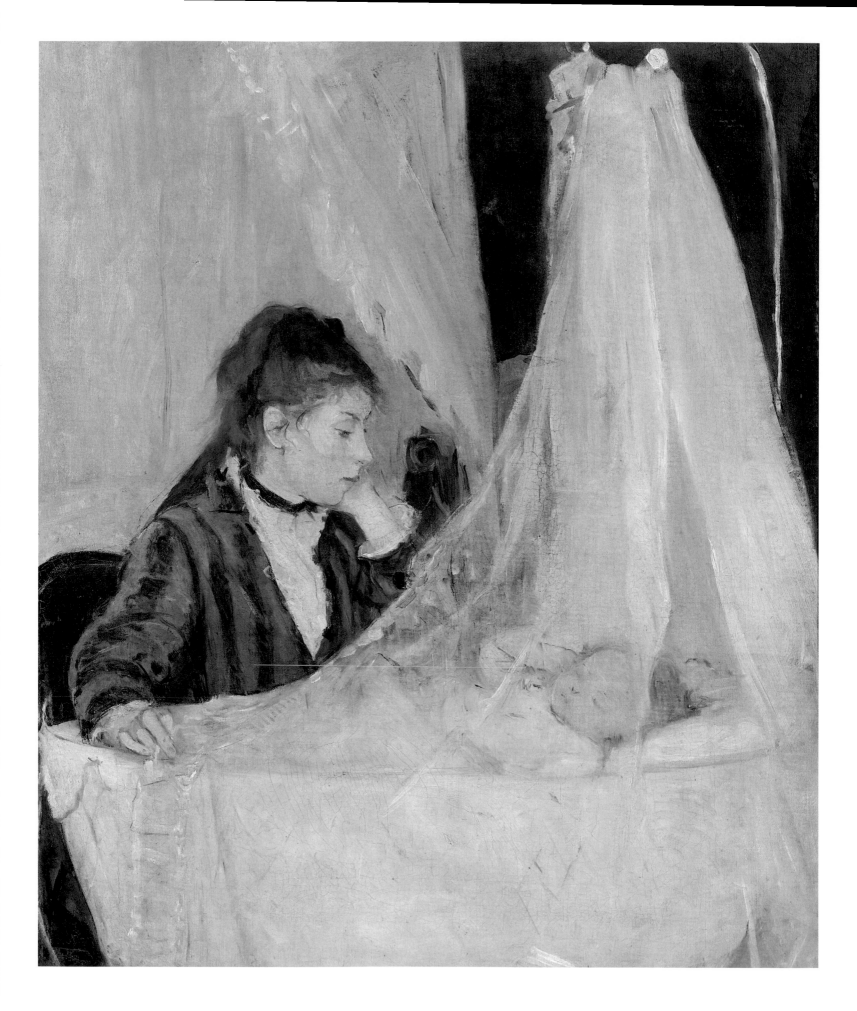

Prussian war of 1870, and the privations of the Siege of Paris, were a matter of grave concern for Berthe, who was unable to leave the city. But her chief preoccupations remained, nonetheless, love, marriage, motherhood, and art.

She was still unmarried, to the great despair of her family, who studied several possible matches. One of the most serious options, in Berthe's heart at least, seems to have been the painter Pierre Puvis de Chavannes, identified by Manet, who followed the quest for an ideal husband with interest and, sometimes, amusement, as "the object of my interest and love,"[42] as reported by Berthe in an unpublished letter to Edma. During this period, Berthe did indeed spend time with Puvis: she was one of the few members of her family to admire his painting. Older and more famous than Berthe, Puvis dispensed advice and established an artistic dialogue that is far less well known today than her exchanges with Manet. Puvis bought a work by Berthe, and continued to take an interest in her painting, even when she subsequently went over to the camp of the "intransigents". In the late 1860s and early 1870s, as she turned thirty, Berthe oscillated between hopes of marriage and motherhood, on the one hand, and the conquest of her own independence, on the other:

> Men readily believe that they will fill a whole life; but for my part,
> I believe that however fond one is of one's husband, one does not
> relinquish a life of work without some difficulty; affection is a very
> pretty thing provided it is coupled with something to fill one's day;
> that something, for you, I see as motherhood.[43]

For her own part, Berthe seems to have decided on independence: "I will achieve it only by perseverance, and by openly asserting my determination to emancipate myself," she wrote in 1871. But, as she wrote to Edma, "I both lament and envy your fate. Bichette [her niece] helps me to understand maternal love; she comes onto my bed every morning and plays so sweetly... life gets more complicated by the day here now I am gripped by the desire to have children, that's all I need!"[44] This ambivalent view of motherhood, seen as a crowning accomplishment, hoped for as an escape from painting and the artist's life, is clearly expressed in *Le Berceau* (*The Cradle*) (**page 28**), painted in 1872, when Edma was visiting her family in Paris.

42. Unpublished extract from a letter from Berthe to Edma, August 13, 1869, published in ibid., 33, private collection.
43. Letter to Edma, April 23, 1869, in ibid., 25.
44. Unpublished extract from a letter from Berthe to Edma, [1869], published in ibid., 31, private collection.

Le Berceau (The Cradle), 1872.
Oil on canvas, 22 × 18 in. (56 × 46 cm). Musée d'Orsay, Paris.

Motherhood

In the picture, Berthe depicts Edma sitting beside the cradle of her daughter Blanche, born in 1871. Edma gazes tenderly at her baby. All is calm and serenity. The play of the curtains—a veritable "symphony in white" very much in tune with contemporary experiments by Manet, Degas, or Whistler—further accentuates the intimacy of the scene, shielding the cradle like protective screens.

Berthe Morisot's painting is a delicate, sophisticated response to the challenge of reproducing effects of transparency and the use of barely tinted whites. *The Cradle* also reads like an anticipatory response to the "innate need for beauty," much praised by Mallarmé: "The troubled, indifferent air, the intimate sorrows that generally mark scenes of contemporary life," as he was to note in 1876, on the subject of Berthe's watercolors of women and children. Like these, *The Cradle* presents an image of harmony, an idyll somewhat detached from reality. Into this Berthe introduces, it seems, an element of mixed feelings, perceptible in Edma's expression. Edma is clearly all alone, watching over her sleeping infant: here again, the treatment of her right hand—one of the most "Manet-esque" passages in all Berthe's oeuvre—suffices to express the mother's tender solicitation. At the same time, Edma seems pensive: the baby's slumber—guaranteeing her immobility and enabling Berthe to paint her picture—does not permit the representation of shared glances between mother and child. And now it is Edma's turn to adopt the traditional pose of melancholia. The young woman seems absorbed, a little troubled, perhaps nostalgic. Ultimately, she is unfathomable. Her indeterminate feelings, and the economy of means employed in this composition, based on the rigorous alternation of whites and blacks, introduce a note of ambiguity that is the key to the picture's complexity and novelty, beneath its superficially pleasing, conventional surface. Berthe chose to show it in public for the first time at the impressionist exhibition of 1874.

In this sense, too, the picture is typical of Berthe Morisot's approach: taking apparently traditional, eminently feminine subjects and offering her own very personal interpretation. In 1874, Berthe became engaged to, and later married, Eugène Manet, one of the painter's two brothers. The match enabled her to reconcile what had seemed, at the beginning of the 1860s, to be two mutually exclusive paths: marriage and painting. The marriage transformed the social and artistic connections of the "Manet clan" into family alliances, "officializing" them, and making them somehow more permanent. Rather than being cut off,

Edgar Degas
Une nourrice au jardin du Luxembourg (A Wet Nurse in the Luxembourg Garden), c. 1872.
Oil on canvas, 25 ½ × 29 ½ in. (65 × 75 cm). Musée Fabre, Montpellier.

La Nurse (The Wet Nurse), 1880.
Oil on canvas, 19 ¾ x 24 in. (50 × 61 cm). Private collection, Washington D.C.

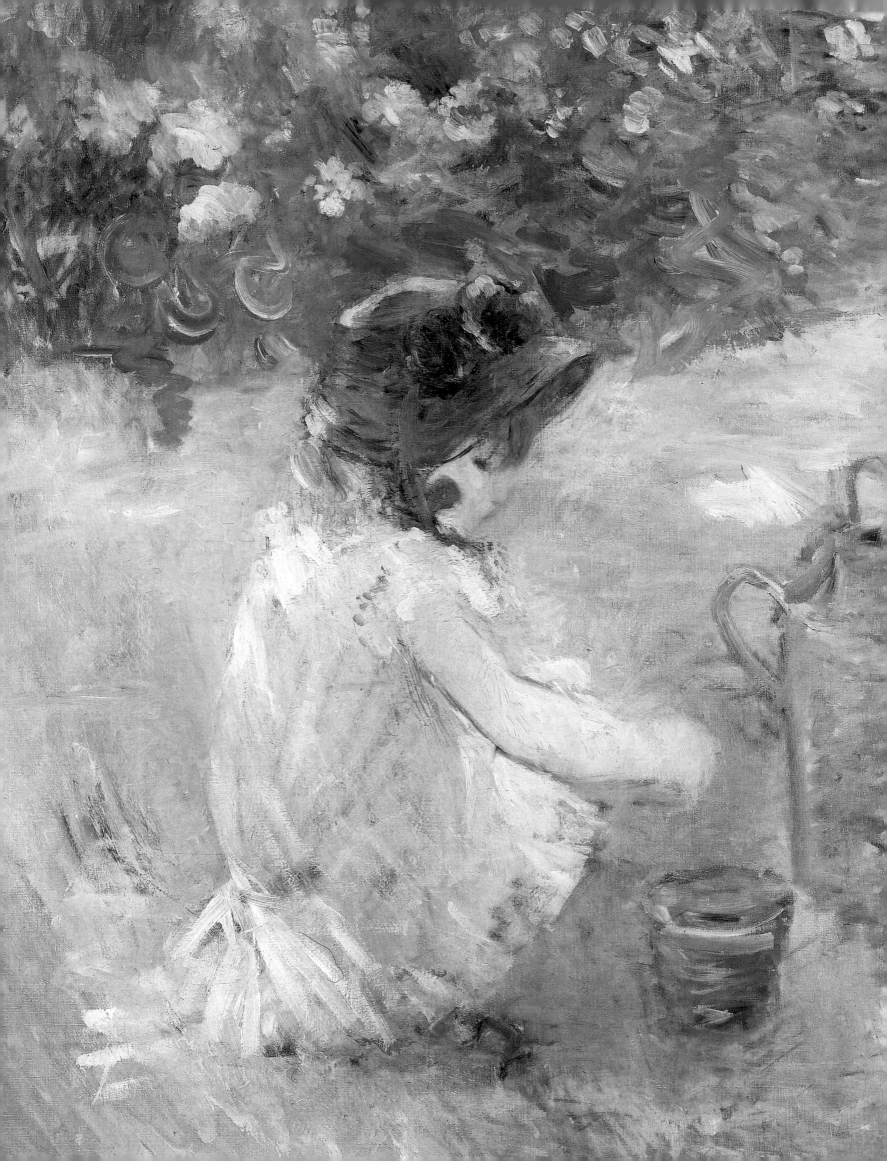

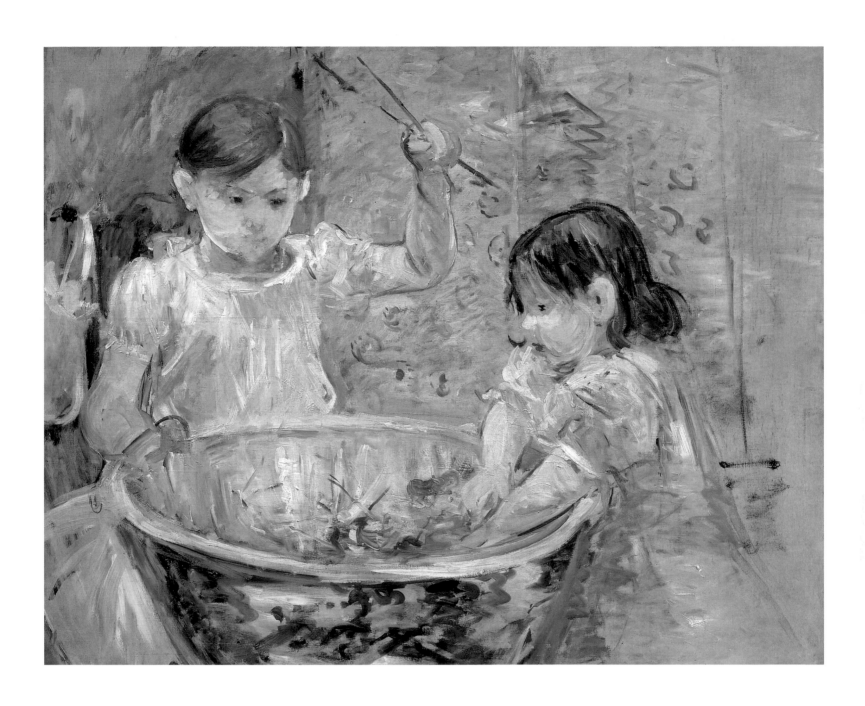

Facing page:
Les Pâtés de sable (Sandcastles), 1882.
Oil on canvas, 36 ¼ × 28 ¾ in. (92 × 73 cm). Private collection, Paris.

*Aged four, Julie Manet was the model one summer for both
Édouard Manet (Julie sur l'arrosoir [Julie Sitting on a Watering Can]
painted in the garden at Rueil), and Berthe Morisot (Sandcastles
painted in the garden at Bougival).*

Above:
Enfants à la vasque (Children with a Bowl), 1886.
Oil on canvas, 28 ¾ × 36 ¼ in. (73 × 92 cm). Musée Marmottan Monet, Paris.

*Drawn from life, this lively scene was painted in the salon at the Rue
de Villejust where the bowl given by Manet took pride of place.*

like Edma, from her beloved circles of friends, and the source of inspiration for her art, Berthe was immersed in them further still. Eugène, himself a painter, gave up his own career to devote himself to that of his wife, an extremely rare arrangement at the time. A convert to the cause of the "New Painting"—that of the impressionists—he handled Berthe's submissions to the impressionist exhibitions, including that of 1882. Four years later, the couple had a daughter, Julie, who would, quite literally, grow up under her mother's paintbrush, like Renoir's two younger sons, Jean and Claude (Coco) at the turn of the twentieth century. As Julie would later recall: "Until her death, when I was sixteen, we were always together. I was very spoiled. It was almost as if my mother knew she wouldn't live for very long; she looked after me, painted me and drew me, with all her strength and tenderness."[45]

From her first months, Julie did indeed become one of Berthe's favorite models: an early painting shows her in the arms of her wet nurse (**page 31**). The American art historian Linda Nochlin highlights this distinctive treatment of a subject dear to Degas (**page 30**), for example—a very particular situation bringing together the mother and her child's wet nurse. Unlike Mary Cassatt or Renoir's depictions of the mother-and-baby theme, Morisot is not updating the image of the Virgin and Child. She does not paint a mother taking care of her child: the scene is a representation and expression of two women at work—a wet nurse and an artist. And this original transformation of a traditional subject is accompanied by a radical painterly treatment. From the later 1870s onwards, Berthe took part in every impressionist exhibition (apart from that of 1879, when she was weakened and busily occupied following Julie's birth), and was hailed by the critics as the embodiment of "impressionism par excellence" (Philippe Burty, writing in 1882). Berthe Morisot applies the loose, sketchy handling of impressionist landscape paintings to figure painting, and domestic subjects. She experiments with painting out of doors, in a register most often characterized by a complementary mix of outdoor sessions and later work in the studio. This radical approach is expressed in her increasing determination not to cover over the traces of the painting's initial compositional stages, and its outdoor execution: parts of the unprepared canvas are left bare, and there are stitch-holes and marks left by the cork used when transporting the still-fresh canvas from the outdoor scene to the studio (see for example *Jour d'été*

45. Julie Rouart, née Manet, interviewed by Rosamond Bernier, "Dans la lumière impressionniste," *L'Oeil*, May 1959, 45.

La Fable (The Fable), 1883.
Oil on canvas, 25 ½ × 32 in. (65 × 81 cm). Private collection, Paris.

(*Summer's Day*, 1879, now in the National Gallery, London, **page 90**). The painting also shows an increasingly "sketchy" handling, blurring the transition between the figures and background, abolishing any indication of a wider setting, any hierarchy of detail or treatment. The compositions are strikingly "unframed," as if captured at random. The main protagonists are often placed at the edge of the picture, as in *Jeune Femme cousant dans un jardin* (*Young Woman Sewing in a Garden*, **page 98**) whose empty chair in the foreground recalls that of Degas's *Une nourrice au jardin du Luxembourg* (*A Wet Nurse in the Luxembourg Garden*), for example (**page 30**).

In Berthe Morisot's paintings, the figure is often immersed in an all-over background of vegetation, often a flowery garden or tall grass, where the sky and effects of atmospheric perspective disappear in favor of dynamic brushwork, the gestural movements of the hand becoming the favored—sometimes exclusive— expressive means of conveying the "impression." All of which prompted the leading critic Paul Mantz—who had spotted Morisot's first submissions to the Salon in 1865—to write: "There is only one impressionist among the group of revolutionaries, and that is Berthe Morisot.... Her painting has all the freedom of improvisation, truly the *impression* experienced by a sincere, honest eye, rendered by a hand that does not to cheat."[46]

This "freedom" reaches its height around 1881–83, in particular the series painted in the garden at Bougival, showing Julie with her father Eugène or the family maid Pasie, as in *La Fable* (*The Fable*, **page 35**). Here, Morisot positions the young maid and Julie facing one another. The title, suggested by Mallarmé, sheds no light on the picture's meaning. The contents of the book being read aloud to Julie by her maid, perhaps? When the picture was exhibited in 1896, one critic saw it as "a reflection of the most charming aspect of family life." But again, the artist seems to the modern viewer to have gone much further than this. The prevailing light and the pastel colors certainly bathe the picture in an atmosphere of irresistible charm and tenderness. The picture seems to represent a happy retreat. But the child and maid are facing each other without seeming to talk or look at one another directly. Pasie wears the same dreamy, absent expression as the elegant young ladies depicted by Berthe attending balls (or just before stepping out). Her rather listless, unselfconscious pose recalls that of Edma in 1869, in her apartment in Lorient, as if Morisot was still

46. Paul Mantz, *Le Temps*, April 21, 1877.

Eugène Manet et sa fille au jardin (Eugène Manet and his Daughter in the Garden), 1883.
Oil on canvas, 23 ½ × 22 ½ in. (60 × 73 cm). Private collection, Paris.

obsessed by the theme of boredom or *ennui*. Similarly, the scene and its figures are undefined, eschewing any attempt at narrative. Berthe takes impressionism's central preoccupations to their extreme: "Music and painting should never be literary, a very subtle distinction according to Renoir. As soon as I try to represent an individual, their physiognomy and attitudes, I become a literary artist,"[47] she wrote in a notebook after visiting her friend and fellow-painter. In *The Fable,* as in Berthe's pictures of the late 1880s, contours disappear, objects and figures are defined by quick touches of the brush, like the chickens in the foreground in *The Fable,* rendered in a "scumbled froth" of shades of white, bordering on abstraction. Morisot's handling becomes increasingly allusive, the apparently disordered streaks of color are vigorously reduced to the absolute minimum required for the construction of a motif, serving the same economy of means admired by Morisot in Manet's drawings, or Japanese prints, the only artworks "capable of indicating a mouth, eyes, a nose with a single stroke of the brush, the rest of the face modeled by the perfect accuracy of these indications,"[48] as she wrote in a notebook. Transports or excesses of brushwork are supplanted by rigorously disciplined simplification, as pointed out by the critic Jean Ajalbert: "If I may put it in these terms, she eliminates cumbersome epithets, weighty adverbs, in her clear phrasing: everything is subject and verb; she has a kind of telegrammatic style with sparkling, polished vocabulary...."[49]

47. In Delafond and Genet-Bondeville, *Berthe Morisot*, 1997, 54.
48. Notebooks of Berthe Morisot, 1885–86, 16–17, quoted in ibid., 46.
49. Quoted in ibid., 58.

Jeune fille au lévrier (Young Girl with Greyhound), 1893.
Oil on canvas, 28 ¾ × 31 ½ in. (73 × 80 cm). Musée Marmottan Monet, Paris, Michel Monet donation.

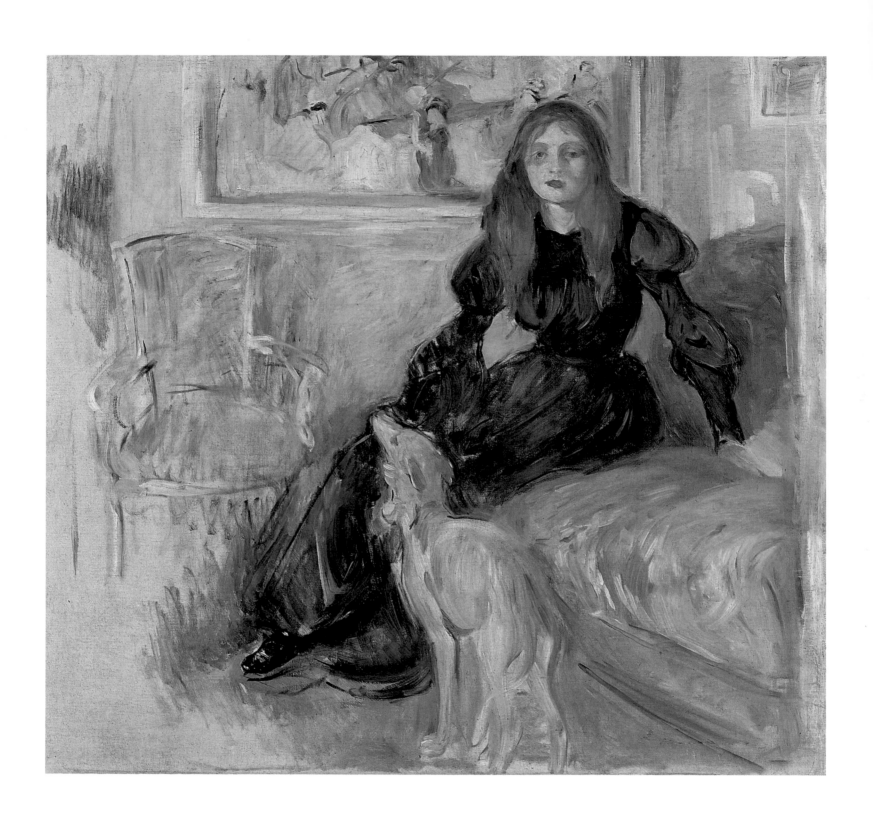

"Fixing something of the passing moment"[50]

This stenographic rendering of daily life, abolishing the frontiers between painting and writing, has less to do with the impulse to record and reflect upon everyday, bourgeois existence than with a desire to halt the fleeting passage of time—a source of anguish perceptible very early on in the artist's letters, which are obsessed with growing old: "Your phrase, 'I am working hard at growing old' is absolutely me. What if you were always to speak in my place?" she wrote to Mallarmé.[50] With the passing years, bereavement took a heavy toll on Berthe Morisot, in particular the death of her husband Eugène: "I say, 'I should like to die,' but that's not true at all, I should like to get younger… youth and old age are similar in more ways than one, and they are the two moments in life when one can feel one's own soul which would be a proof that it exists."[51] That added touch of soul at key moments of existence may perhaps explain the omnipresence of young girls in her work. Her protagonists seem to be poised expectantly on the threshold of their lives, captured at one remove from the real world, in unison with the artist's own existence: "I have entered into the positive side of life after living for years with insubstantial dreams that did not make me happy," she confided in 1874 on the subject of her recent marriage to Eugène Manet.[52] Hence our impression of Morisot's or Renoir's young women at the ball, or at home, as "débutantes" taking their first steps in the world, beneath our gaze (**pages 40**; **41**; **61**). Almost twenty years later, the artist continued to paint young girls, in the person of her daughter Julie, or her nieces Jeannie or Paule Gobillard (**page 47**). The theme finds a new expressiveness in her later works, not so very far removed from those of Edvard Munch in their handling and use of color. The extended, flowing, supple brush strokes, in which "color is nothing but an expression of form"[53] transforms the models into unreal, vibrant apparitions in the very beautiful *Jeune fille au lévrier* (*Young Girl with Greyhound*, **page 39**) which belonged to Claude Monet, the better to offset the young girl and the Japanese print on the wall.

50. July 14, 1891, in Rouart, *Correspondance*, 160.

51. Notebooks, quoted in Delafond and Genet-Bondeville, *Berthe Morisot* 1997, 70.

52. Rouart, *Correspondance*, 80.

53. Notebook of Berthe Morisot, Mézy, 1890, 56, Paris, Musée Marmottan Monet; quoted in Delafond and Genet-Bondeville, *Berthe Morisot* 1997, 50.

Facing page:
Jeune femme en toilette de bal (Young Woman in a Ball Gown), 1879.
Oil on canvas, 28 x 21 ¼ in. (71 x 54 cm). Musée d'Orsay, Paris.

Above:
Pierre-Auguste Renoir
Une loge à l'Opéra (At the Concert or Box at the Opera), 1880.
Seventh impressionist exhibition of 1882.
Oil on canvas, 39 x 31 ½ in. (99 x 80 cm). The Sterling and Francine Clark Art Institute, Williamstown, Massachusetts.

Portrait de Marcel (Portrait of Marcel), 1895.
Oil on canvas, 25 ¼ × 18 in. (64 × 46 cm). Musée Marmottan Monet, Paris.
Denis and Annie Rouart Foundation.

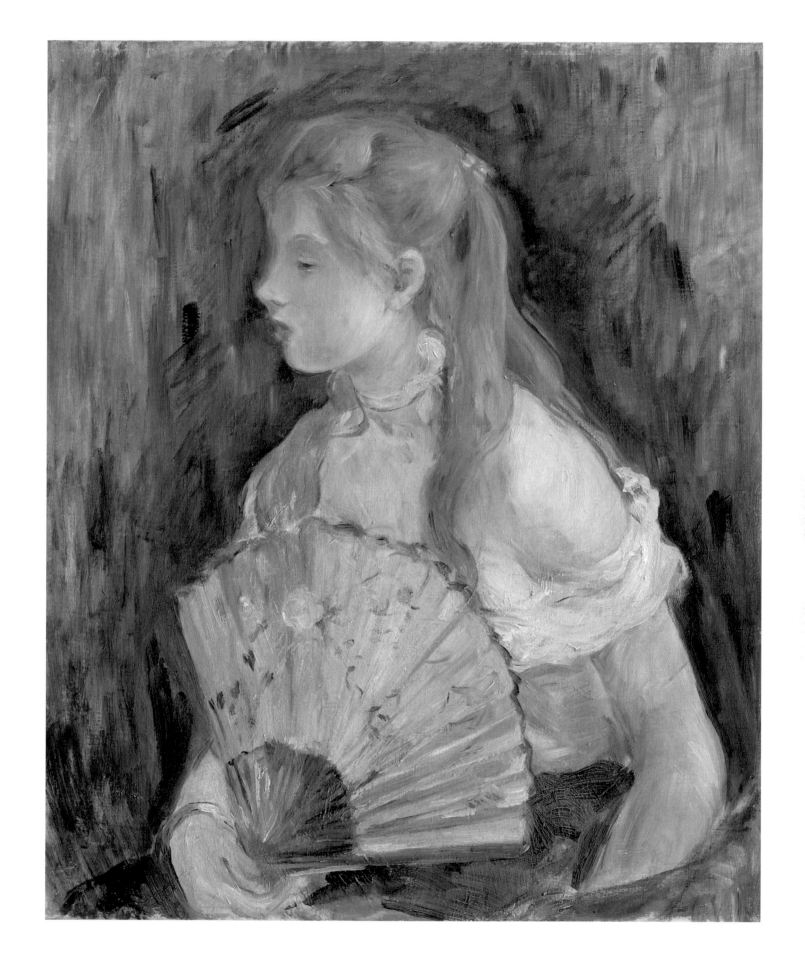

Jeune fille à l'éventail (Young Girl with a Fan), 1893.
Oil on canvas, 25 ½ × 21 ¼ in. (65 × 54 cm). Private collection.

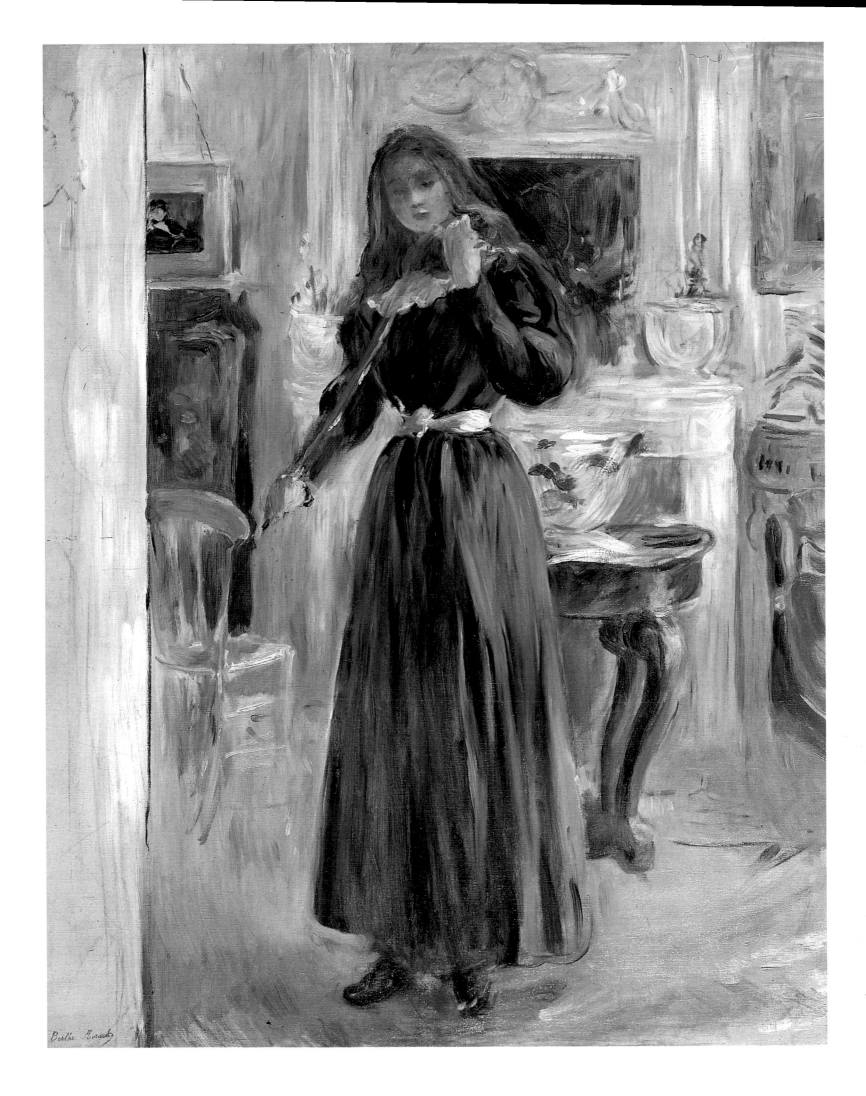

This association of motifs, and the picture's "framing" and composition, echo Manet's picture *Repose*, which had been painted while Berthe modeled for him, thirty years earlier. Berthe Morisot's later works are full of references to the past, and pictures within pictures, like resurrections of the artist's earlier life and youth, her dear departed companions: behind *Julie au violon* (*Julie Playing the Violin*, **page 44**), we see another portrait of Berthe by Manet, taking us back to the early 1870s. The painting takes on a kind of commemorative role: "The touch, sure and light" tries to "fix something of the passing moment," suggesting the fragility of appearances, and the passage of time. Berthe Morisot's painting as a whole reminds us that "memory is the true, imperishable life, that which has sunk without trace and been forgotten was not worth experiencing, the sweet hours, and the great and dread, are immutable. Dreams are life itself—and dreams are more true than reality; in them we behave as our true selves—if we have a soul it is here."[54]

54. Notebook of Berthe Morisot, quoted in ibid., 74.

Julie au violon (Julie Playing the Violin), 1893.
Oil on canvas, 25 ½ × 21 ¼ in. (65 × 54 cm). Hermann Mayer Collection.

Édouard Manet
Detail of **Berthe Morisot Reclining,** (page 21).

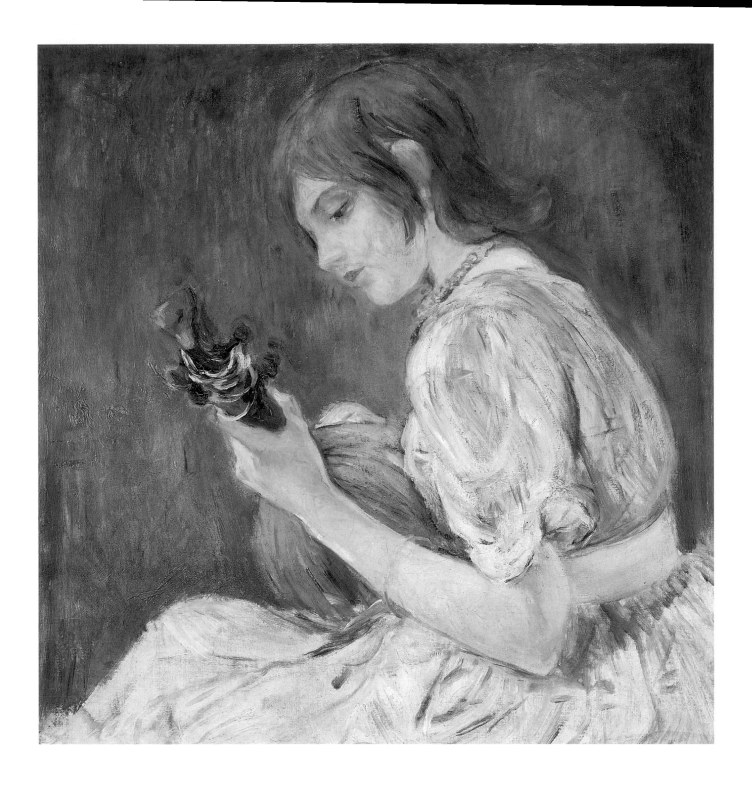

La Mandoline (The Mandolin), 1889.
Oil on canvas, 21 ¾ × 22 ½ in. (55 × 57 cm). Private collection. Paris.

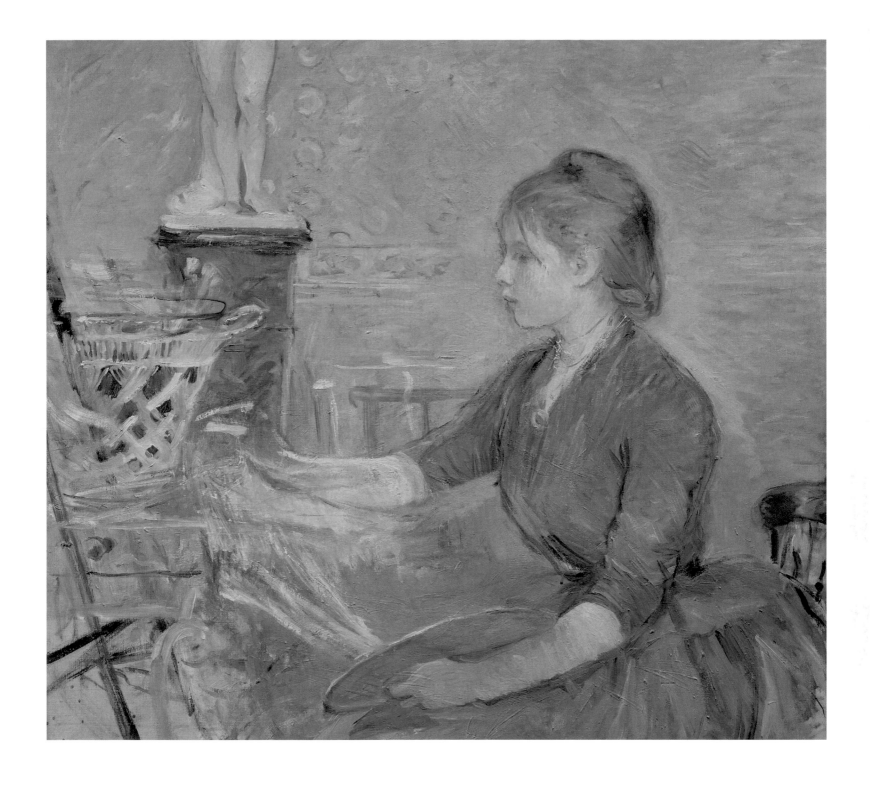

Paule Gobillard peignant (Paule Gobillard Painting), 1887.
Oil on canvas, 33 ¾ × 37 in. (86 × 94 cm). Musée Marmottan Monet, Paris.
Thérèse Rouart donation.

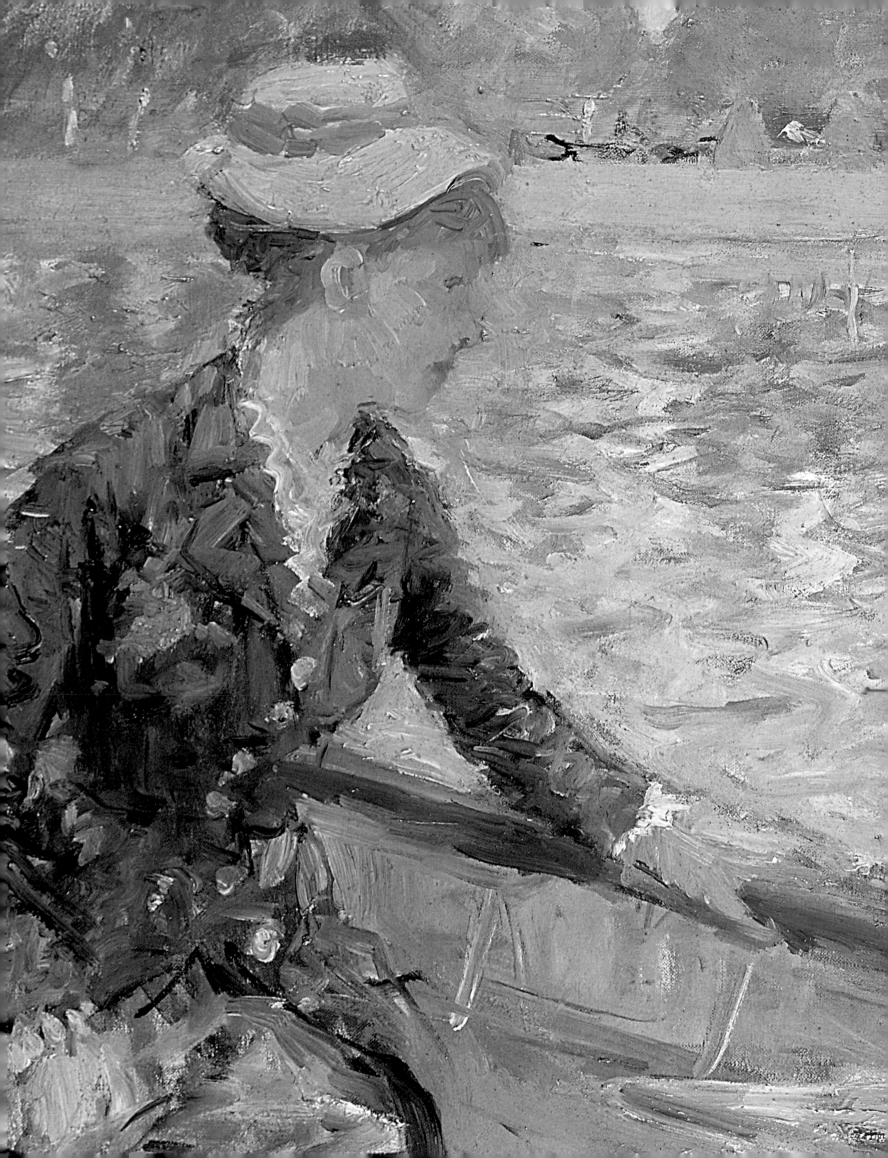

The Beautiful Painter

Jean-Dominique Rey

Over a hundred years have gone by, and Berthe Morisot's work has not aged a day. But for the details of dresses or hats, it might have been done just now. Perhaps, in the first instance, this is explained by the fact that it has, for many years, remained in obscurity, less disclosed than other oeuvres, less reproduced, less worn and tarnished by our gaze, retaining its capacity to astonish and delight the eye. But its intact charm, for us today, is due to qualities other than this simple accident of fate: in the first instance, to that happy, endlessly renewed blend of freshness and subtlety, spontaneity and concealed skill that is the secret of its balance and harmony, and the reason for its lasting appeal. A body of work as discreet as the woman who so diligently produced it, without fuss or show, a secret oeuvre whose true value is discovered with the distance established by time, a body of work of profound depth that seems, on the surface, merely to gather the fruits of each passing moment, to capture the pollen that floats rapidly away. But appearances only serve to mask Morisot's diffidence and restraint: her work is suggestive, allusive, never overdone; yet it holds everything captive—with no appearance of doing so—in its subtle, quintessential touch. Hence that impression, a century later, of youthfulness and full-blown modernity, as if everything had been painted yesterday, and the studio cloth just lifted on the canvas in progress. And while her paintings have gone down only quietly in history, slipped modestly into the ranks of artistic tradition, they delight and astonish us today by comparing so admirably to works that have fared so much better down the years.

Let us look for a moment, before stepping into the art, at the beautiful face captured so delightfully by Manet, and which she herself tried, on several occasions, to approach in paint. There is a touch of severity at times, perhaps, as in the most conventional of her self-portraits, the merest hint of distance, deflecting and disconcerting; but as we read her countenance, beyond the veils, it is impossible not to be struck by the mix of charm and intelligence, sensuality and anxiety, diffidence and decisiveness, ardor and self-doubt, their intensity revealed in another, more quickly sketched self-portrait, brushed directly onto the unprepared canvas. Qualities whose conflicts and combinations, blossoming and transposition are embodied in her work, and which we find confirmed, rooted, or reflected in her letters, her life and friendships, her role in the lives of those closest to her, in the lives of other painters, her friends.

Detail of **Jour d'été (Summer's Day),** (page 90).

And if we are truly to understand her work, we must remember this: beneath her gentle appearance, this woman possessed an unshakable will, so that nothing could divert her from her chosen path. Her work demanded effort and tenacity, but the cost was never apparent. Great art erases all trace of the road traveled, and allows us to see only the final flowering.

She was born on January 15, in 1841—the same year that Frédéric Bazille and Auguste Renoir, Armand Guillaumin, and prime minister Georges Clemenceau were born, just one year after Claude Monet and Auguste Rodin. She entered the world in the town of Bourges, the exact geographical center of France, but came from a quintessentially Parisian family. Her father, Edme-Tiburce Morisot, was the local prefect, but should have been an architect like his own father, also called Edme-Tiburce. Jean-Honoré Fragonard was a distant relation of her grandparents' generation. Évariste Fragonard, Jean-Honoré's son, certainly painted Madame Morisot, the architect's wife and Berthe's grandmother. But what is important here, beyond a shared taste for female subjects, is a certain similarity of handling between the great Fragonard and Berthe Morisot, a lightly accented yet decisive touch, an apparent *fa presto*, as if the brush were just flicking the surface of the canvas, appending colors as if pinning a rose to a corsage—bonds far more decisive than those of blood.

The fairies certainly seem to have heaped blessings on Berthe Morisot's cradle, and this is perhaps the most surprising part of her destiny as a painter: that, with every gift from heaven, every advantage on earth, she resisted the lure of facility and became a great painter, with all the effort and sustained struggle that that entails. Her life unfolded serenely, so it would seem—biographers hungry for anecdote regularly break their teeth on the glassy, unruffled surface of an existence traversed by events that glide smoothly by, like swans on a quiet lake. The good fairies, the peace and tranquility are doubtless explained by Berthe's social milieu, and her times. But here, once again, the miracle is at work: Berthe was born into an affluent middle-class family, yet nothing and no one stood in the way of her vocation—rather, her family encouraged and promoted it. It was remarkably fortunate that her talent awoke and grew under the Second Empire, a moment when, perhaps, history lay quiet for an instant, before stridently thundering once again. Did her parents feel a sense of intuition? Or did things progress naturally because nothing stood in their way? Unquestionably, Berthe found understanding and complicity in her mother. And, in herself, a permanent sense of dissatisfaction, coupled with rigorous, implacable standards that were never challenged.

Completing our outline of some of the initial conditions framing her output, it is worth noting that few lives are more "centered" than that of Berthe Morisot. With the exception of the accident of her birth, in Bourges, a place she never saw again, and her peripatetic early years following her father's postings, her life was lived between Rue des Moulins in Paris (now Rue Scheffer), where the family settled in 1855; Rue Franklin nearby, where the prefect built the house that became the Morisot family seat; Rue Guichard and Avenue d'Eylau, and finally Rue de Villejust, where she remained until just prior to her death on Rue Weber in 1895. She is buried in the Passy cemetery, near Rue des Moulins and the beginnings of her Parisian life—few lives unfold within such narrow confines, those of a single quarter of one city. The quarter with a rustic atmosphere: at Rue Franklin, her parents' home was surrounded by a garden in which she installed her studio, a terraced garden overlooking the whole of southern Paris and the Grenelle plain, which was still largely given over to vegetable plots at the time; at Rue de Villejust, the windows opened onto a vista of fields and a quiet neighborhood, near the Bois de Boulogne and a fertile source of motifs—ladies walking, ponds, trees, swans. Berthe Morisot never had far to go to find her fleeting or quiet, contemplative models, taking their image, fresh in her mind, back to her studio.

It is also true to say that she traveled a great deal more than many of her contemporaries, visiting Spain, England, the Channel Islands, Italy, Belgium, and Holland; she traveled frequently, too, in and around France, but each of her journeys or sojourns, during which she would paint and visit museums, was to be a springboard for her art, whose promise flourished, and whose fruits were gathered, back at home in her studio.

We have used the word "studio," but this is somewhat overstating the case. For many years, Morisot painted where she lived, making no distinction between her work and daily existence; canvases and brushes disappeared into a cupboard (or behind a screen, on Rue de Villejust) when a visit was announced, a fact that bears witness to her diffidence as a painter, and to the constant, close proximity of her art and life—in fact, the two were intimately linked.

We know little about her childhood except that she loved reading, developed an interest in Shakespeare at an early age, and enjoyed modeling everyday objects in clay. She studied piano with Camille-Marie Stamaty, a celebrated musician whose features are captured in a superb drawing by Jean-Auguste-Dominique Ingres, surrounded by his nearest and dearest. This drawing was perhaps Morisot's first encounter with the living art of her day: we imagine her gaze, in a distracted moment during her lessons, moving from the model to the drawing, prominently displayed

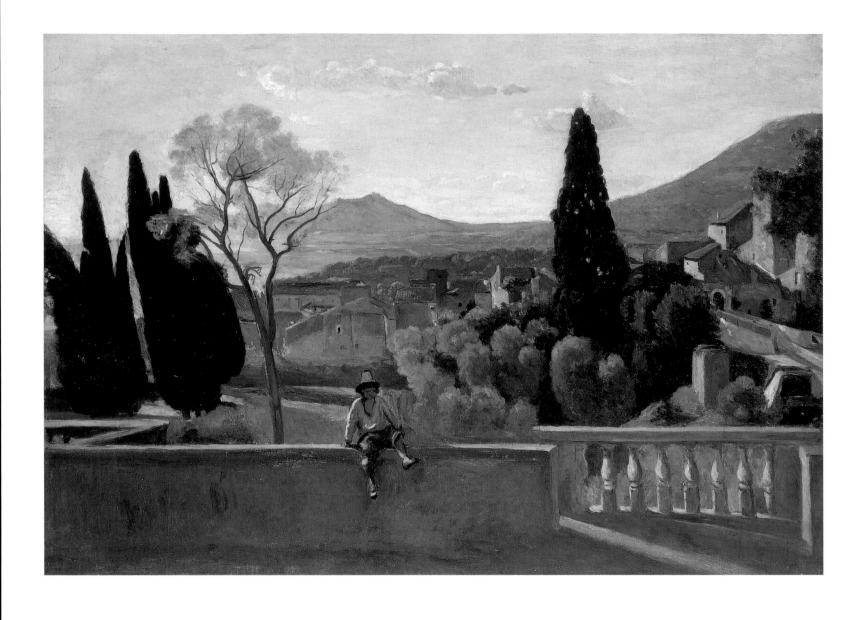

in the musician's salon. It takes more than this to spark a vocation, and hers was revealed by a quite banal accident of fate, one of those small, everyday occurrences pregnant with unforeseen consequences. Berthe was just sixteen years old when, in 1857, her mother wanted to surprise her husband with three drawings by his three daughters and took them to the studio of Geoffroy-Alphonse Chocarne. As we have seen, the lessons were short-lived but Edma and Berthe discovered a liking for drawing. For twelve years, the sisters worked together, until Edma gave up drawing to get married. Berthe persevered alone, and art became her reason for living. With the exception of Chocarne, her successive teachers all glimpsed her gifts or foresaw her potential, including Joseph Guichard, the Morisots' neighbor in Passy, who taught both sisters the rudiments of painting— their first lesson was an exercise in shades of white, to teach them about tonal values—and took them to see the Venetian artists at the Louvre. Seeing that he had nothing more to teach them, and given Berthe's insistence on painting out of doors (a heresy in the eyes of this traditional history painter), Guichard introduced them to Camille Corot. And Corot—surprised, perhaps, by Berthe's independence of spirit, and after having the girls copy some of his own works (a *View of Tivoli* by Berthe survives)—steered them in the direction of Achille Oudinot, through whom, in his workplace at Auvers-sur-Oise, they came into contact with the Daubignys, Honoré Daumier, and Antoine Guillemet.

In 1863, the two young girls spent time in Chou, a tiny hamlet between Pontoise and Auvers whose appearance may be imagined from an etching belonging to Dr. Gachet—a handful of rustic houses on the edge of a river bluff above a towpath, soon to be captured on canvas from the other side of the river by Pissarro, Cézanne and, later, Gustave Loiseau. Berthe Morisot's only surviving record of this decisive stay is a single painting, *Vieux chemin à Auvers* (*Old Lane at Auvers*), reminiscent of Corot but already distinct from his style, and heralding a free handling that several contemporary painters had begun to develop. The painting was Berthe's first Salon showing, in 1864.

In the same year, the Morisot family rented Léon Riesener's country house in Beuzeval, in Normandy, the starting point for a series of friendships. Léon Riesener, grandson of the famous cabinet-maker, a cousin of Eugène Delacroix and himself a painter, followed Berthe's progress, and encouraged her experiments and explorations. At Riesener's house on Cours-la-Reine, Berthe Morisot met the sculptor Marcello, alias the beautiful duchess Adèle de Castiglione-Colonna, who painted her portrait in oils, in 1875. Attracted to sculpture, Berthe Morisot studied the medium with Aimé Millet, and later executed a bust of her daughter, Julie.

Vue de Tivoli (View of Tivoli), 1863.
Oil on canvas, 16 ½ × 23 ¼ in. (42 × 59 cm). Private collection, Paris.
A "cult painting" by Corot, that the painter lent to Berthe
Morisot to copy. Henri Rouart acquired the original in 1875.
Camille Pissarro saved the copy from destruction.

Let us look now at the beginnings of Morisot's oeuvre (or what survives, since she herself destroyed many of her early attempts): her first original paintings, beyond the initial copies of Old Masters in the Louvre, including Veronese, or the assimilation of the early lessons of Corot. *Chaumière en Normandie (Thatched Cottage in Normandy)* (**page 55**)—a pure landscape, rare in Morisot's oeuvre— already shows her distinctive charm and decisive touch, that blend of certitude and mystery, one half unveiling the other: the painter remembers Corot, but there is an early intimation of impressionist light. The grass has a particular soft, downy quality, scattered with comma-shaped hooks of paint that catch the diffuse light reverberating among the elegant shafts of the birch trees.

There is no room to expand here on each successive painting through which Berthe Morisot learned and perfected her expressive means. But her canvases in Auvers, Normandy and, soon, Pont-Aven—so many places later made famous in the annals of painting, places that she often discovered ahead of other painters— are striking today, beyond their still perceptible artistic influences, for their highly personal sense of light.

Let us turn to her early canvases, in which she affirms her style, finds her own personality, defines the climate of her work—paintings like *Ombrelle verte (The Green Parasol)* painted in 1867 in Petites Dalles, near Fécamp, where Monet would come in his turn, twelve years later, to paint some views of cliffs. Against a landscape background suggested with great economy of means, a young woman sits reading on the grass, her fan cast aside. The accent of black on her corsage, another in the ribbon around her neck, and a third marking her hat, are all dark touches designed to bring out the chorus of light colors used in the rest of the picture. If one had to pinpoint the absolute originality of Morisot's work, single out what it is that distinguishes her from her contemporaries, one might identify her as a painter of early morning light, a characteristic she owes to the early advice of Corot. Better than anyone else, she fixes—but already the word seems too heavy, rather she "touches"—the quiet golden light of morning onto her canvas.

The year 1868 marked a turning point in her life. One morning at the Louvre, in front of a Rubens that she was copying with her friend Rosalie Riesener, Berthe met Édouard Manet. Fantin-Latour made the introductions. A singular conjunction of painters, a sudden coming together of past and present. Controversial, much discussed and criticized, frequently wounded by his lack of official recognition, Manet was revered as an esteemed forebear by the young painters of his day. He and Berthe went on to form a lasting, unbreakable friendship—the event was truly a meeting of minds. And yet their bond, often commented upon, has most often been

Facing page:
Chaumière en Normandie (Thatched Cottage in Normandy), 1865.
Oil on canvas, 18 × 21 ¾ in. (46 × 55 cm). Musée Marmottan Monet, Paris.
Denis and Annie Rouart Foundation.

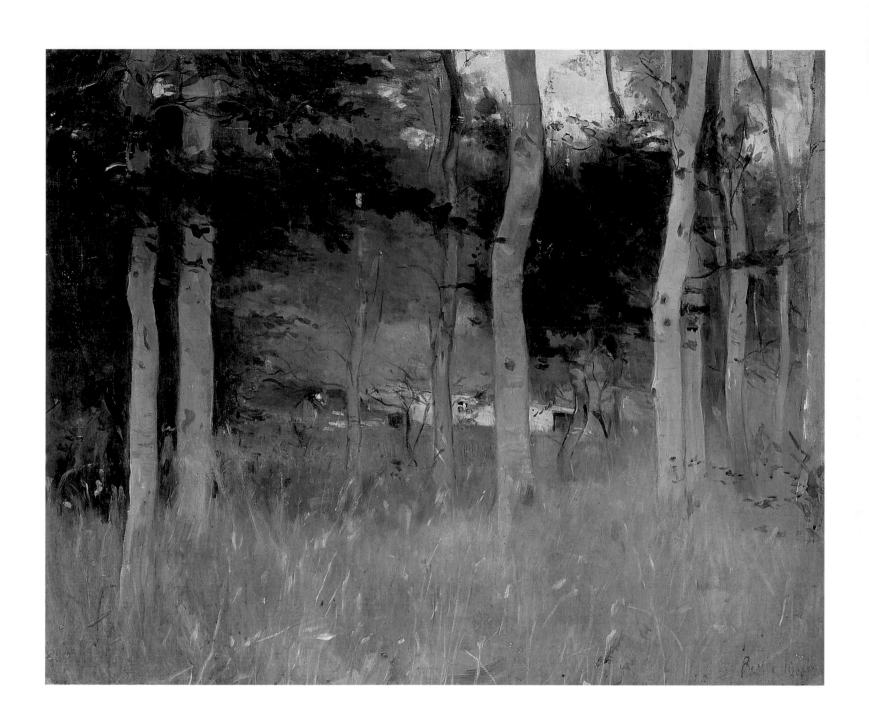

misrepresented almost always to the detriment of Morisot. The young artist was indeed attracted to the persona of the illustrious older painter, and admired his work. He, in turn, was dazzled by this young woman, seeing beyond initial appearances to the fullness of her promise and inspirational artistry. Manet soon asked Morisot to pose for *Le Balcon* (*The Balcony*) (**page 21**), where she appears with the landscape painter Guillemet, whom she knew from Auvers-sur-Oise. And this was to be the first of the prodigious series of portraits—paintings, drawings, prints, numbering fourteen in total, some of them simple sketches homing in on her essential characteristics, others finished works capturing the very essence of her being—that Manet dedicated to Morisot. A constellation centered on the famous painting that Paul Valéry rightly placed at the summit of Manet's output, the portrait of *Berthe Morisot au bouquet de violettes* (*Berthe Morisot with a Bouquet of Violets*) (**page 58**), also known as *Berthe Morisot au chapeau noir* (*Berthe Morisot in a Black Hat*) bearing the date 1872, the year in which Berthe painted her own *Femme et enfant au balcon* (*Woman and Child on a Balcony*) (**page 63**) on Rue Franklin. Framed by her black ringlets, Berthe's gaze as depicted by Manet is supremely bright and intense: her green eyes become dark nuggets—the penetrating gaze of a painter, a woman's gaze of competing passion and melancholy. This is a portrait beyond mere portraiture—a picture the viewer never tires of looking at, an image of all that has passed between the two painters: tender friendship, the exchange of ideas, mutual inspiration; all seem condensed and crystallized here. And this somewhat aloof independence, this sovereign distance tainted with just a hint of sadness, marvelously defines Berthe Morisot for us today.

Here we must put an end to a persistent misunderstanding that would have Morisot as Manet's pupil. Impressed by her talent, Manet certainly encouraged and advised Berthe early in her career, and even retouched one of her paintings, *La lecture* (*Reading*), better known as *Portrait de la mère et de la sœur de l'artiste* (*The Mother and Sister of the Artist*) (**page 17**) of 1869, which distressed her somewhat, but he never made her his pupil or disciple. And yet this putative relationship is repeatedly referred to, from Zola's earliest articles of 1880: "Mme Berthe Morizot [sic] is a very personal pupil of Édouard Manet" (in *Le Naturalisme au Salon*), to Huysmans, who takes up the refrain the following year: "Like M. Manet, her teacher, Mme Morizot [sic] undoubtedly has a [good] eye...." (*L'Exposition des Indépendants*, 1881), and has been tirelessly rehearsed down to the present day by articles and entries in reference works, hastily written and hopelessly trotting out the same formulae, the same mistakes.

Contemporary commentators disdain the question of artistic influence to such an extent that it is either viewed as a defect, deemed to operate in one direction only,

Le Calvaire (Calvary), 1860.
Oil on canvas, 27 ½ × 27 ½ in. (70 × 70 cm). Private collection, Paris.
It was Joseph Guichard who prompted Berthe Morisot to make two copies of Veronese at the Louvre in 1860 and who introduced her to Henri Fantin-Latour in front of these works. The latter would introduce her in turn to Édouard Manet, again at the Louvre, a few years later.

or conveniently erased when it contradicts the sacred ideal of originality. In this context, we should note simply that Morisot came under the influence of Manet's ascendant early in her career, like most of the impressionists, and that the two explored some common subject matter, but that all of the impressionists shared identical themes and subjects in their paintings. It could just as easily be demonstrated that Manet borrowed certain themes and subjects from Morisot, as we shall see later. But Morisot's treatment of them is highly personal, like her *Déjeuner sur l'herbe* (1875), possibly her only rendering of the subject, reduced to one couple and given a far more intimate appeal. She inspired Manet not only as a subject for portraits: as a painter, she became his link to the impressionists, enabling him to understand what he had first rejected. In the context of Manet's later work, we can quite properly talk in terms of her influence on him, the final phase of a long exchange.

Returning now to Berthe Morisot's work during these decisive years, we find her painting the people closest to her, as she was to do for the rest of her life: her mother and her sister. Edma had practiced painting at her sister's side, and now became her sister's favorite model. We find her in *The Mother and Sister of the Artist*, or the famous *Jeune femme à sa fenêtre* (*Young Woman at Her Window*) (**page 23**), dreamily playing with her half-open fan. Soon, she would appear in the celebrated *Le Berceau* (*The Cradle*) (**page 28**), Berthe Morisot's best-known and most-reproduced painting, in which the same young woman gazes through transparent tulle drapes at her sleeping infant, the entire picture playing on the contrast of the ethereal white curtains and the young mother's black ribbons and dress. But Morisot's finest family painting of the period remains the *Interior* (1872), painted on Rue Franklin.

The left-hand side of the composition features an early version—almost an oil sketch—of the *Woman and Child on a Balcony* painted two years later from the same balcony, glimpsed here in the window frame, and presented first as a watercolor sketch. This is a lighter, paler version, however (a gray dress, a blonde woman), and the barely parted curtain seems to symbolize the act of waiting. Counterbalancing this reference, in the center of the composition, a young woman dressed all in black is seated in profile, posing quietly. Behind her, at the right-hand edge of the picture, a *jardinière* sprouts a huge, flourishing bouquet of red and green. Berthe Morisot uses the same floral background for her painting *Au bal* (*At the Ball*) (**page 61**), more broadly brushed this time, and dotted with yellow to echo the flowers worn by her subject. Sometimes, moving freely from one canvas to another, we can follow not the repetition of certain motifs, but their redeployment for new ends and a different orchestration. The impression is that of a stage set turning slowly under the gaze of a painter who changes place as required, for the work in progress.

Édouard Manet
Berthe Morisot au bouquet de violettes (Berthe Morisot with a Bouquet of Violets), 1872.
Oil on canvas, 21 ¾ × 15 in. (55 × 38 cm). Musée d'Orsay, Paris.

Édouard Manet
Portrait de Berthe Morisot, 1872.
Etching, Museo Zuloaga, Zumaia.

Looking at Morisot's work from the distant standpoint of our own time, another appealing aspect emerges, and one which has, perhaps, received relatively little attention to date. At times in the early part of her career, Berthe Morisot was a painter of city life. It was a city undergoing rapid change, witnessed in a series of canvases that leave modern viewers dreaming of the Paris of bygone days (*La Seine au pont d'Iéna*, 1866, *Vue de Paris des hauteurs du Trocadéro*, 1872, *Paysage à Gennevilliers*, 1875, and others) while at the same time revealing their author as a painter of the fleeting moment, a painter of modern life. Perhaps Baudelaire's cherished phrase was overheard on visits to Manet? We can wager with greater certainty that the idea reflected the spirit of the age: modern subjects offered painters exciting new domains, soon to be accompanied by the rediscovery of light. The *Woman and Child on a Balcony* is the finest of these urban views: a woman in black (Edma Pontillon) leaning on a balustrade, and a child in white with red-blonde hair (Paule Gobillard) look down at a garden hidden from our view. There is a lingering hint of Manet in the black dress, but the composition is original and very much Morisot's own: the broad city horizon, the river encased between the balcony rail and the empty Champ-de-Mars, seeming to flow towards some parallel horizon, all give the couple—formed by the woman and child—a striking sense of simultaneous presence and absence; a sharply observed present overlaying the unseen horizon of their dreams. A watercolor shows us the initial idea for the picture: dark and light patches of color, an allusive setting, a lightly sketched bridge, the river summarily indicated. In the finished painting, however, the landscape is both relegated to the background and amplified, and the whole composition orchestrated around a series of colorful echoes—the brown of the balcony wall, the red dots of the flowers, the black dress, the gold dome of the Invalides, all find an answering detail elsewhere in the picture. This picture may be seen as one of the high points of Morisot's oeuvre, a pivotal work in her career—the birth of a style and its apotheosis, a summing up, and a new beginning. Ultimately, however, Nature supplanted the city in her work, and in this she follows the wider course of the impressionist movement, born at this same moment. But she never relinquished this modernity: we shall see it again as we approach some of her finest female figure studies.

The fact that the impressionist group of painters included a woman among its ranks from the outset is seen today as symbolic, bearing witness to the painters' embrace of a revolution that was not confined to the world of painting, but was also a sign of a much wider evolution in society as a whole. Throughout her life, with each new work, each new exhibition, the impressionists considered Morisot their equal, and her paintings were greatly appreciated by every member of the group.

Au bal (At the Ball), 1875.
Oil on canvas, 25 ½ × 20 ½ in. (65 × 52 cm). Musée Marmottan Monet, Paris.

From Manet, the senior grandee who drew closer to the group only at the friendly insistence of Berthe Morisot, to Degas—at once reticent and ground-breaking—on the outer limits of impressionism, and from Renoir to Monet, respectively the soul of the movement and its most powerful expression, all were keenly aware of the painterly quality and spontaneous charm of her work, and all were eager to own works by Berthe Morisot themselves. Manet quickly acquired the *Vue du petit port de Lorient* (*The Harbor at Lorient*) (**page 12**), a poem in blue and brown, in which all the light from the sky and water reverberates on the white dress of the young woman sitting on the harbor wall, like a fresh, living signature. Camille Pissarro owned the *View of Tivoli* (**page 52**), still marked by the influence of Corot, and Alfred Sisley a later canvas, *Devant la glace* (*Before the Mirror*) (**page 143**), which may have been given as a gift or exchanged in 1893 during a trip Morisot and the poet Stéphane Mallarmé, made to Moret-sur-Loing. Degas, for his part, acquired a canvas painted in Fécamp in 1874: *Dans une villa au bord de la mer* (*In a Villa at the Seaside*). Two versions of this scene exist, like two pendants, in which the woman is seated by turns to the left and right of the picture. We note here the discreet human presence which, with impressionism, now becomes an integral part of the landscape. Curiously, two inseparable friends, Edgar Degas and Henri Rouart competed to own one of these two complementary paintings. The version chosen by Degas has a mysterious quality, a climate of expectation or suspense, almost but not quite contradicted by the pale Nile green of the sea, the dark blue of the woman's skirt ringed with lines of white trim, like wavelets, and the pale pink of the sky. But the bold silhouette of the wooden balcony, the boats sailing between its supporting columns, were sure to delight Degas, whose radical misogyny is shown once again for the myth it was: the over-hasty judgments eagerly heaped upon him by later commentators are surely toppled when we remember that he immediately defended the work of three remarkably talented women—Berthe Morisot, Mary Cassatt, and Suzanne Valadon.

The impressionists, often rather hastily pictured as naturalists favorable to the encroachments of industrial society, appear more as artists striving—with a totally new approach and a rare delight—to capture a world about to disappear as a result of the rise of industrial society, holding fast by the tips of their brushes to a natural scene that was fast receding, and to fleeting impressions soon to be obliterated by a fast-changing society and modern lifestyles. Paradoxically, thanks to their work, these moments have been made permanent; today, we still identify closely with their spontaneous inventory of disappearing nature, the happy conjunction of being and looking in their work—more closely, indeed, than with anything that has attempted to replace them. Hence the astonishing fascination that, over a century later, is still exerted by impressionism.

Dame et enfant sur la terrasse or **Femme et enfant au balcon**
(Woman and Child on a Balcony), 1872.
Oil on canvas, 23 ½ × 19 ¾ in. (60 × 50 cm). Private collection, Switzerland.
Courtesy, Fondation Pierre Gianadda, Martigny.

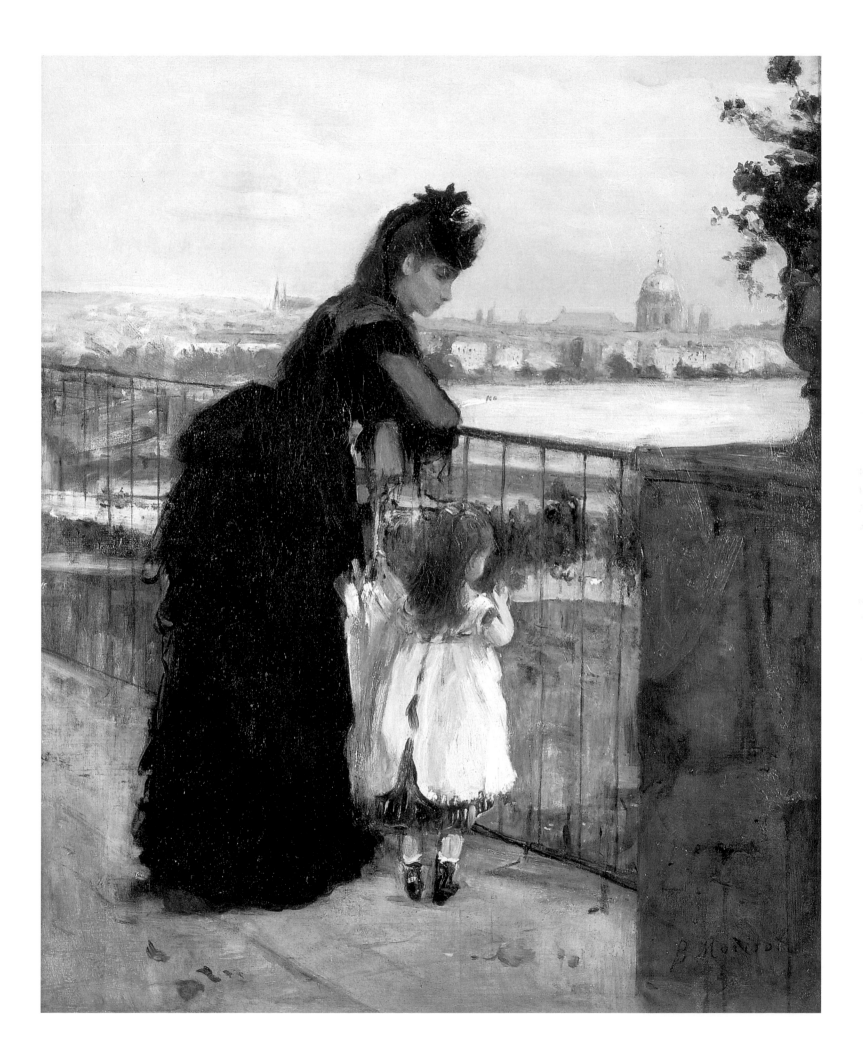

Pissarro's vast open meadows, Monet's poppy fields, Renoir's grassy tracks are imprinted on our collective memory, but Morisot's more discreet landscape paintings should also give us pause. The watercolor entitled *Jeune femme et enfant dans l'herbe* (*Young Woman and Child on the Grass*) is one of her most evocative landscapes, with a light, quick touch that cannot be attributed solely to the medium. In the distance, a blue-tinted urban skyline is silhouetted against a pale sky. But here, the figures of the young woman and child would detract from the landscape if they were not perfectly incorporated into it, integral to the grass, the air—whiter shades of pale on an expanse of grass bleached yellow by the sun. What the impressionists celebrated, with extreme simplicity of means, is the marriage of the sentient human figure with nature at a time when this relationship was being rediscovered, beyond mythology, in all its naked simplicity. On the subject of impressionism, about which everything has surely been said, it is worth noting—in the context of this book's subject and approach—a phenomenon that has perhaps been insufficiently stated to date: that there is something feminine in the very concept of impressionism, in its zest for the fleeting moment, the primacy of impressions over perception. It should, then, come as no surprise that the group included a woman from the outset, and that she should go on to become its longest-lasting member. This was perhaps the first movement in painting to include a woman among its founder members. Later, she was joined by another woman painter, Mary Cassatt, who contributed to the movement's transatlantic expansion and success. But Berthe Morisot remains the female artist whose work best expressed, with such grace and freshness, the fleeting quality, the primacy of direct sensation over recollection that would now transform the art of painting and take it forward in new directions.

It is worth noting that—compared with their attitude to Manet, Monet, and later Cézanne—the critics were relatively gentle in their treatment of Berthe Morisot. Although this did not prevent them—with the exception of Philippe Burty—from misspelling her name with a "z" instead of an "s." Even Zola, even Huysmans. The practice was something of a habit at the time: Cisley, Degaz, Sésame, the innumerable errors might have been the result of haste or, more probably, on occasion, the scant regard in which these innovative artists were held. Inevitably, like her contemporaries, Berthe was treated to the ironic commentaries of Louis Leroy in *Le Charivari*, in 1874: "Tell me about Mademoiselle Morisot! This young person is perfectly unconcerned with the reproduction of a host of pointless details. When she has a hand to paint, she gives as many long strokes of the brush as there are fingers, and there it is!"

Femme en noir or **Avant le théâtre (Figure of a Woman** or **Before the Theatre), 1875.**
Oil on canvas, 22 ½ × 12 ¼ in. (57 × 31 cm). Private collection.

One of the rare full-length portraits in Berthe Morisot's oeuvre: this symphony in black, white, and pink, discreet but vibrant, belonged to the famous actor Edward G. Robinson.

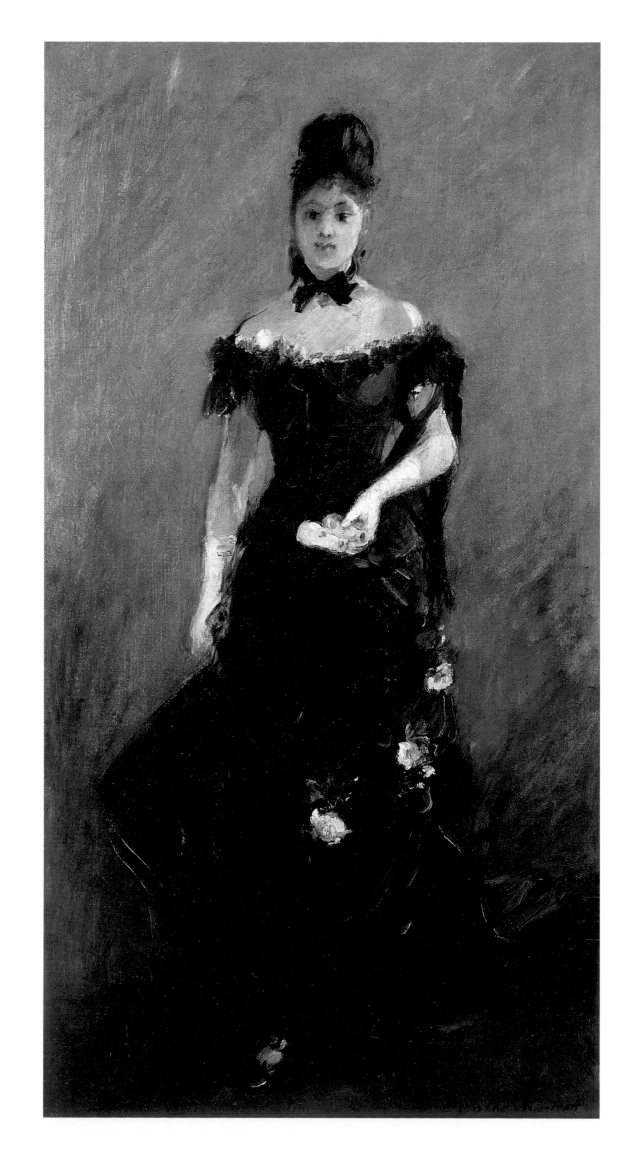

Paysage à Gennevilliers (Landscape at Gennevilliers), 1875.
Oil on canvas, 12 ½ × 16 ¼ in. (32 × 41 cm). Private collection, Paris.

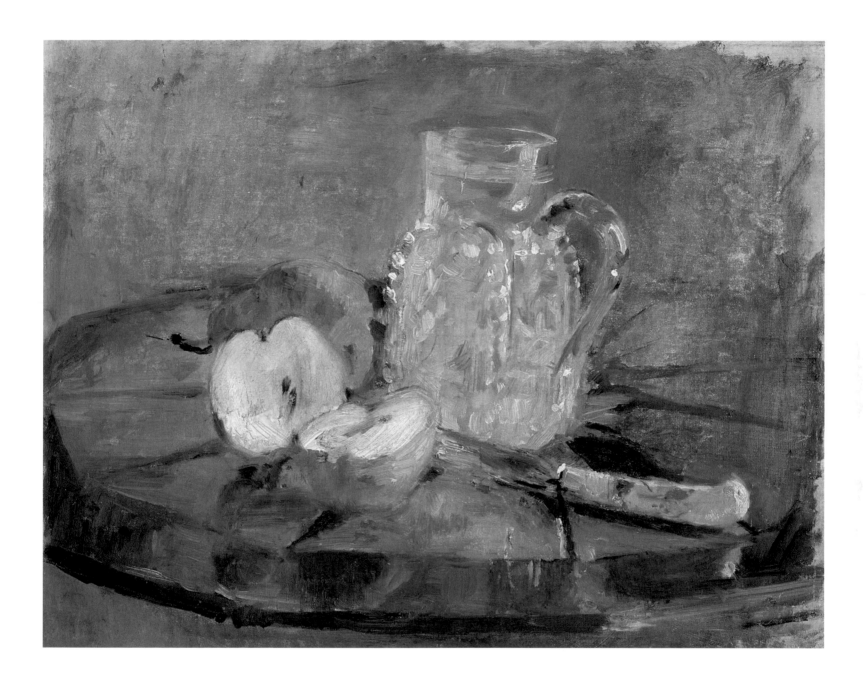

Nature morte à la pomme coupée et à la cruche (Still Life with a Cut Apple and a Pitcher), 1876.
Oil on canvas, 12 ½ × 16 ¼ in. (32 × 41 cm). Musée Marmottan Monet, Paris.

**Bâteaux en construction
(Boats under Construction), 1874.**
Oil on canvas, 12 ½ × 16 ¼ in. (32 × 41 cm).
Musée Marmottan Monet, Paris.
Denis and Annie Rouart Foundation.

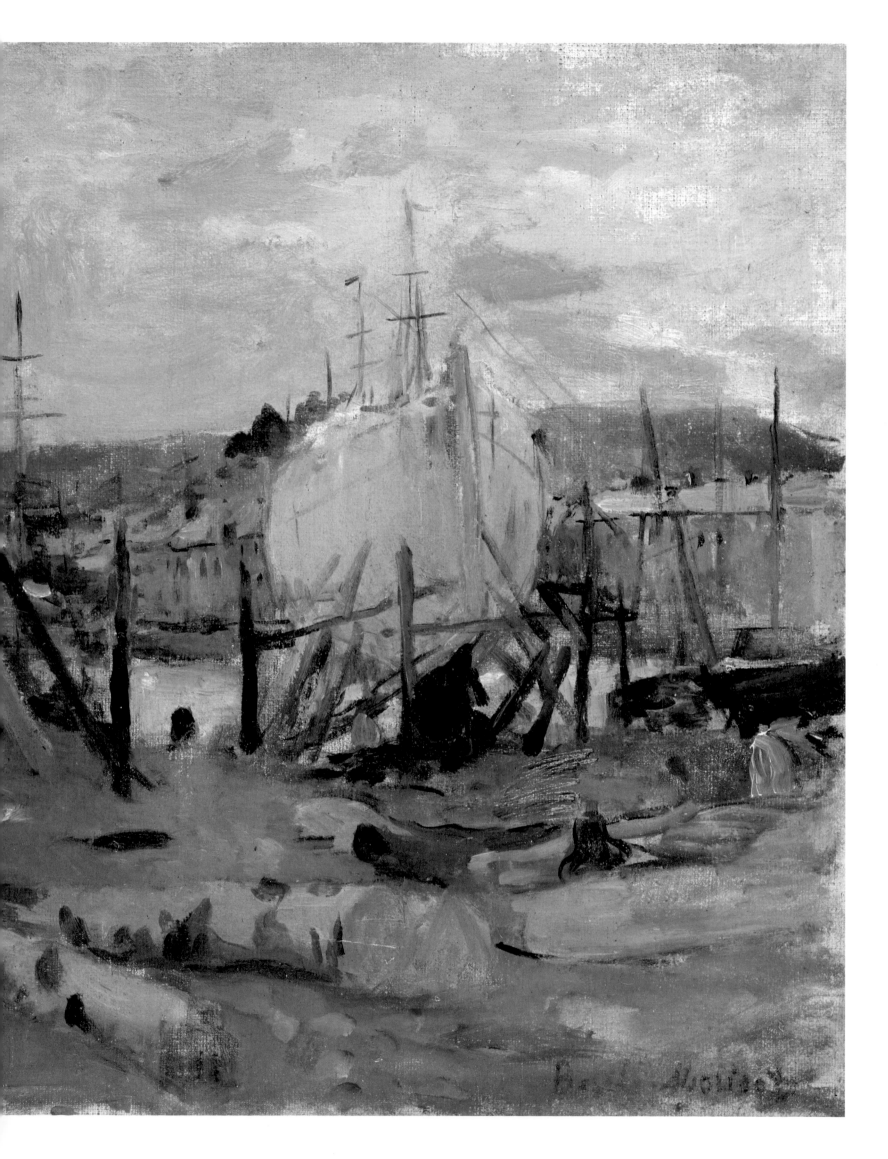

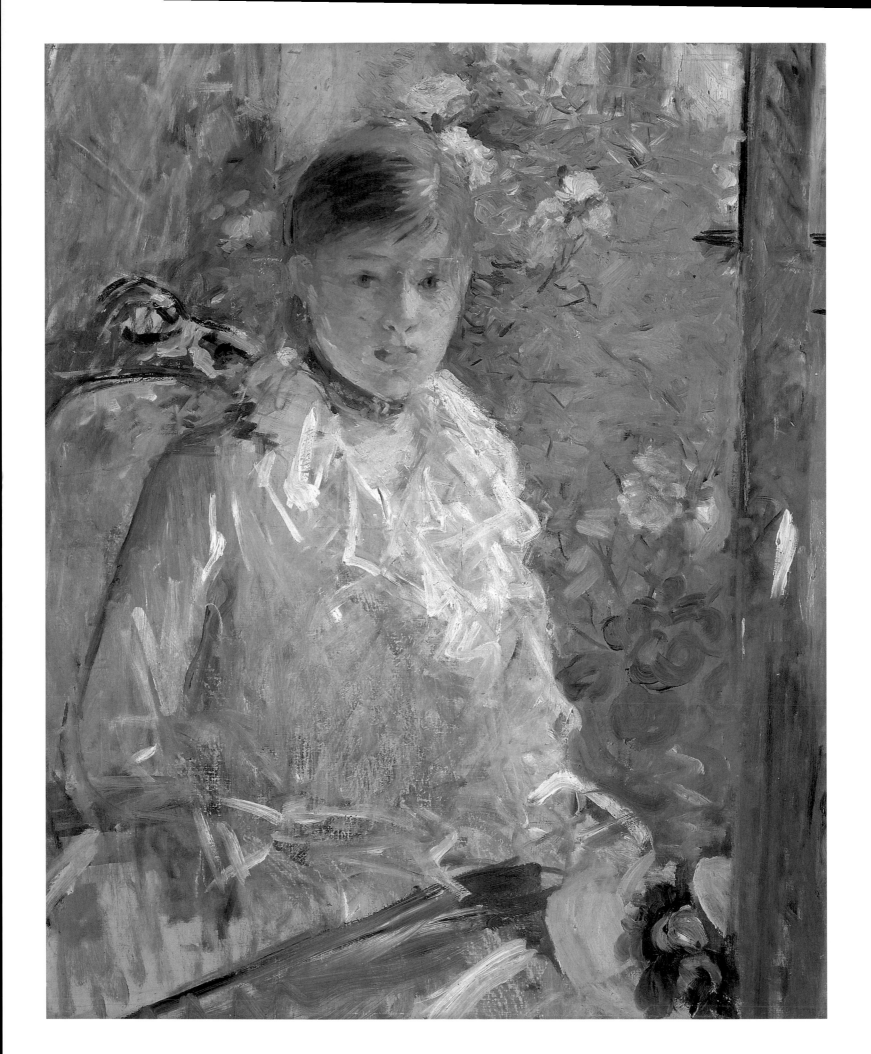

Soon, however, a handful of critics acknowledged her talent in more considered terms. Georges Rivière, writing in 1877, speaks of "the unexpected, feminine charm of Mademoiselle Morisot." He soon added:

> Her watercolors, her pastels, her paintings all show ... a light touch and unpretentious allure that we can only admire. Mademoiselle Morisot has an extraordinarily sensitive eye ... the young woman at her toilet is a delightful picture, as is the young woman before her looking glass. [Hanging above these is] a charming little landscape full of greenery and sunlight, with a young woman in a blue dress. Mademoiselle Berthe Morisot succeeds in capturing fleeting notes on her canvases, with a delicacy, spirit, and skill that ensure her a prominent place at the center of the impressionists' group.

The canvases mentioned by Rivière are indeed among the finest of the period. The woman in a blue dress is the rather melancholy, dreamy figure from *In a Villa at the Seaside*. The young woman in her dressing gown is doubtless the superb portrait of Madame Hubbard, now in Denmark **(page 73)**, easily identifiable as one of the supreme works of Berthe Morisot's oeuvre, and the period as a whole. Stretched out on a bed with a white pillow and a pale blue-tinted coverlet, a woman dressed all in white and pink—organdy and tulle—gazes at us with eyes as black as her hair. The back wall is summarily sketched. In her hand she holds an open fan, its yellow top echoing the color of her mules, while the base is black and dotted with red and blue. The picture shows a blend of charm and sensuality to which only a woman artist can aspire, depending as it does on a powerful identification with womankind, and a deep knowledge of the female state, which too often escape the male painter. And it is here, in this canvas, that we sense the true difference between Morisot and Manet. The unquestionably modern subject is bent here to a perfect osmosis with the model—a quite new phenomenon in painting, as in literature (we may be reminded of Flaubert's cry, "*Madame Bovary, c'est moi!*"). The emergence of this forceful subjectivity will become another important aspect of impressionism. And perhaps only a woman could have taken it quite so far.

The *Jeune femme à sa toilette* (*Young Woman at Her Toilet*) mentioned by Rivière is doubtless the painting later acquired by Mary Cassatt. The subject furnished some of Berthe Morisot's greatest masterpieces, painted between 1875 and 1877. The *Jeune femme au miroir* (*Young Woman at Her Looking Glass*, 1877) **(page 72)**, whose real title—according to Julie Manet—was *La Question au miroir* ("The Question

Jeune fille près d'une fenêtre (Young Girl by a Window), 1878.
Oil on canvas, 30 × 24 in. (76 × 61 cm). Musée Fabre, Montpellier.

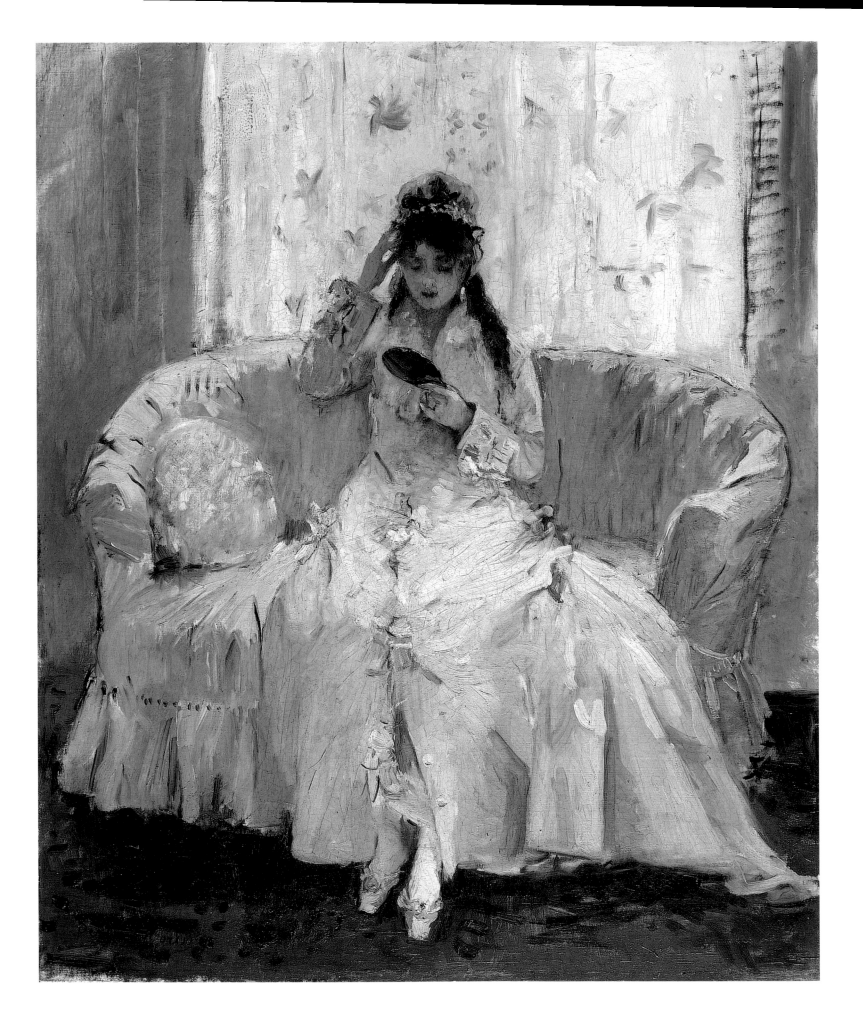

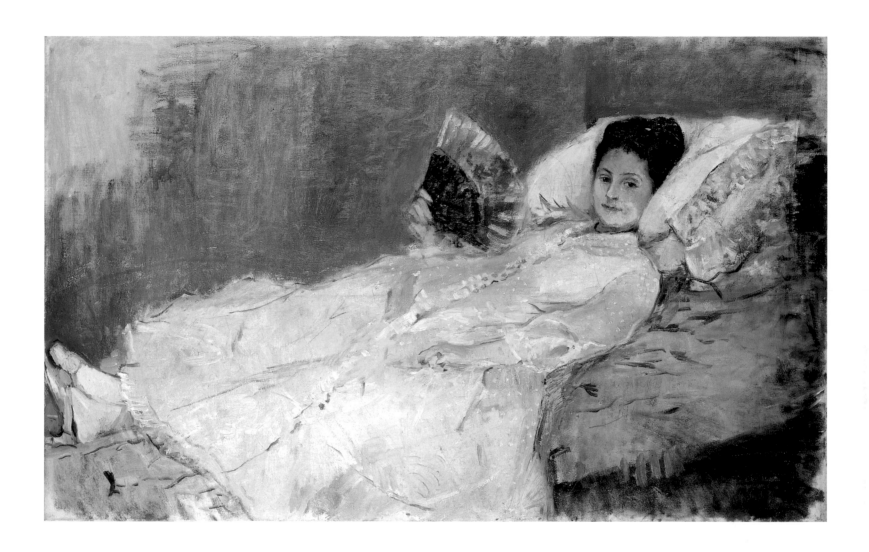

Facing page:
Jeune femme au miroir (Young Woman at Her Looking Glass), 1876.
Oil on canvas, 21 ¼ × 17 ¾ in. (54 × 45 cm). Private collection.

Portrait de Mme Hubbard (Portrait of Mme Hubbard), 1874.
Oil on canvas, 20 × 32 in. (50 ½ × 81 cm). Ordrupgaardsamlingen, Copenhagen.

before the Looking Glass") is a superb poem in white, a kind of extreme magnification of Guichard's first lesson in painting, nowhere better described than by the artist's own daughter, in her journal, when she saw the canvas at the Choquet sale in 1899:

> A small woman in white, wearing a delicate knitted cap, looks at herself in a small hand-held mirror; she is sitting on a sofa, also white, silhouetted against a white muslin curtain through which the light passes, playing deliciously over the whole symphony of white, and the effect of the back-lighting creates astonishing shades of gray. Such difficulty overcome with such charm.

The same white is seen again in *Jeune femme se poudrant* (*Young Woman Powdering Her Face*) (**page 75**) painted at about the same time and now in the Musée d'Orsay: a work of more sustained color, with its morsels of red (the lacquered box on her gueridon table, the corner of a cushion, the body of a chair), the vibrant pictures hung against the yellow of the wall, and lastly three minuscule dots of pink, a bud to the left, the young girl's lips, and a flower pinned to the bottom of her robe, discreet touches that relay the picture's light and make the whole canvas sing. In this small, unassuming picture, Berthe Morisot orchestrates the coming-together of the modern era and the eighteenth century, combining the dainty, pretty style of Fragonard with the fresh, juvenile grace of *peinture claire*. In *Psyche*, painted the previous year, we find another admirably orchestrated harmony of white (dresses, curtains) and red (the carpet), and the fusion of both in the Venetian red of the hair.

Through these pictures, and with our eyes trained by over a century of looking, we grasp the obvious, great discovery of impressionism: light is no longer a ray or shaft falling upon the objects depicted, but an impalpable brilliance radiating from everything, immanent and omnipresent. Time, now, to revisit that same light in the never once mentioned the name of Berthe Morisot, although their diagnosis of the Berthe's own, sumptuous, open-air *fêtes*. Just before the emergence of impressionism, when a handful of people were quietly preparing its advent, the Goncourt brothers— art lovers whose tastes (almost uniquely, during this period) were more focused on the eighteenth century—wrote in their *Journal*, in December 1866: "Truly, the cycle of great painting is closed . . . and all that remains is landscape." If they had opened their eyes a little wider, they would have found "great painting" in the work of Manet, or a canvas like the *Young Woman at Her Looking Glass*, whose subject matter, at least, would have delighted them. Yet these two implacable misogynists

Jeune femme se poudrant (Young Woman Powdering Her Face), 1877.
Oil on canvas, 18 × 15 in. (46 × 38 cm). Musée d'Orsay, Paris. Antonin Personnaz donation.

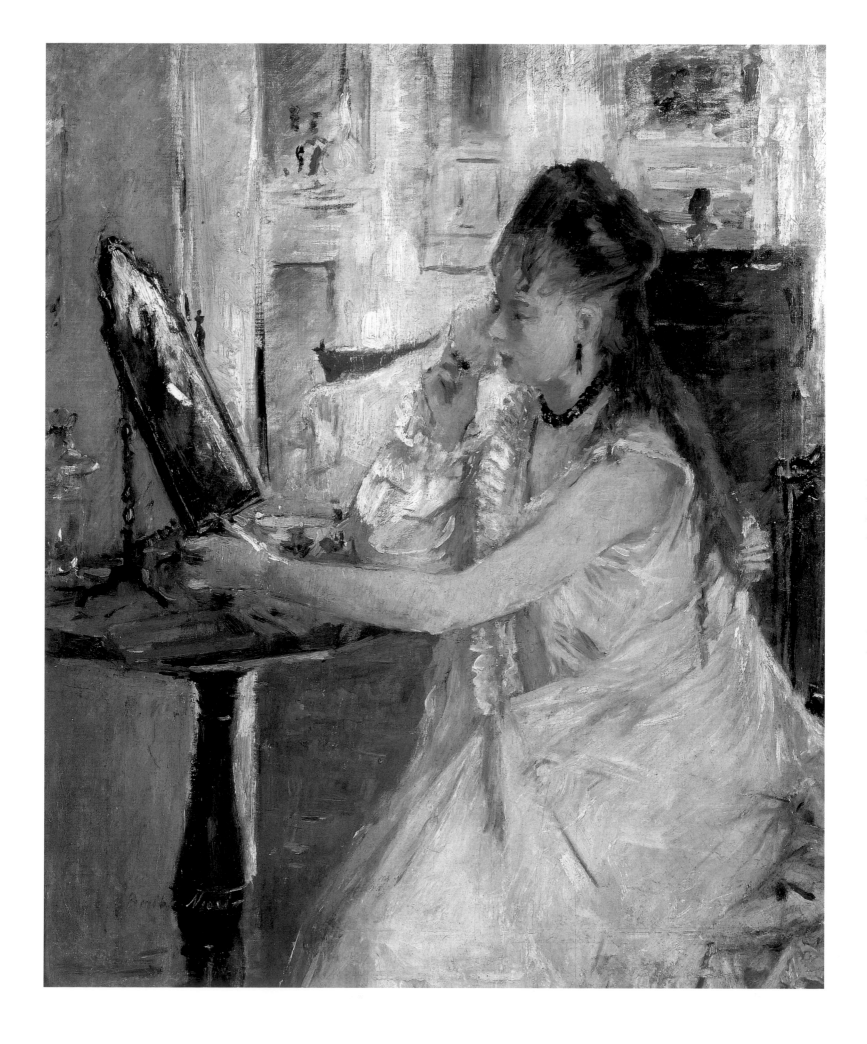

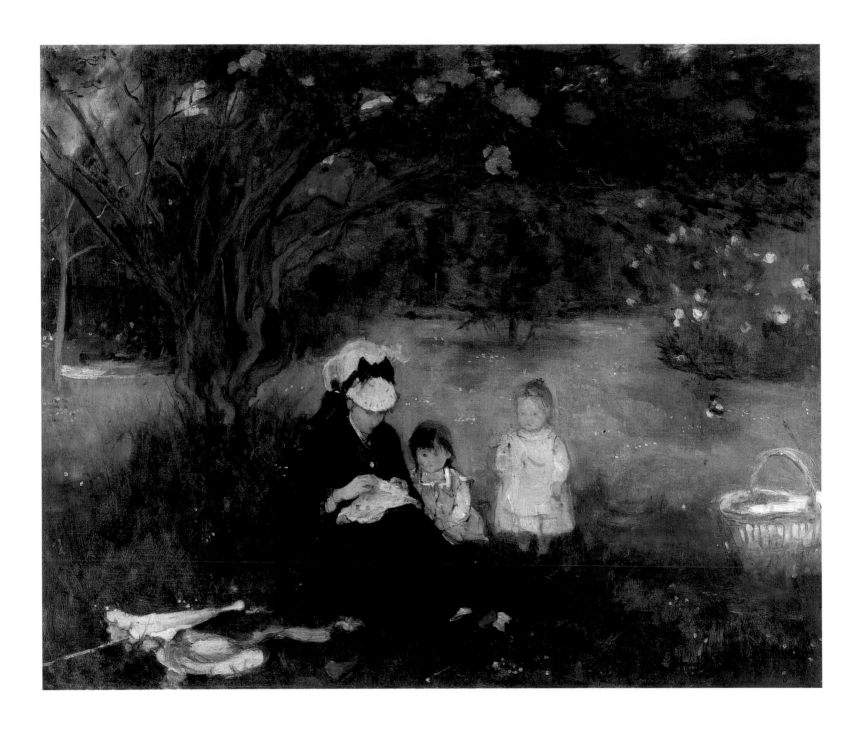

never once mentioned the name of Berthe Morisot, although their diagnosis of the predominance of landscape was undeniably accurate.

Returning from a journey to Spain and a brief stay at Petites Dalles, before the death of her father and her marriage to Eugène Manet, Berthe Morisot stayed for the first time in Maurecourt, with her sister Edma. That year, 1874—the year of the first impressionist exhibition, in which she took part—may be seen as a landmark in Morisot's work and her artistic development. Having established a certain distance from her own past, and from Manet, Morisot was then at the height of her powers, giving us some of her most important works, and some of the key masterpieces of impressionism, even if all too many art historians, afflicted by the myopia of misogyny, neglect to stress their importance, or even to reproduce them. Near Le Chou and Auvers, where she painted her earliest landscapes, Maurecourt—her sister's home from 1873 onwards—was the setting for Berthe's painting *Cache-cache* (*Hide and Seek*), one of her finest outdoor scenes. In the center of the composition, a young woman with a green parasol seems to be turning around a bush with red flowers, while to the left, a little girl in a tiny frock and a big, top-heavy hat, reflects and absorbs the bright, all-pervasive daylight. The landscape, with a suggestion of the River Oise, is brushed in broad, horizontal strokes, over which grass and shrubs are inscribed in short, brusque, accented flecks. Once again in a painting by Berthe Morisot, we have the sense of a landscape being carried from left to right, like the flow of a river, or the progress of a life, while in the middle, the turning movement of the two figures seems to suspend the fleeting passage of time, for an instant.

By contrast, *Les Lilas à Maurecourt* (*Beneath the Lilac at Maurecourt*) (**page 76**) is a moment captured, concentrated, almost motionless, a poem of pale touches of color against a background of greenery and brown trees: flowers, hats, baskets, and parasols stand out like bright, happy appoggiaturas, reinforcing the deep black of the dress at the center. And while we are here, we should note a superb piece of painting, a detail worth enlarging for its own sake; namely the white umbrella and the hat rimmed with a blue ribbon, a kind of figured signature, like a rebus or symbol, seemingly tossed carelessly in the left-hand corner. In the pastel *Sur la pelouse* (*On the Lawn*), we see the same children, the same young woman, sitting in the taller summer grass, grouped into a more tightly composed, almost hieratic pyramid. Here, however, the static quality of the figures is countered by the dynamism of the landscape: inflected branches, the soaring form of the central tree, the overgrown flowerbed to the right, give the work a sense of movement quite different from that expressed in *La Chasse aux papillons* (*Chasing Butterflies*) (**page 79**), depicting the same garden and the central figure

Les Lilas à Maurecourt (Beneath the Lilac at Maurecourt), 1874.
Oil on canvas, 19 ¾ × 24 in. (50 × 61 cm). Private collection, Paris.

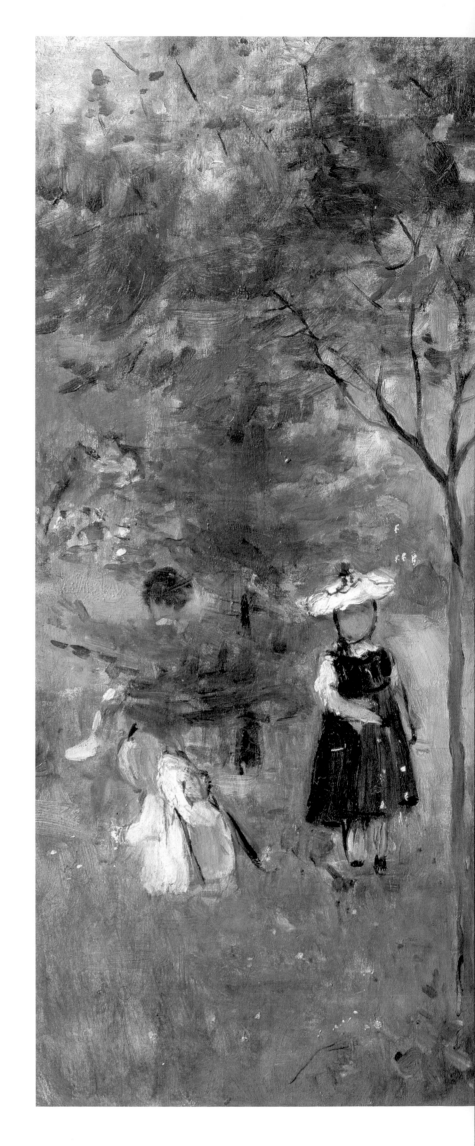

Right and following pages:
La Chasse aux papillons (Chasing Butterflies), 1874.
Oil on canvas, 18 × 22 in. (46 × 56 cm). Musée d'Orsay, Paris.
Étienne Moreau-Nélaton donation.

*Mme Pontillon, née Edma Morisot, sister of the artist
with her two daughters, Jeanne and Blanche.*

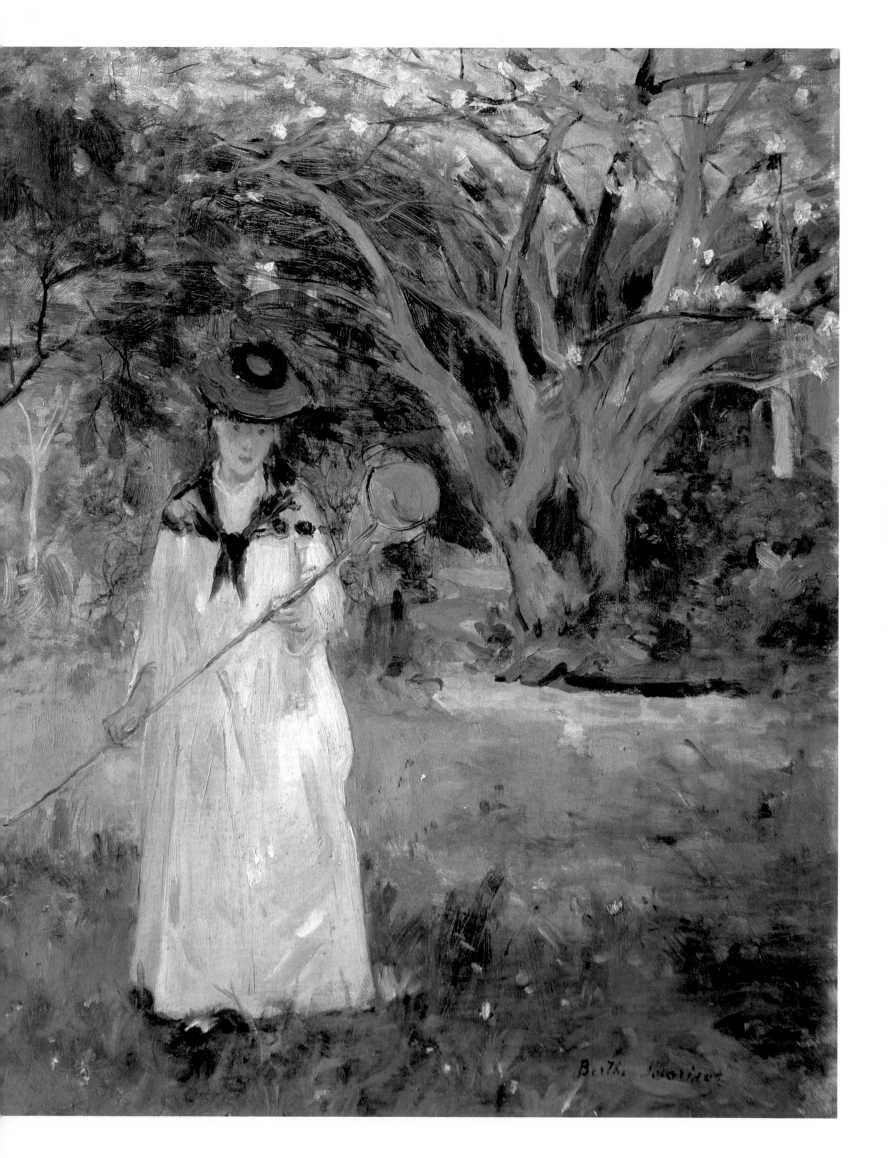

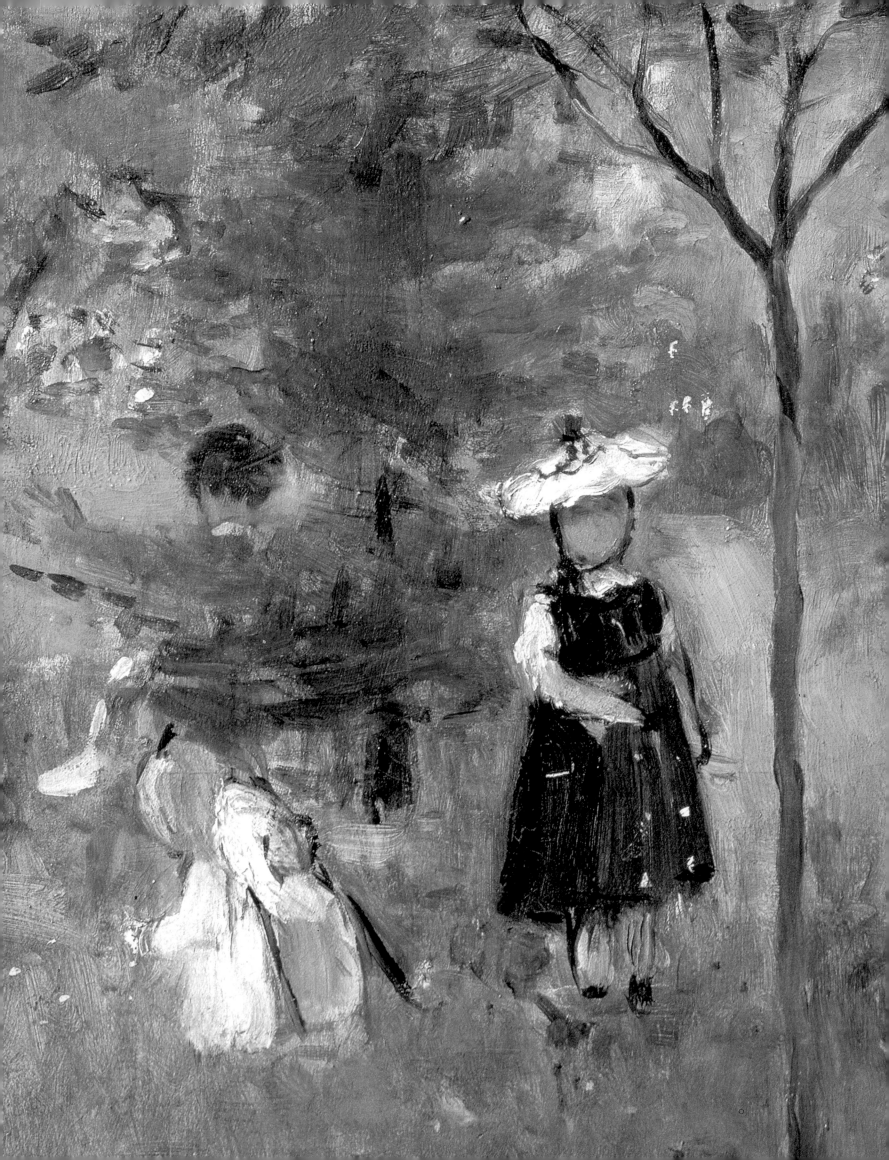

of a young woman (wearing a white dress this time, crossed by the oblique shaft of the butterfly net, parallel to a shrub that has yet to come into leaf), whose sad gaze seems to freeze the moment. Here, it is the prevailing light, falling in pools on the ground, dancing beneath the trees, that brings the picture to life.

Beyond the seemingly joyous quality of the light, we often, in Berthe Morisot's paintings, come across a sad gaze, a huddled child, a pose more melancholy than vivacious; and it is this combination of apparent joy and latent sadness that gives her paintings their true value, as if, in certain works, a seemingly happy, harmonious existence was suffused with the Baudelairean concept of beauty as a phenomenon that only truly exists when some minor flaw underscores its glory. Her profound, reflective nature, her anxious character, the melancholy that scarcely left her throughout her life—glimpsed, at times, in a brief turn of phrase in a letter or notebook—also show through on occasion (in a diffident, allusive gaze, the involuntary projection of a pose) in Morisot's canvases.

Among the landscapes of this period, we should also note *Dans les blés* (*In the Cornfields*) (**page 84**), a fine, typically impressionist picture, composed of broad horizontal lines, with the exception of the figure of a young boy in the foreground, rising from the wheat as if from out of the sea, a note of blue in the midst of the yellow and green. Édouard Manet would come to love this picture, painted in Gennevilliers, gazing at it and steeping himself in its lessons, when he found himself questioning his relationship to the youthful impressionist movement and, on Morisot's advice, allowed the light of the open air to flood his work. At one of the impressionist exhibitions, her former teacher, Guichard, was alarmed by the presence of his former pupil, and wrote to her mother: "One cannot hope to consort with madmen unscathed... none of them thinks straight." But beyond his naïvely expressed fears, Guichard struck home (albeit involuntarily) when he reproached Berthe for wanting "to do in oils things that are the exclusive preserve of watercolor," adding that "to be the finest watercolorist of one's age is a quite enviable lot in life."

The second half of the nineteenth century marks one of the high points in the art of watercolor: this swift technique, capable of seizing the moment in all its brevity, capturing fleeting scenes and landscapes in its allusive script, is perfectly adapted to the spirit of the age: soon, impressionism and watercolor become synonymous. Morisot elevated the technique to its greatest heights. Some of her chroniclers situate her first forays in the medium no earlier than the Siege of Paris, when painting out of doors was restricted to her garden in Passy. And while her very earliest watercolors—the *Jeune fille sur un banc* (*Young Girl on a Bench*)

Jeune femme et enfant sur un banc (Young Woman and Child on a Bench), 1872.
Watercolor, 13 × 9 in. (33 × 23 cm). Musée d'Orsay, kept in the Department of Prints and Drawings at the Musée du Louvre, Paris. Étienne Moreau-Nélaton donation.

Before entering the Louvre, thanks to Étienne Moreau-Nélaton, this watercolor appeared in the first impressionist exhibition in 1874 and was acquired by Charles Ephrussi, who was the model for Proust's character Swann.

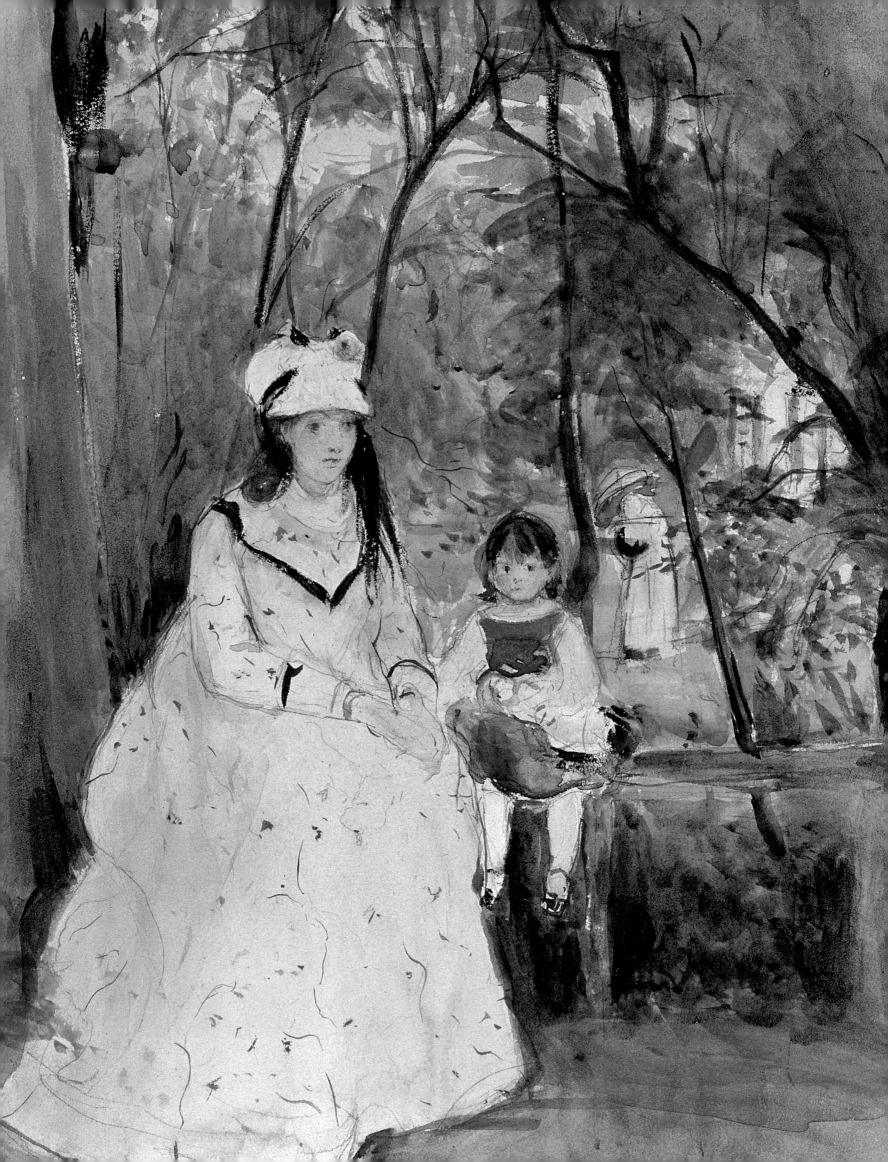

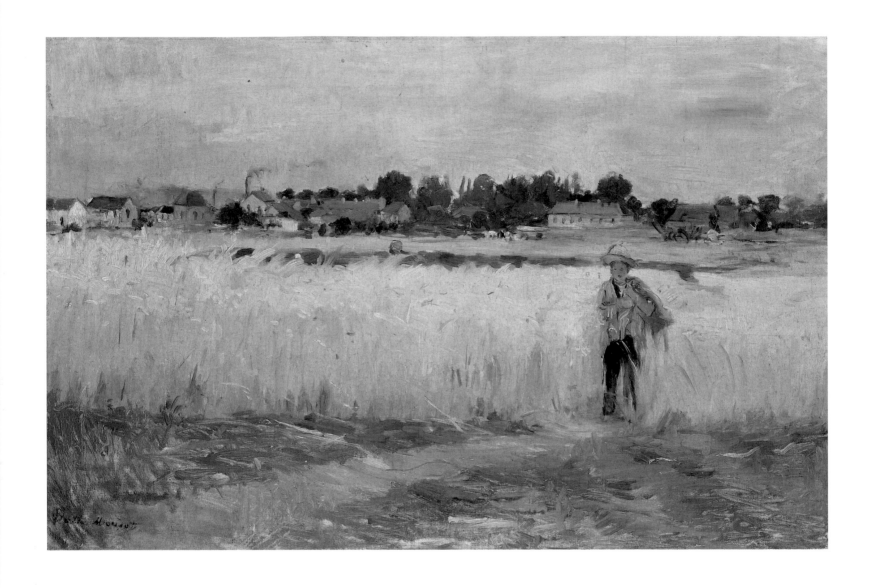

Dans les blés (In the Cornfields), 1875.
Oil on canvas, 18 ¼ × 27 ¼ in. (46.5 × 69 cm). Musée d'Orsay, Paris.
Antonin Personnaz donation.

"This painting won the complete admiration of your brother-in-law," Mme Cornélie Morisot wrote to her daughter Berthe in August 1875.

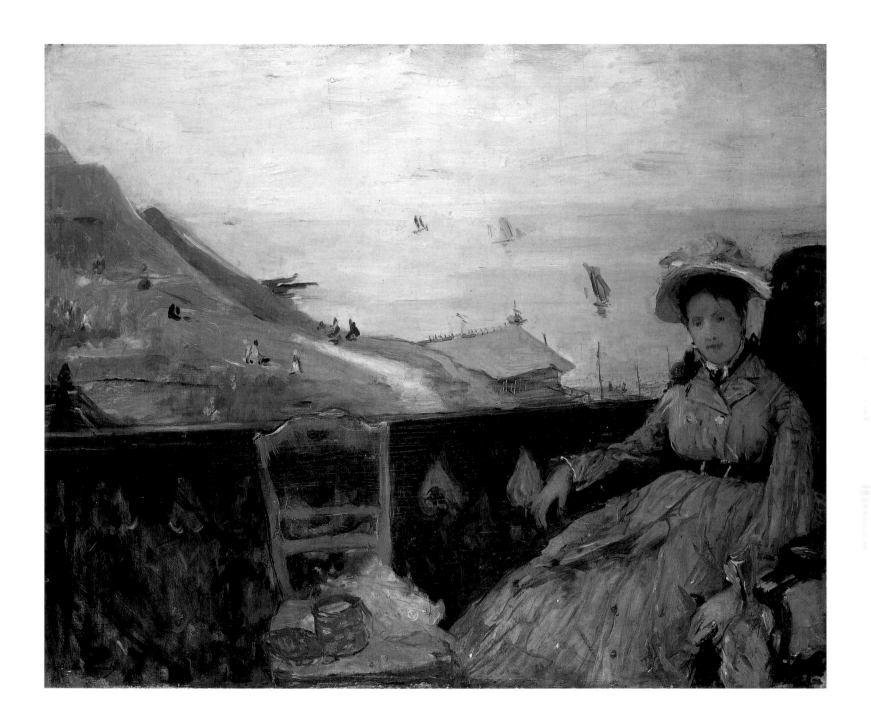

Sur la terrasse (On the Terrace), 1874.
Oil on canvas, 17 ¾ × 21 ¼ in. (45 × 54 cm). Tokyo Fuji Art Museum, Tokyo.

and *Rosalie Riesener*—date from 1864 and 1866 respectively (one still suffused with the influence of Corot, the other with the spirit of Delacroix and Gavarni), her first great essay in the medium, *Sur le sofa* (*On the Sofa*) does indeed date from the siege, in 1871, and has a freshness that seems to spring to life as we gaze at the play of red (the armchair) and blue (the skirt), reinforced by the light tachism defining the profile. And this same year produced the *Femme et enfant assis dans un pré* (*Woman and Child Sitting in a Meadow*) that belonged to Degas, a subject that afforded some of her finest effects. In 1872, the watercolor *Woman and Child on a Balcony* preceded and organized the composition of the oil painting executed in the same spot, on the same subject. The same is also true of the *Jeune femme et enfant sur un banc* (*Young Woman and Child on a Bench*) (**page 83**): silhouetted against a delicate, woodland backdrop, we see a young woman in a dress scattered with barely formulated, script-like motifs, accentuated solely by the little, black-edged collar, a harbinger of the famous black ribbons that were soon to become her signature.

A series of works now followed, in quick succession, which we may readily hold up as some of Morisot's finest and most important: *Sur la falaise* (*On the Clifftop*, 1873) (**page 87**), in which a young woman seated in profile shields herself from the sun with her hand and seems to enter, quite literally, into the landscape; or the *Femme et enfant au bord de la mer* (*Woman and Child at the Seaside*, 1874), which graced the great collections of Henri Rouart, Jacques Doucet, and David-Weill, whose paint and brushwork seem suddenly to gather up and capture time and space, the transient and the eternal, in the merest jotting of signs and colors. Followed soon by *Gennevilliers*, an essay in transparency, and next a *Young Woman and Child on the Grass*, painted in the same year, 1875, near the town of Cambrai, whose windmills we glimpse subtly silhouetted in blue against the sky. Some of these watercolors are compositional experiments for oil paintings, as we have just seen, while others are finished, accomplished works in their own right; year after year, we follow the progress of this increasingly allusive, atmospheric art, including the *Promeneuse* (*Woman Walking*) of 1883, an abstract before its time, and the *Jeune femme assise, avenue du bois* (*Young Woman Sitting in an Avenue of Trees*), two of her finest and most successful works.

Earlier, the first year of her marriage was marked—in summer 1875—by a trip to England and, first, the Isle of Wight, from where Berthe returned with an important painting: *Eugène Manet à l'île de Wight* (*Eugène Manet on the Isle of Wight*). Sitting at the far left of the picture, wearing a panama hat, the artist's husband gazes out of the window overlooking a small garden, the harbor, and a woman and girl passing by. A simple, familiar scene. But the space contained

Sur la falaise (On the Clifftop), 1873.
Watercolor, enhanced by gouache, black pencil, 7 × 9 in. (18 × 23 cm). Musée d'Orsay, kept in the Department of Prints and Drawings at the Musée du Louvre, Paris. Étienne Moreau-Mélaton donation.

This watercolor, painted at Fécamp, of Mme Pontillon and her daughter Jeanne, featured in the first impressionist exhibition of 1874.

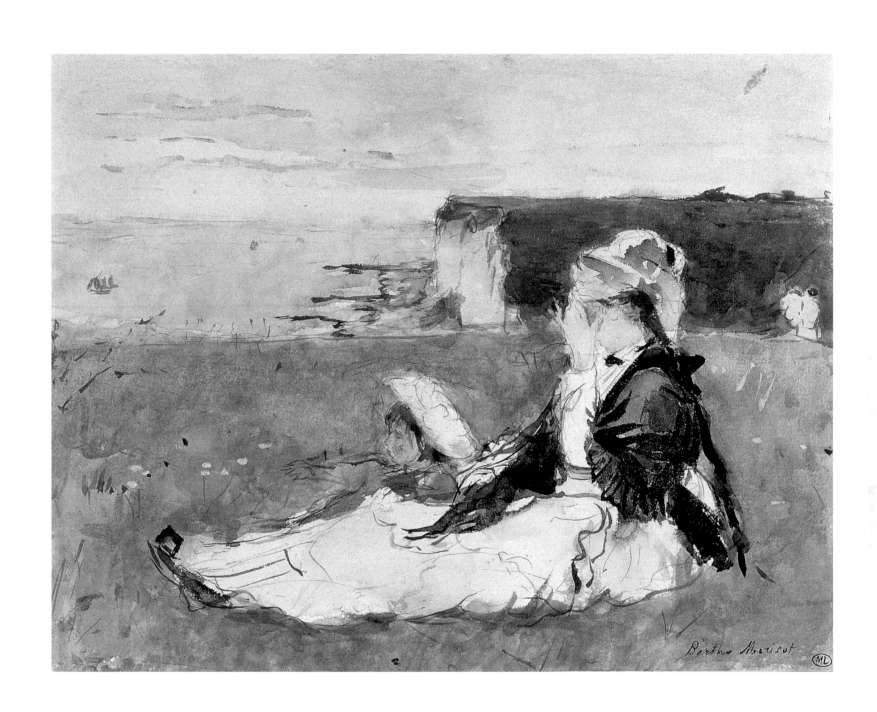

Bertha Morisot

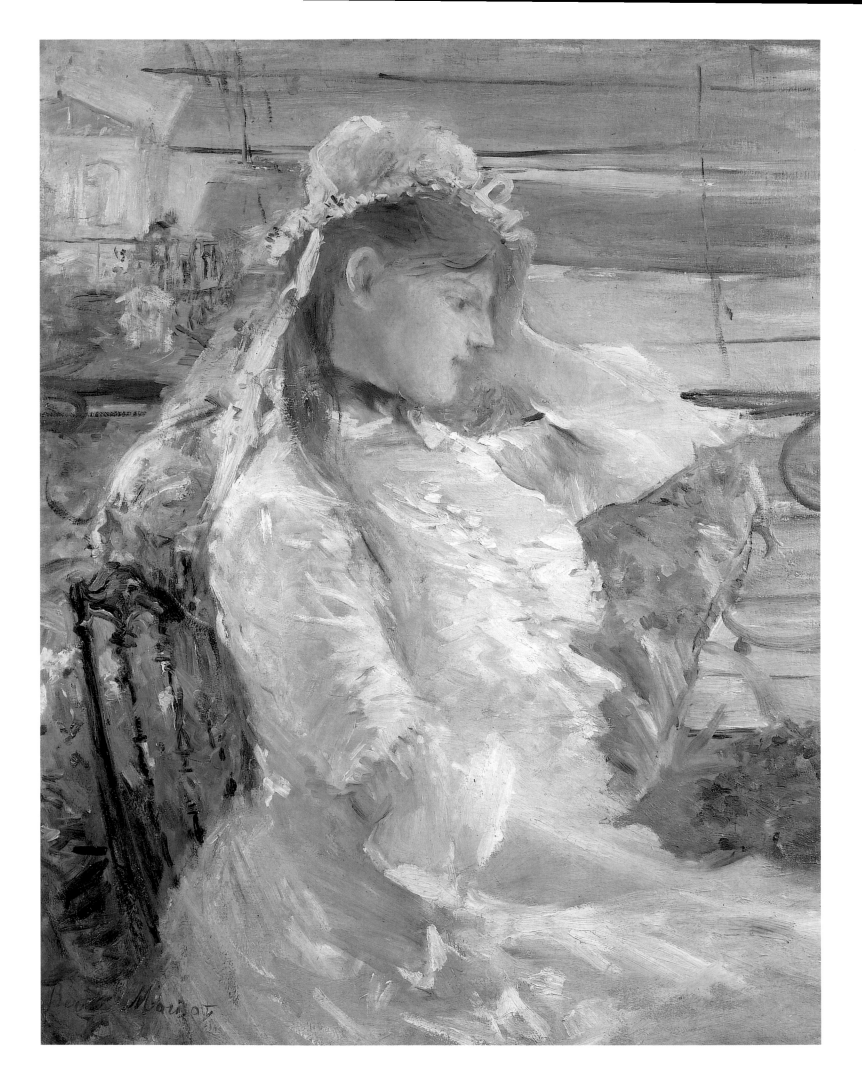

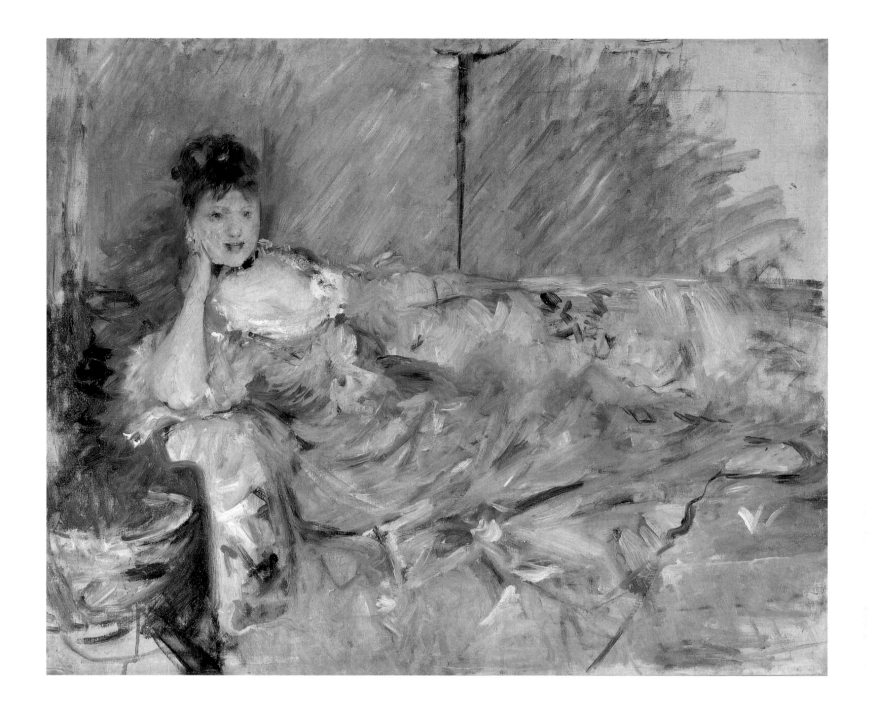

Derrière la jalousie (Behind the Blinds), 1879.
Oil on canvas, 29 × 23 ½ in. (73.5 × 59.5 cm). Private collection, United States.

After belonging to Tadamasa Hayashi, the foremost Japanese impressionist collector, it passed into the hands of Théodore Duret, the foremost impressionist historian, who, some time after 1878, had noted: "The colors on Mme Morisot's canvases are uniquely delicate, velvet, soft."

Jeune femme en gris étendue (Young Woman in Grey Reclining), 1879.
Oil on canvas, 23 ½ × 28 ¾ in. (60 × 73 cm). Private collection.

A more freely painted counterpart to Portrait of Madame Hubbard, *painted four years later, this painting inspired the following words of praise from Octave Mirbeau: "A few strokes of the brush, two, three pale touches of watercolor wash, and we are filled with emotion, dreaming."*

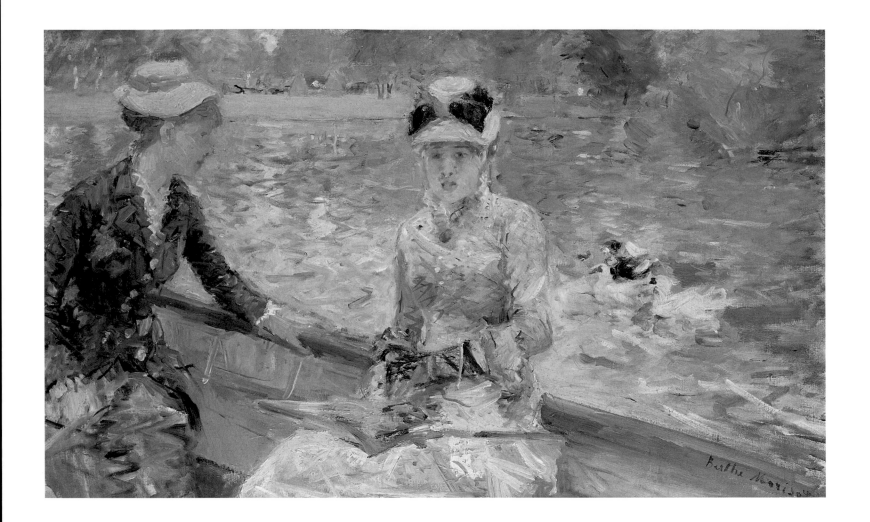

between the half-open sash window and the garden fence—an elongated rectangle that seems like a natural extension of Eugène Manet's eyeline, with its suggestion of boats and female passers-by, their faces barred by the window frame—this space resembles the panoramic aperture of a camera lens, focusing on dreams and reality and foreshadowing the cinematographic image. Here, Morisot shows herself to be every bit as bold and inventive as Degas.

Soon, she would show herself to be every bit the equal of Monet, too, with the painting *Jour d'été* (*Summer's Day*) (**page 90**): two young women in a rowing boat, one captured from the front, the other framed in profile, which has come down to us both in a finished, painted version, and as a watercolor sketch. The painting opens a new cycle in Berthe Morisot's work, revisited in earnest shortly afterwards and taking as its main subject the Bois de Boulogne: elegant ladies out strolling, swans, reflections in the lake. The artist was doubtless inspired by the same two models depicted in the painting *Jeunes femmes cueillant des fleurs* (*Young Women Gathering Flowers*, or *In the Bois de Boulogne*). The figures show the exact same contrast of blue and white, their hats are the same natural straw color, the background features the same palette of blues and greens, but the low horizon of the first picture, at the level of the water's surface, is raised here by a line of trees. Juxtapose the two pictures, and we have the impression of scenes from a film.

What astonishes us, at this distance in time, is that these pictures should have been neglected and treated as minor works in the impressionist constellation, when in fact they represent important, ground-breaking developments. Remarkably, *Summer's Day*—shown at the impressionist exhibition of 1880—predates Monet's canvases on the same theme by some eight years. Note here that the faces in Morisot's outdoor scenes are barely suggested, unencumbered by excessive detail or precision, as if absorbed into the light: they are no longer firm contours, but patches of light, touches of color; simple, luminous gleams on a par with the fabrics or grass. Here we see again the influence of watercolor on oil painting: the subject is captured not by the memory but through the senses, as the immediate projection of the atmospheric ambience of a single instant. Hence the impression of lightness, transparency, and spontaneity. And yet, in the early 1880s, as we approach her work in one of its most inventive periods, the painting *Jeune fille près d'une fenêtre* (*Young Girl by a Window*) (**page 70**) features a more precise depiction of the model's face, tenderly sculpted by the prevailing light. Above all, in this canvas, we are struck by the extreme *fa presto* of the artist's touch, and the bright, luminous roses: we may imagine that Manet, painting his final canvases in Bellevue or Rueil, was indeed impressed and influenced by this means of suggesting and capturing light.

Jour d'été (Summer's Day), 1879.
Oil on canvas, 18 × 29 ¾ in. (45.7 × 75.3 cm). National Gallery, London.

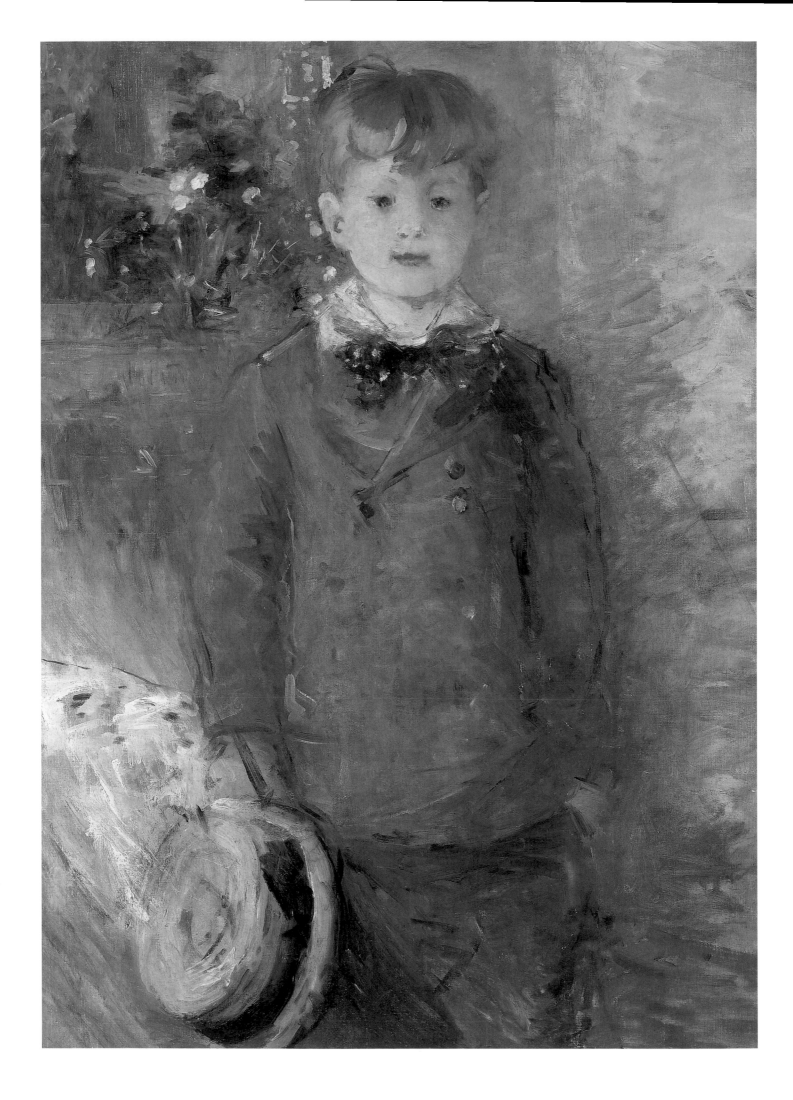

Morisot's painting of a young boy—her nephew Marcel Gobillard, boater in hand, known as *Petit garçon en gris* (*Little Boy in Gray*) (**page 92**)—is one of the highlights of her oeuvre, and a portrait of striking intensity. The quick dabs of color, the light brushwork, the vigorous background of flowers all contribute to the powerful presence of the child captured in close-up, his firm pose anything but static. At almost exactly the same moment—and certainly during the year 1880, confirming the scope and diversity of Morisot's work—*Young Woman at Her Toilet* seems to have been captured in a powdery, soft-focus cloud, a dazzling burst of light. Once again, it seems that Berthe Morisot has outstripped her impressionist peers and friends: the free handling seen here was to be matched only by Monet in his paintings of water lilies.

This free, expressive handling was misunderstood by the finest—or supposedly most enlightened—minds of the day, including Joris-Karl Huysmans, noted for his distinctive, acerbic, inquisitive but guarded approach to painting, who declared himself "seduced but not conquered" by Berthe Morisot in the 1880s, preferring Mary Cassatt, whose paintings seemed to him "more balanced, more serene, wiser." Huysmans reproached Morisot for leaving her works "as oil sketches...a pretty froth of pink and white," adding this judgment, which might raise a smile today, although we should remember that we have the advantage of distance: "like Chaplin [Charles Chaplin, a contemporary French painter] under hypnosis, and with a turbulent fit of tense, agitated nerves." Reading these lines, we might feel that Huysmans is in fact describing himself, especially when he continues, still on the subject of Morisot: "An air of society elegance, heady and sensual, wafts from these rough, unwholesome sketches, these surprising improvisations which we may, perhaps justly, qualify as hysterical." The conjunction of "heady" and "unwholesome," the juxtaposition of improvisation and hysteria are a comprehensive foretaste of Huysmans's fictional character Jean Des Esseintes (the hero of his novel *À Rebours*, published in 1884).

It is sometimes difficult, when writing about art, especially if we do not look below the surface, to avoid projecting what we are onto what we see. It is curious, too, on reading Huysmans, to note how the various points contained in his judgment seem neither wholly fair, nor completely wrong, but exaggerated by his choice of words. Each painter finds his (or her) writer, and Morisot's is not Huysmans. In his words we see not only a misogyny determined to resist the charm of her work, but everything that distances impressionism from naturalism.

Among the subjects that might have attracted Huysmans's attention, but which no one had yet treated—apart from the Dutch in the seventeenth

Petit garçon en gris (Little Boy in Gray), 1880.
Oil on canvas, 33 ¾ × 24 ½ in. (86 × 62 cm). Private collection.

century, and then only as crowd scenes—that of a woman skating on the frozen lake in the Bois de Boulogne gave Berthe Morisot further scope for innovation. Manet's work *Skating* dates from 1877, but the main focus of his painting—a society scene with a figure in close-up occupying the foreground—is a kind of formal pun on the scrolling motifs embroidered on the woman's corsage, and the marks inscribed on the ice by the blades of the skates.

On the other hand, in Morisot's painting *Jeune femme remettant son patin* (*Young Woman Fastening Her Skating Boot*) "the beautiful painter"—a moniker coined by a female friend of her mother-in-law—gives us a poem in three hues: deep blue-black (the young woman), white tinted with blue or pink, and lastly the pink of the winter light defining the shafts of the tree trunks. Once again, everything is allusive, suggested rather than defined, using the lightest of touches, inscribed in delicate signs traced with the tip of the brush. We think of Mallarmé, his subtle turns of phrase, his words falling like petals or the strains of music. In this canvas we also see the contribution of both watercolor and pastel to Morisot's delicate, finely judged palette. A few years earlier, in April 1877, one of her first champions, Philippe Burty, noted:

> She uses pastel with the freedom and charm that Rosalba Carriera first brought to the medium in the eighteenth century.... Here is a delicate colorist who succeeds in making everything cohere into an overall harmony of shades of white which it is difficult to orchestrate without lapsing into sentimentality.

Berthe Morisot began making sustained use of pastel relatively late, from 1871 onward; prior to this date, the catalog of her work records just two works in the medium. The technique quickly became one of her instruments of choice. In the *Portrait of Madame Pontillon*, the composition remains classical, but the melting handling of the great black garment enveloping her sister Edma contrasts with the curtain, inscribed with flowers and signs, or the thickly padded folds of the sofa: this duality is seen, as well, in the two sides of the sitter's face, as if the right-hand side was a true likeness of the model, while the left consisted of a self-portrait. Or as if—unwittingly—Berthe Morisot had recorded the two sides of her own nature, a duality played out over the course of her life, and transcended in her work.

In Fécamp, as in Maurecourt, Morisot found her natural element: pastel. *Sur la plage* (*On the Beach*) is an amplified variation of the watercolor *Au bord de la mer* (*At the Seaside*), and the pastel *On the Lawn*, a quest for the

Facing page and following pages:
Portrait de Madame Pontillon (Portrait of Madame Pontillon), 1871.
Pastel, 32 × 25 ½ in. (81 × 65 cm). Musée d'Orsay, Paris.

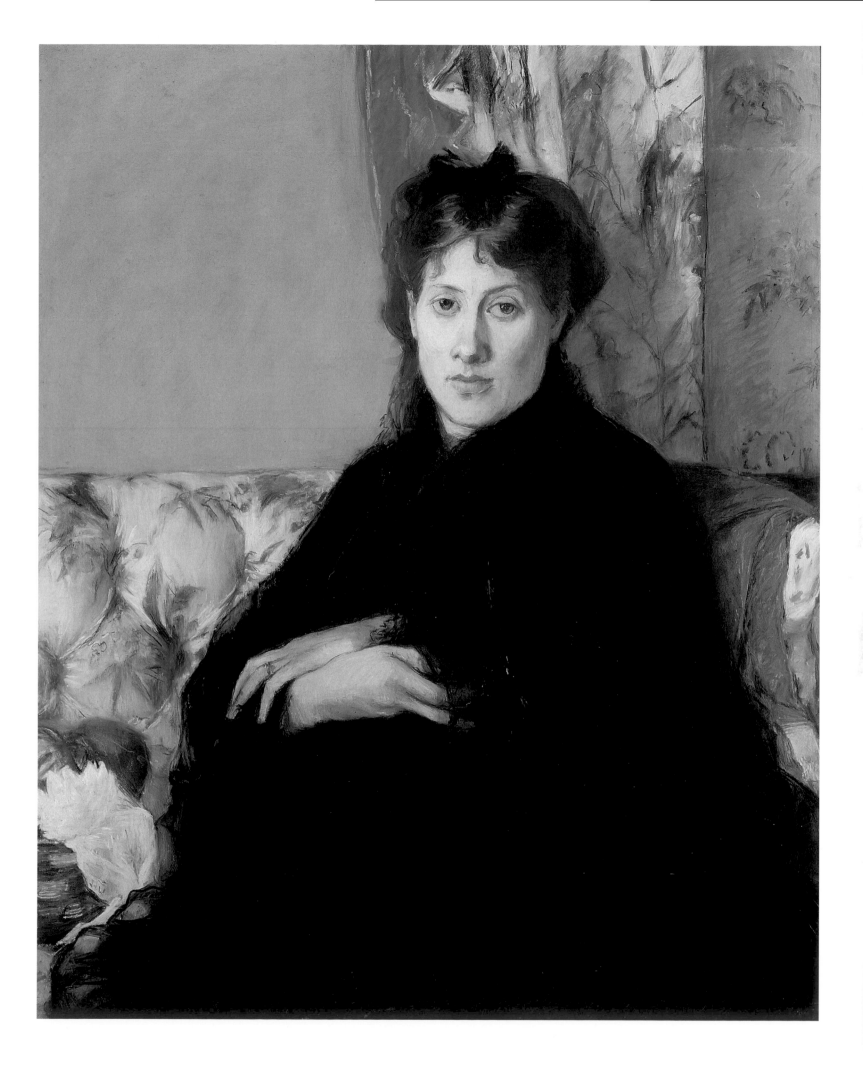

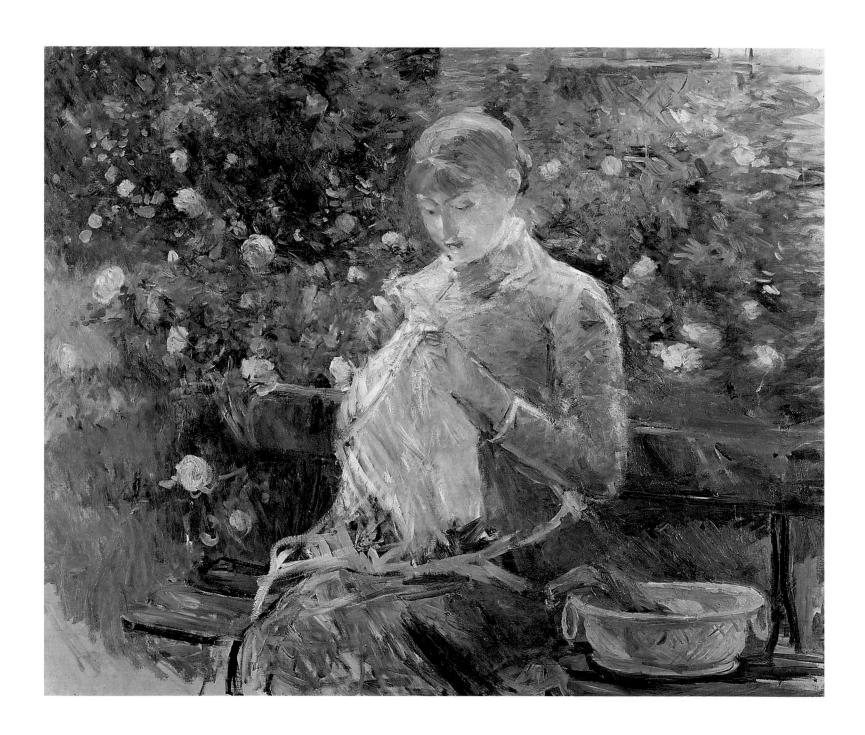

contrasts of stillness and movement. Morisot shows a marvelous mastery of the pastel technique, using it to create new effects that were to enrich her painting, as we have just seen with the skater. The links between the three techniques—watercolor, pastel, and oil paint—provide the starting point for a whole series of explorations, comparisons, discoveries, inventions, and innovations found in the work of no other contemporary artist but Degas. Berthe Morisot's picture of her niece Paule Gobillard drawing reveals her as Degas's true equal: treated in a subtle blue palette with cross-hatching in brown bistre, the scene, with its suggestion of a classical statue on a column base, the studious model leaning forward very slightly over her board, the long plait of hair balancing her profile, presents an admirably strict, rigorously understated ensemble.

Berthe Morisot's work includes subjects whose seriousness may seem less attractive from a modern standpoint, although their handling and treatment are as appealing as ever. Take the *Jeune femme cousant dans un jardin* (*Young Woman Sewing in a Garden*). The light transfigures her face and caresses her shoulders, and the garden dotted with roses gives the picture a festive air. The same is even truer of *The Fable* (**page 35**), in which a young woman sitting on an identical bench converses with a small child, captured as if in a shower of light, in the midst of a flourishing bouquet of color. We are again reminded of a fact that can never be overstated: in the world of art, the subject matters little, while the treatment and handling are everything. In the present picture, what matters most is Morisot's ability to transpose the immediacy of everyday life into something truer than reality itself: her ability to detect unseen dimensions and imperceptible echoes, and to render them palpable through brushstrokes, touches of light, patches of color.

One of impressionism's greatest contributions—and this applies to any period in which art explores and experiments with the painterly representation of reality—has been to present scenes never before treated in painting, and to use these scenes as the springboard for a magnificently innovative canon that challenges and reinvents all that has preceded it. Impressionism owes its continued ability to seduce painters and fascinate mass audiences to the success of its central endeavor to suggest reality by reducing it to a series of luminous dabs of paint, reconstituting the effect of real-life perception better than any overly detailed imitation.

This everyday enchantment—now that Morisot had "entered into the positive side of life," as she wrote to her brother on the day after her wedding—was nourished and enhanced by the birth of her daughter Julie. Her constant presence, her games, her smile, her movement, her progress are traced throughout her mother's work. For almost fifteen years, Julie was her favorite model, soon to be joined by her

Jeune femme cousant dans un jardin (Young Woman Sewing in a Garden), 1881.
Oil on canvas, 32 × 39 ¼ in. (81 × 100 cm). Musée des Beaux-Arts, Pau.

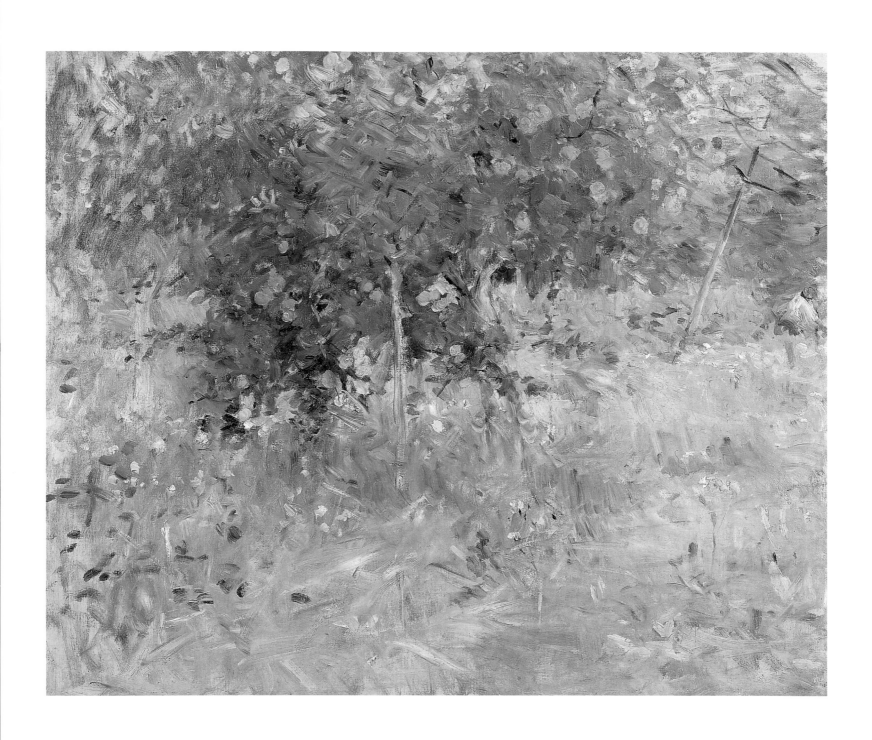

Jardin à Bougival or **Jardin du docteur Robin (Garden at Bougival), 1884.**
Oil on canvas, 19 × 21 ¾ in. (48 × 55 cm). Private collection, France.

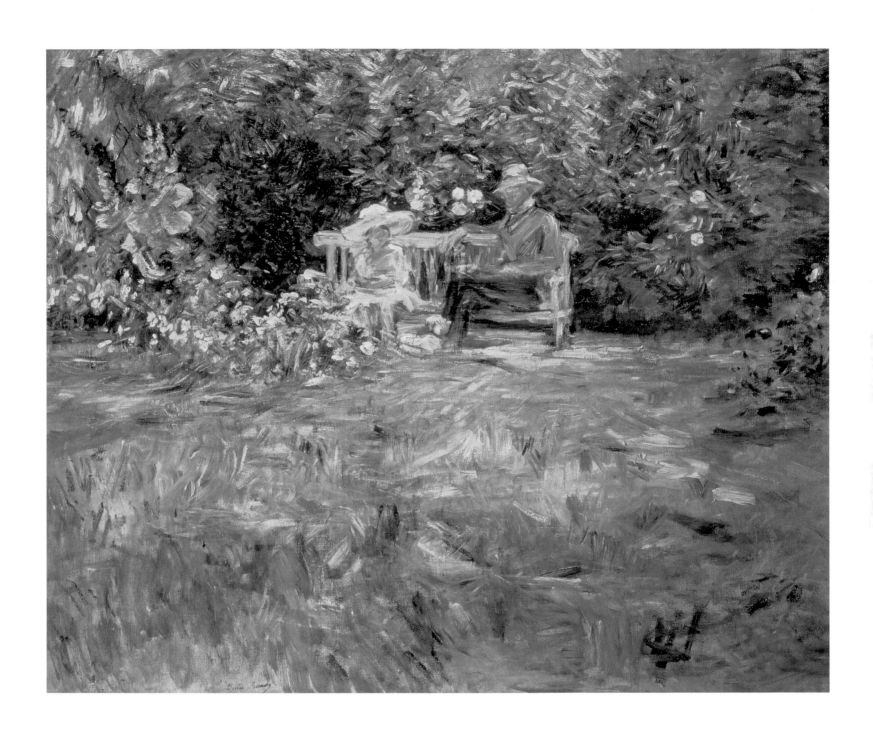

Above and following pages:
La Leçon dans le jardin (The Lesson in the Garden), 1886.
Oil on canvas, 23 ¾ × 28 ¾ in. (60.3 × 73 cm). Private collection.

female cousins and friends. Julie first appears immortalized by her mother's brush in Bougival, starting in 1881, the first of four summer holidays spent in a house near the Seine, in the midst of a garden overrun by shrubs and flowers, roses and clematis, irises and peonies—a particularly fertile period for Berthe Morisot. Here she painted some of the very rare pictures of men in her work. In one of these pictures we see her husband, Eugène Manet, reading, seated informally on a folding chair opposite his daughter Julie. Here, the touches of paint—trees, grass, the volumes of the figures—create a kind of counterpoint, and a feeling of circular movement.

Two years later, another version of Eugène Manet and his daughter in the garden shows the two closer together, in a composition enlivened by the play of oblique lines, the contrasting greens and browns of the garden, and the bright touches of flowers, or the figure of the child. The inrush of inspiration prompted by this setting reaches its height in the *Jardin à Bougival (Garden at Bougival)*, one of Morisot's subtlest works, bordering on abstraction. A corner of sky, a few rooftops blocked in to the left of the composition, and a scattering of roses in the central section, are the picture's only legible points of reference. The rest is all efflorescence, surging energy, dynamic brushwork, quick-fire touches: painterly signs in their purest form. The picture's date corresponds to a period when the impressionists as a group had begun to break apart, and when two painters took the movement to its furthest extremes: one all too briefly, the other right on to the end of the first quarter of the twentieth century. The first was Berthe Morisot, who had only a decade to live, and the second was Claude Monet.

The same energy is soon seen again in the *Poupée dans la véranda (Doll on the Veranda)* (**page 105**); here, however, the houses glimpsed opposite, the foreground table with its teapot, armchair and doll, and the wooden upright dividing the landscape vertically into two unequal halves are clearly legible points of reference. This whole canvas is inseparable from another, bigger, painting entitled *Dans la véranda (On the Veranda)* (**page 126**), in which everything—the blind, the window-pane—is both suggested and still more clearly legible, while the diffuse light of the first canvas is reflected and augmented here by two sources within the picture: the carafe in the foreground, and the little girl's hair. The central tree in *Young Woman Sewing in a Garden*, also painted in Bougival, seems to stand as a pivot around which the grass is turning. In this painting, the speed of execution, hurrying to capture a fleeting impression, a transient effect of light, contributes to the sense of the exuberant dance of nature, attenuated by nothing but the human figures.

From Bougival, crossing the Seine and traveling upstream towards Pontoise, Morisot sometimes called in at Maurecourt where, in 1884, she revisited a scene painted just ten years earlier: *Dans le jardin de Maurecourt (In the Garden*

Poupée dans la véranda (Doll on the Veranda), 1884.
Oil on canvas, 23 ¼ × 19 in. (59 × 48 cm). Private collection, United States.

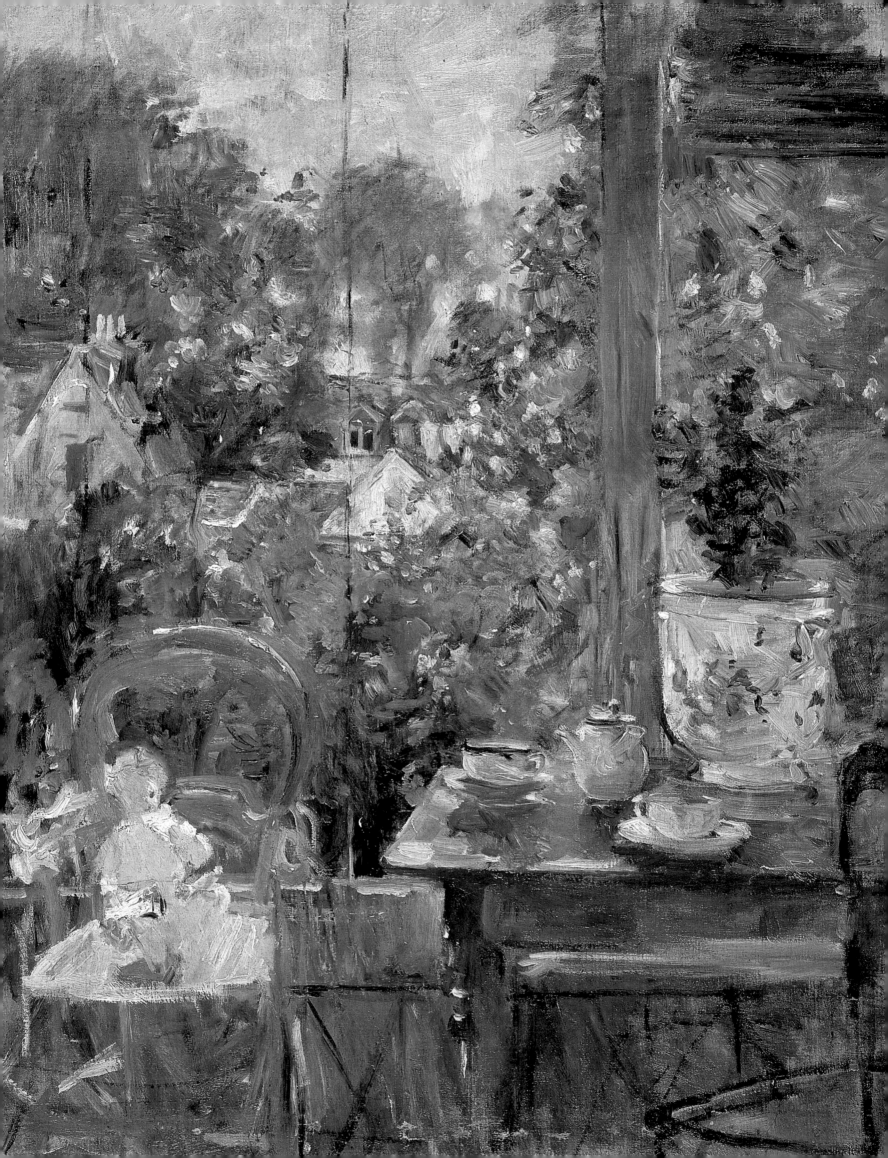

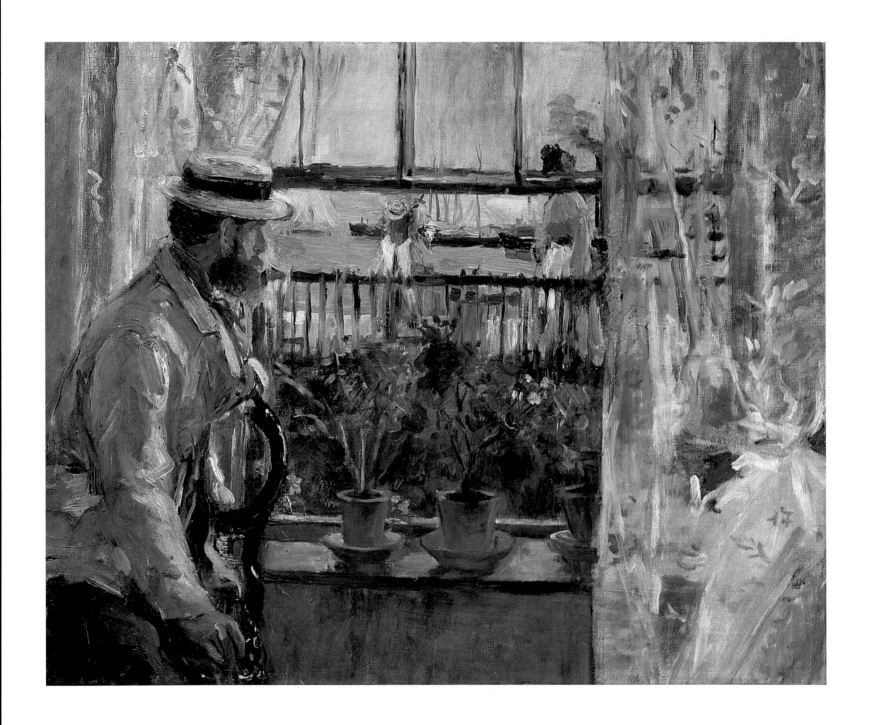

Eugène Manet à l'île de Wight (Eugène Manet on the Isle of Wight), 1875.
Oil on canvas, 15 × 18 ¼ in. (38 × 46 cm). Musée Marmottan Monet, Paris. Denis and Annie Rouart Foundation.

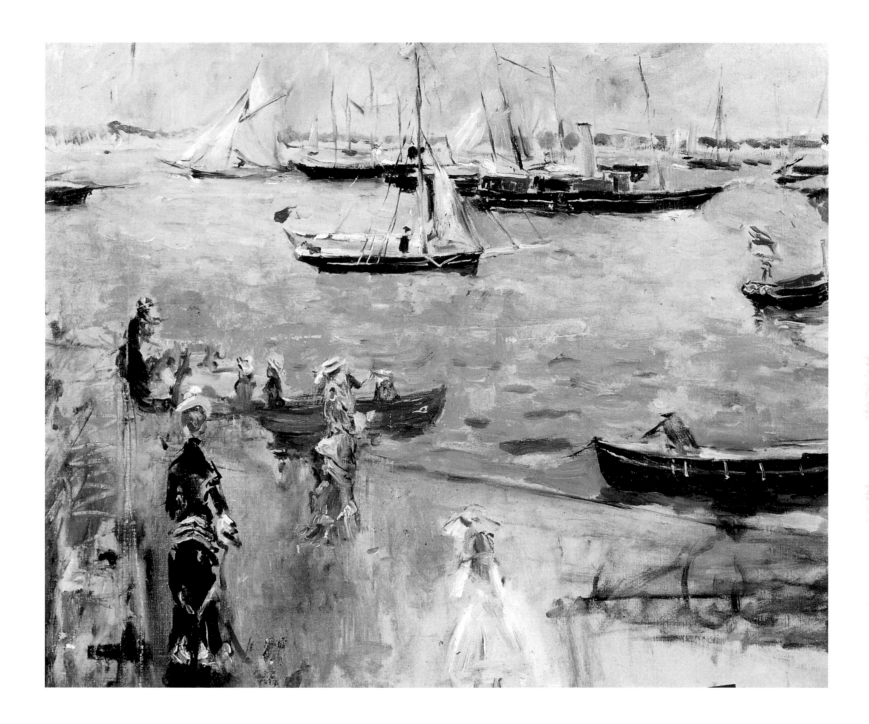

Vue du Solent (île de Wight) or **Marine en Angleterre**
(View of the Solent or **English Seascape** or **Harbor Scene, Isle of Wight), 1875.**
Oil on canvas, 15 × 18 ¼ in. (38 × 46 cm). Private collection.

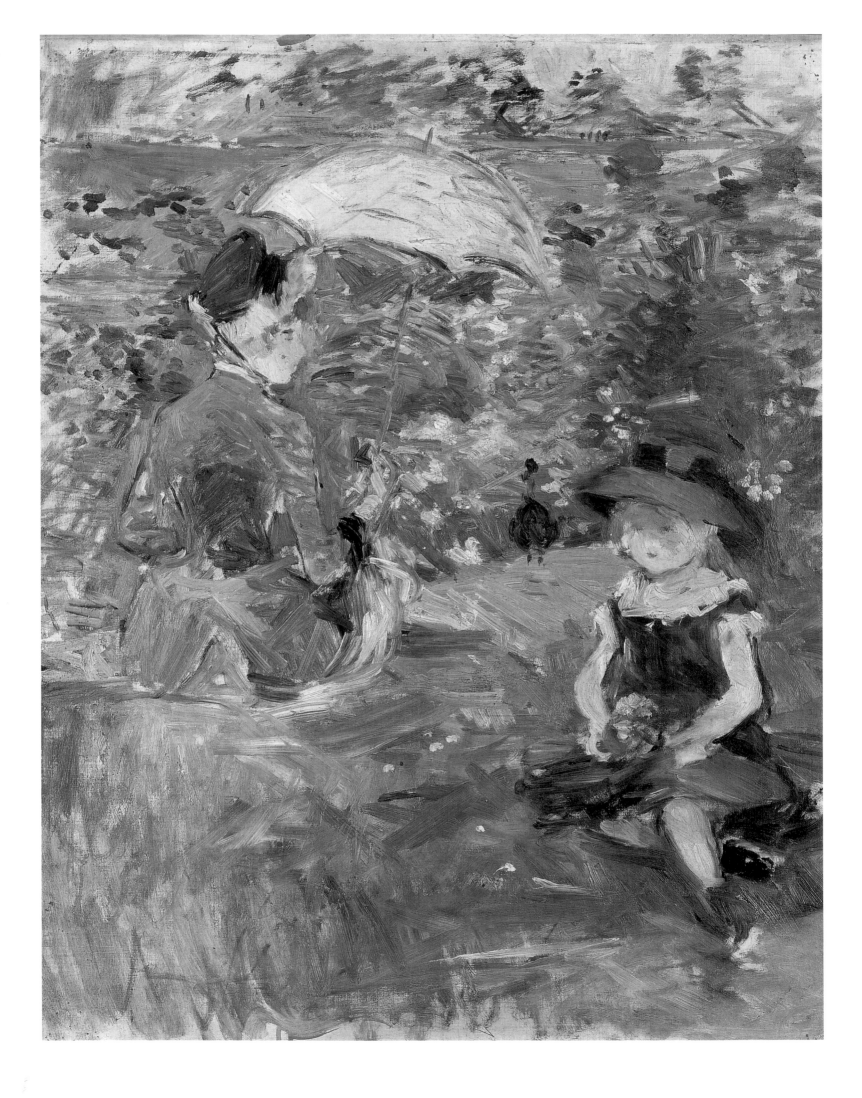

at Maurecourt). The later canvas is freer, with a livelier, lighter touch; it exists in the form of watercolor sketches and painted variations. Here, the sky has disappeared, as if the painter had planted her canvas directly on the ground; the trees are defined not by lines, but touches of color; the grass is crushed beneath the brush, as if by the slight weight of a body, and the silhouette of the young girl's back, in the foreground, has become transparent.

At each stage in Berthe Morisot's life, we find canvases that revisit earlier subjects, or rather atmospheres evoked earlier in her work, since the subjects are always enriched or differently orchestrated. In this context, the cottage interior painted in Jersey in 1886 is reminiscent of *Eugène Manet on the Isle of Wight*, with its solitary figure near a window opening onto a seaside landscape. This time, however, the figure is a child, centrally positioned and apparently uninterested in the scene outside, her luminous dress serving as a central pivot for the "scene," whose anecdotal quality has been discarded in favor of a focus on the handling of the paint itself: taking a closer look at the picture, we discover a Bonnard before its time. From the tablecloth to the curtain, from cup to fruit, everything is pure painting. We may note the picture's various analogous forms, too, although they very probably escaped the painter: the napkin in the foreground, tied in the shape of a swan, that seems to glide across a mirror-like plane of water. Through involuntary details like these, an artist may find herself ahead of her time.

Perhaps too much has been made of the influence exerted by Renoir over Morisot in the second half of her career. Undeniably, some of her later works—not her finest—are impregnated with aspects of Renoir's style, showing a common climate, an apparent mimetic quality. The painters saw one another frequently and often worked on similar motifs, but this was constantly the case for all the impressionists, dedicated as they were to the shared discovery of ways to lighten our perception of the world in paint. As we shall see, at the end of the 1880s, Berthe Morisot used drawing to reinstate a more obvious sense of structure in her work, while at the same time retaining the lively, effusive touch so characteristic of her style. Pastels like *Le Piano* (*The Piano*) or the *Jeune fille au panier* (*Young Girl with Basket*) and finished paintings followed one after the other in quick succession. Take, for example, the different versions of *Le Cerisier* (*The Cherry Tree*) (**page 129**), *Fillettes à la fenêtre* (*Young Girls at the Window*) (**page 141**) or *Sous l'oranger* (*Under the Orange Tree*), all of which have something in common with certain canvases by Renoir—the forms of the trees, twisted by the light; hair piled under hats; scattered reflections of light in the brushwork. But in fact, taking a closer look at the *The Cherry Tree*, for example (which existed in three painted versions and

Jeune femme et enfant dans l'île (Young Woman and Child on the Island), 1883.
Oil on canvas, 24 × 19 ¾ in. (61 × 50 cm). Private collection, Paris.

From the 1880s, and in particular after the move to Rue de Villejust in 1883, the Bois de Boulogne became one of the central themes of Morisot's paintings— the paths, the lake, the island, the swans, and in the midst of it all, Julie growing up.

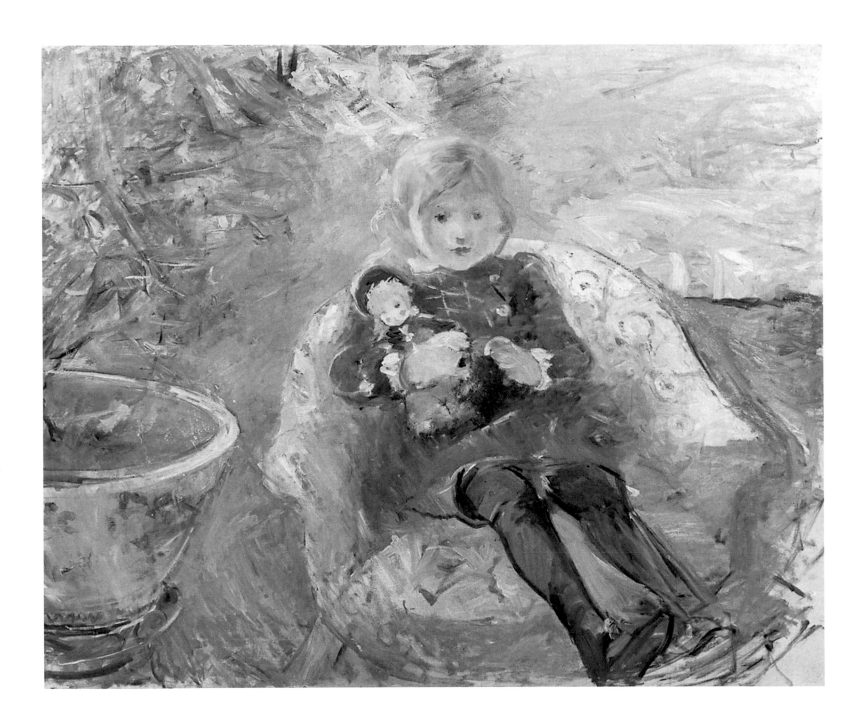

Julie à la poupée (Julie and Doll), 1884.
Oil on canvas, 32 ¼ × 39 ½ in. (82 × 100 cm). Private collection.

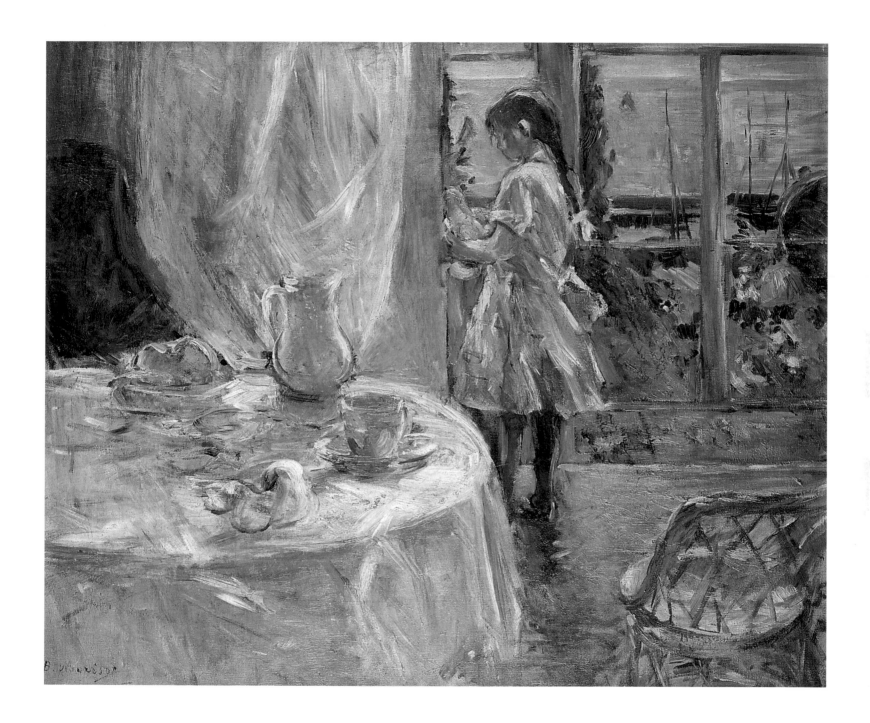

Intérieur de cottage or **L'Enfant à la poupée (Cottage Interior** or **Little Girl with a Doll), 1886.**
Oil on canvas, 19 ¾ × 23 ½ in. (50 × 60 cm). Musée d'Ixelles, Brussels.

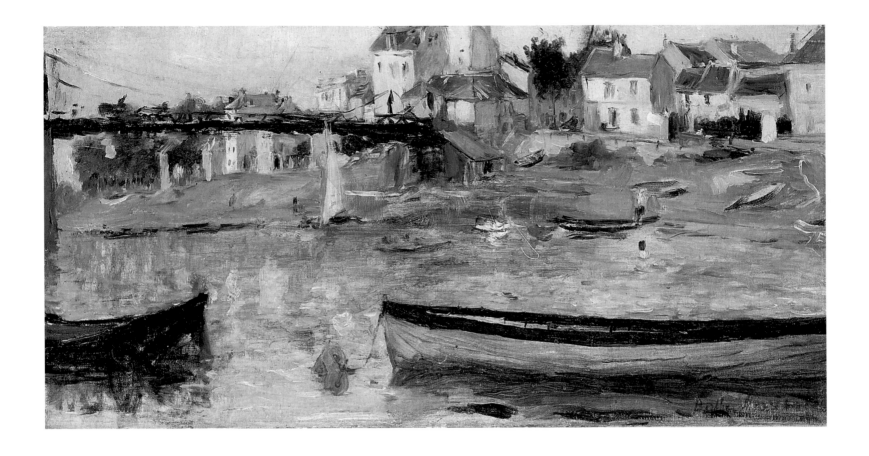

Bateaux sur la Seine (Boats on the Seine), 1880.
Oil on canvas 10 × 19 ¾ in. (25.5 × 50 cm). Private collection, Switzerland.

Painted in the area of Bougival, this canvas acquired by
Mary Cassatt remained for a long time in the hands of her heirs.

Bateau de Mallarmé (Mallarmé's Boat), 1893.
Oil on canvas, 11 x 13 ¾ in. (28.5 x 35 cm). Mr. and Mrs. Palmer Stearns.

Following pages:
Eugène Manet et sa fille dans le jardin de Bougival
(Eugène Manet and his Daughter in the Garden at Bougival), 1881.
Oil on canvas, 28 ¾ × 36 ¼ in. (73 × 92 cm). Musée Marmottan Monet, Paris.
Denis and Annie Rouart Foundation.

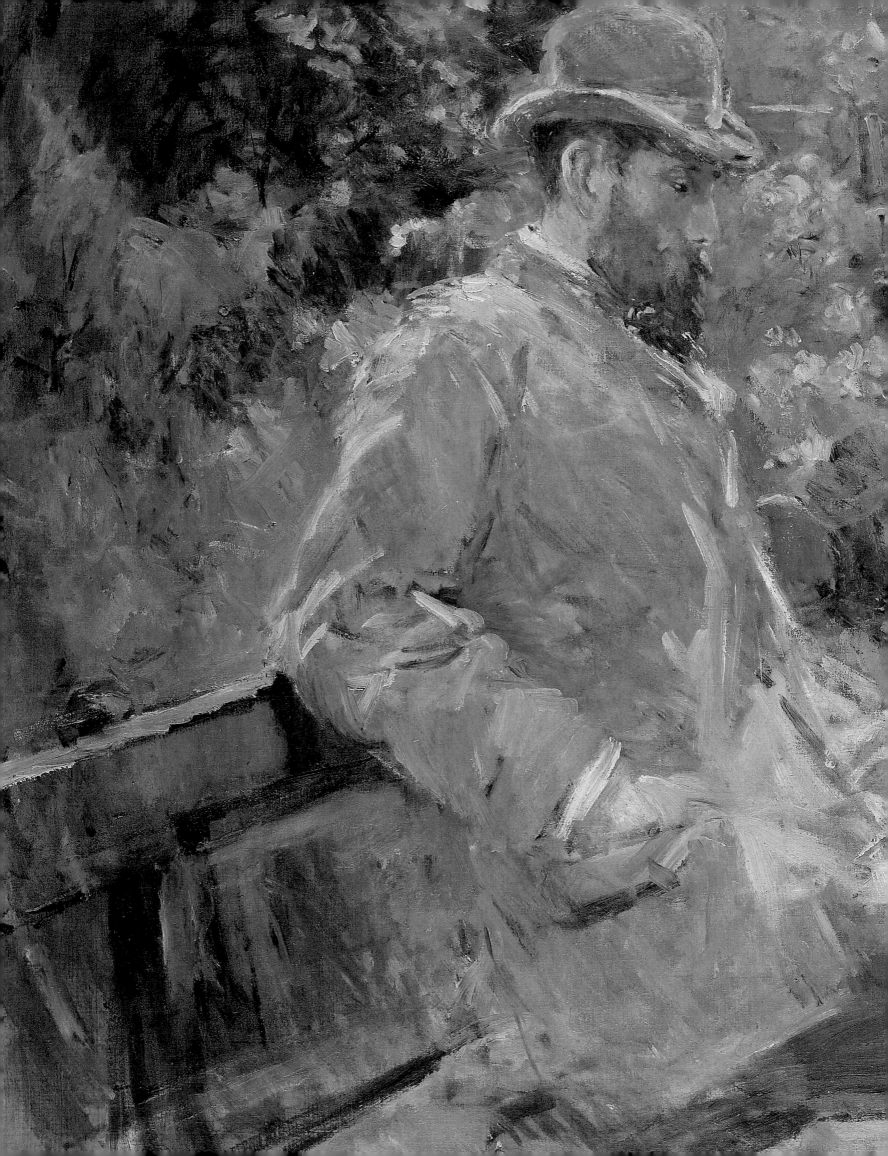

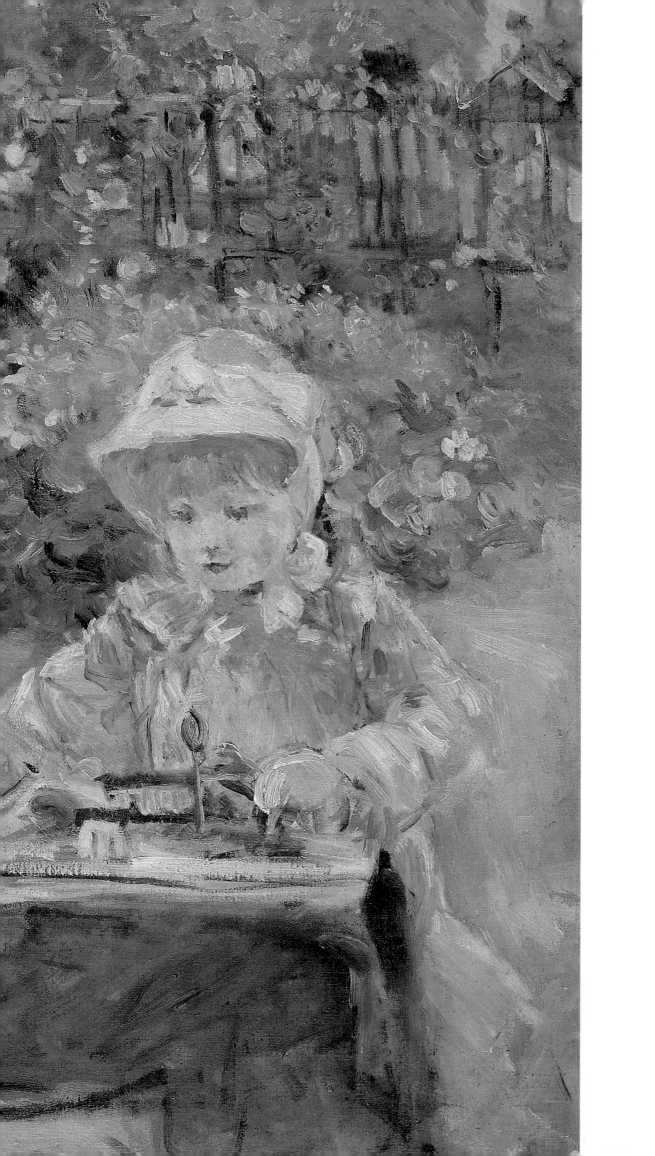

a number of drawings and watercolors), we see that the picture's secret strength is its confrontation of two complementary rhythmic movements: the young girl's arms, lifting her basket and body upwards, are inscribed beneath a ladder that also points to the apex of the picture, countering the downward movement of the arms laden with fruit, and the luminous dress of the girl picking fruit. The composition's dynamic is quite different from anything by Renoir (the greater sensualist), whose brushstrokes seem to bind form, and who remained attached to a more horizontal movement, but who also—at around this same period—seemed to strive for a much smoother version of impressionist brushwork (*La Danse, Les Baigneuses*), moving away from the impressionist aesthetic and aspiring to a more classicizing approach, via Italian art. Morisot effected no such about-turn, nor was she ever tempted to try.

Analogies exist between the two painters: a certain resemblance is detectable, which we may be tempted to qualify as skin-deep. But to seek to extend this similarity to the whole of Berthe Morisot's work in her last years—out of sheer intellectual laziness—borders on abuse, willful blindness or bad faith. Because, parallel to these canvases (which may perhaps constitute the beginnings of a tentative exploration whose later development was cut short by death), throughout these same years, Morisot produced works with barely any connection to Renoir. Above all, we discover not so much an influence as a close convergence, and a subtle art of transposition, with the work of a poet, namely Stéphane Mallarmé. Mallarmé's great refinement, the feminine quality in his work, find a subtle pendant in the pictures of Berthe Morisot, that most Mallarméan of painters. Her canvases resemble the quatrains inscribed by the poet on envelopes (**page 215**); all allusive effusion, refined diffidence, and modest restraint. Certainly, her work shows none of the esoteric quality sometimes found in Mallarmé's language. But through subtle touches, and an extreme lightness of appearance, the essential is attained. Their subjects are similar, and here we situate the series of landscapes in the Bois de Boulogne, the swans, in which the merest hint of color, a few brushstrokes, a few dabs of paint suffice, and everything, miraculously, is present.

But it is also in this series—bordering on abstraction in its quest for the quintessence of things—that we discover what is perhaps Berthe Morisot's most original characteristic: her sense of transparency, unequaled by any other impressionist painter. We need only think of prints like *Les Oies* (*The Geese*, 1885) or *Le Canard* (*The Duck*, also known as *Ducks and Water Plants*, 1888?), or a canvas like *Julie et son lévrier Laërtes* (*Julie and Her Greyhound Laertes*, 1893—Laertes was a present to Berthe Morisot from Mallarmé) (**page 39**) in which the armchair and dress, painted but not completely covered with pigment, reveal the prepared canvas

L'Oie (The Goose), 1885.
Oil on canvas, 65 × 34 ¼ in. (165 × 87 cm). Private collection.

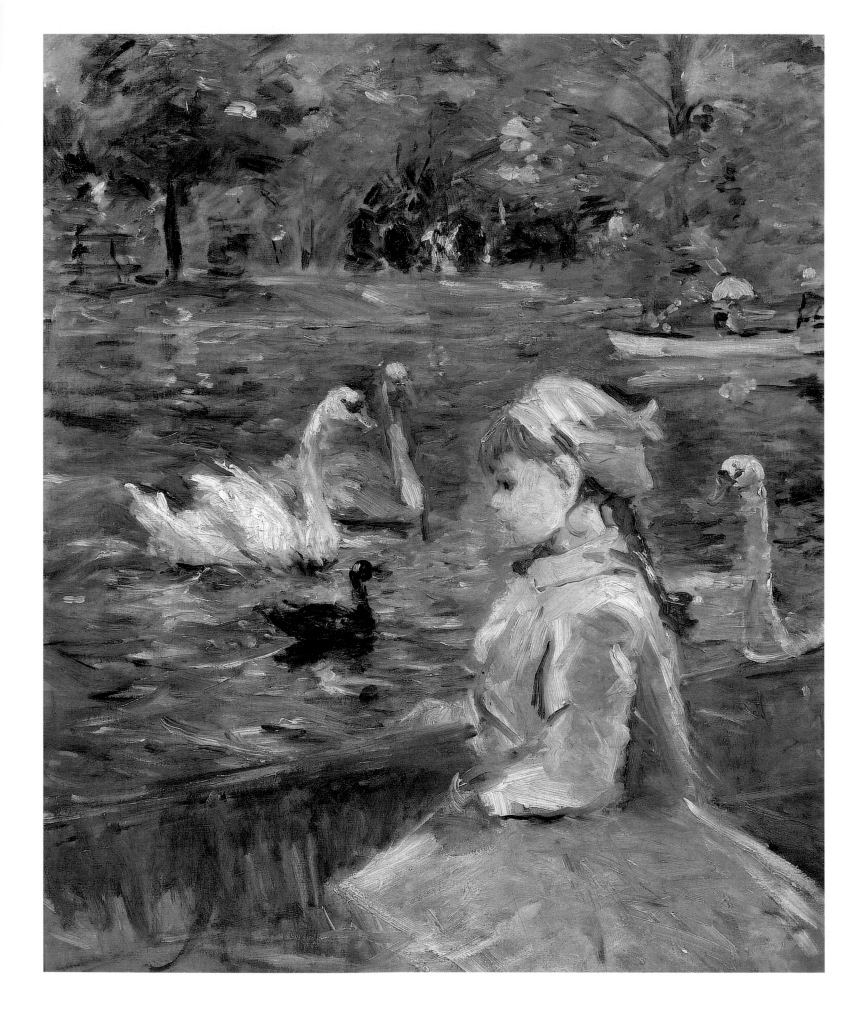

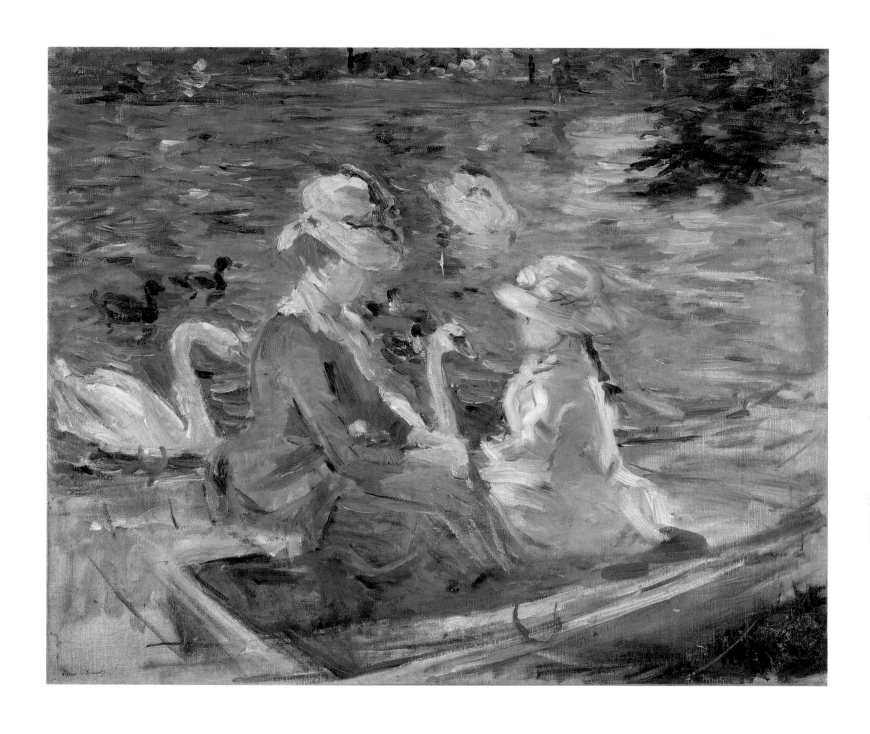

Sur le lac or **Petite fille au cygne (On the Lake), 1884.**
Oil on canvas, 25 ½ × 21 ¼ in. (65 × 54 cm). Private collection, Paris.

Sur le lac du bois de Boulogne (On the Lake in the Bois de Boulogne), 1884.
Oil on canvas, 23 ½ × 28 ¾ in. (60 × 73 cm). Private collection.

The motif of the lake and swans recurs tirelessly; and if we are to believe
Jacques-Émile Blanche, Berthe Morisot threw the studies which didn't satisfy
her into the lake.

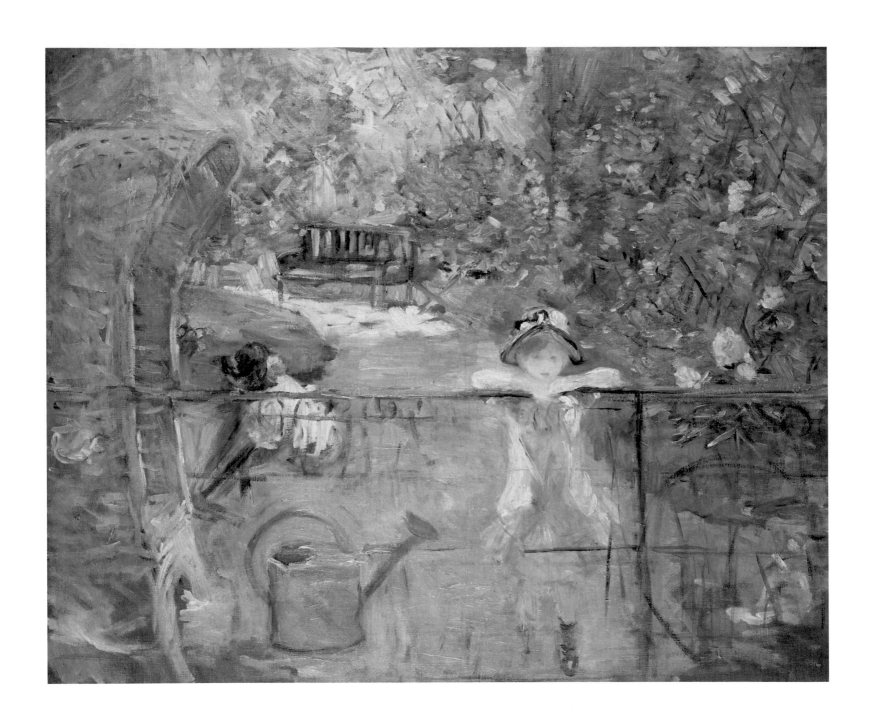

Petites filles dans le jardin or **Le Fauteuil à bascule (Little Girls in the Garden** or **The Basket Chair), 1885.**
Oil on canvas, 24 ¼ × 29 ¾ in. (61.3 × 75.6 cm). Museum of Fine Arts, Houston.

Enfant dans les roses trémières (Child in the Hollyhocks), 1881.
Oil on canvas, 20 × 16 ½ in. (50.6 × 42.2 cm). Private collection.

underneath and suggest the vibrant energy beneath the light top coat. Or a canvas like *Cygnes sur le lac* (*Swans on the Lake*, which belonged to Paul Valéry) or *Cygnes en automne* (*Swans in Autumn*): all of these works attain the ineffable through an effect of transparency that is not only an important discovery in the field of painting, but the beginning of a new approach that pierces and looks beyond appearances.

Berthe Morisot and Mallarmé had long since formed a friendship that became closer over time, lasted until the painter's death, and was extended thereafter by Mallarmé's attentive solicitude toward Berthe's daughter, Julie Manet; he became her guardian for the few remaining years of his own life. In around 1887 or 1888, Stéphane Mallarmé had the idea of asking some of his painter friends to illustrate one of his forthcoming collections of poetry, *Le Tiroir de laque*, each artist taking a different poem. Morisot, Degas, and Renoir were all invited to contribute. Berthe had done very little printmaking prior to this, but set to work and produced a number of plates. Of these, at least two seem to be connected with Mallarmé's project: *Le Lac du bois* (*Woodland Lake*) and *The Duck*. The book never appeared under the original title or format, and Berthe Morisot's plates remained packed away in boxes for many years. And yet these fluent drypoints are quintessentially Mallarméan—nothing is stressed or overstated, but the artist's exquisite feeling for watery reflections and reflected light says it all: the prints are extraordinarily suggestive, with exceptional economy of means. Berthe doubtless saw Mallarmé's project—for which she was to illustrate the poem *Le Nénuphar blanc* (*The White Water Lily*)—as an opportunity to practice making prints based on her own paintings or drawings: a self-portrait with her daughter Julie, a nude seen from the back, a young girl resting, and (inspired by Renoir's painting), a version of *Julie Manet au chat* (*Julie Manet with a Cat*). The experiment came to nothing, but it is worth noting that this series of prints coincides with Berthe's return to drawing. With a few exceptions, almost all of her drawings can be dated with certainty, since they are all working drawings and preparatory studies for particular paintings, many from the late 1880s or early 1890s.

But while Morisot seems, at this point in time, to have been briefly tempted to strive for a more solid structure in her work, it cannot be overstressed that, in her last years, she also pursued a parallel quest that led her to eliminate everything but patches of color and luminous signs. In the few years left to her, Berthe was fated to pre-empt but not resolve that which soon Monet and later Bonnard would carry through to completion. Indeed, the most striking thing about her late work as a whole is not the impression of unfinishedness—this is only true of her very last pictures—but the sense of a sudden interruption provoked by a brutal twist of fate: as if everything that she foresaw, discovered, and fixed for an instant in her last

Portrait de Berthe Morisot et de sa fille
(Portrait of Berthe Morisot and Her Daughter), 1885.
Oil on canvas, 28 ¼ × 35 ¾ in. (72 × 91 cm). Private collection, Paris.

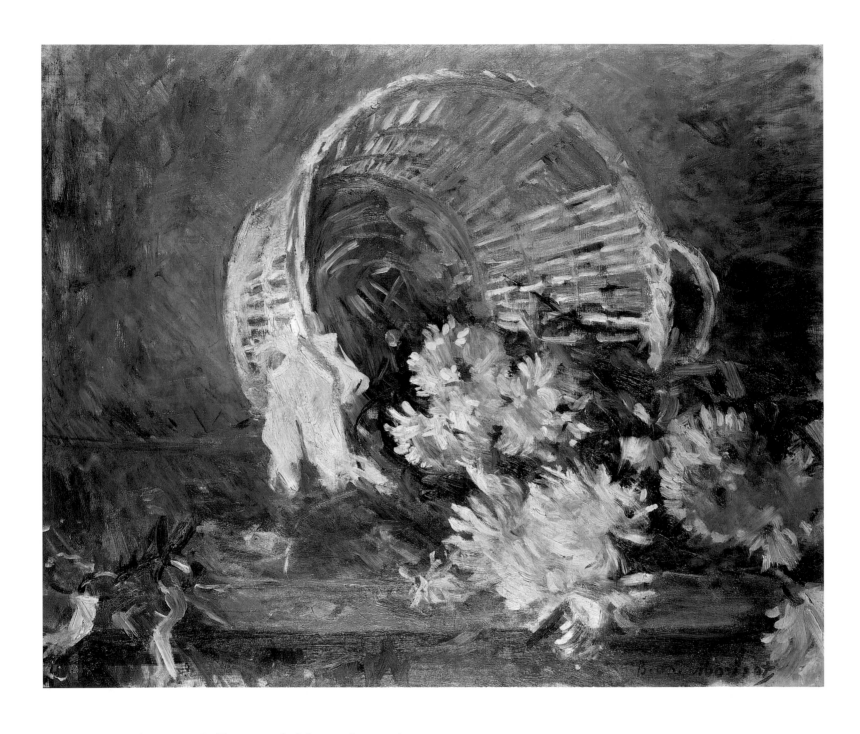

Chrysantèmes or **Corbeille renversée (Chrysanthemums), 1885.**
Oil on canvas, 17 ¾ × 21 ¾ in. (45 × 55 cm). Private collection, Paris.

Berthe Morisot only painted a few still lifes and, as if to belie this categorization, she has filled this one with movement, making it more dynamic.

Jeune fille au chien (Girl with a Dog), 1887.
Oil on canvas, 31 × 23 ¾ in. (78.8 × 60.1 cm). Armand Hammer Museum of Art, Los Angeles.

The older sister of Jeannie, Paule Gobillard, who is modeling here, reappeared several times, either painting or in a ball gown, in the work of Berthe Morisot.

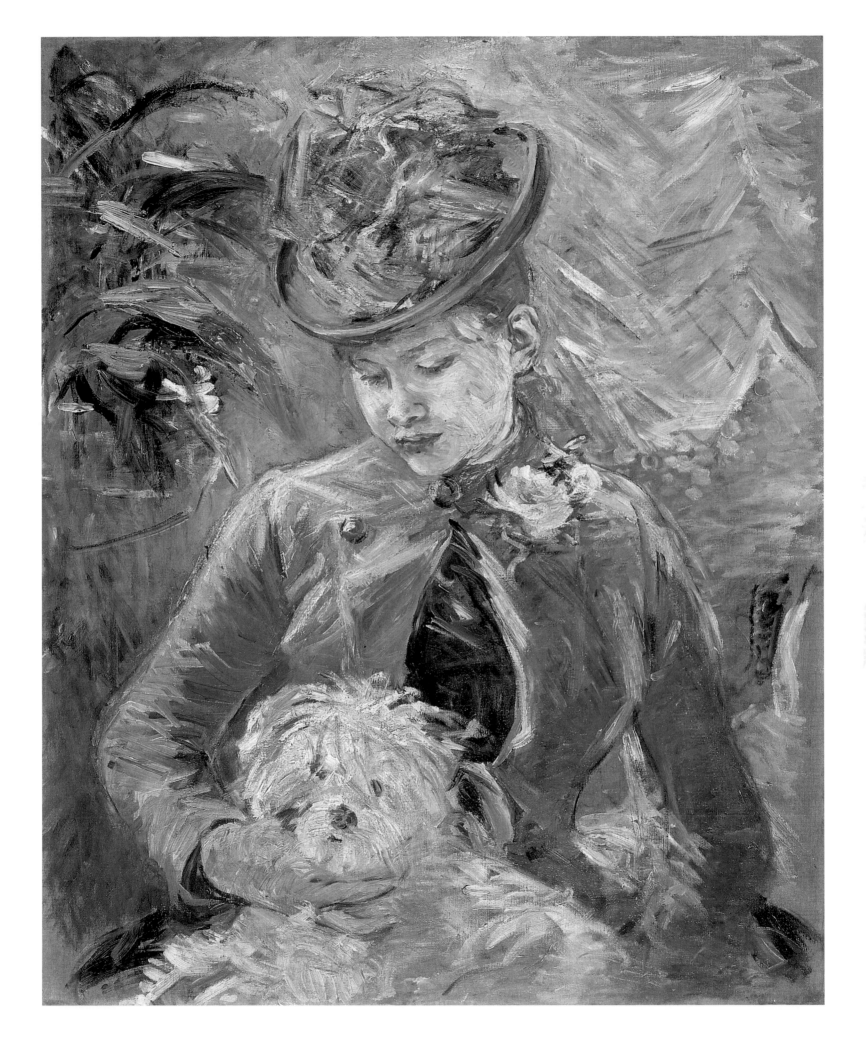

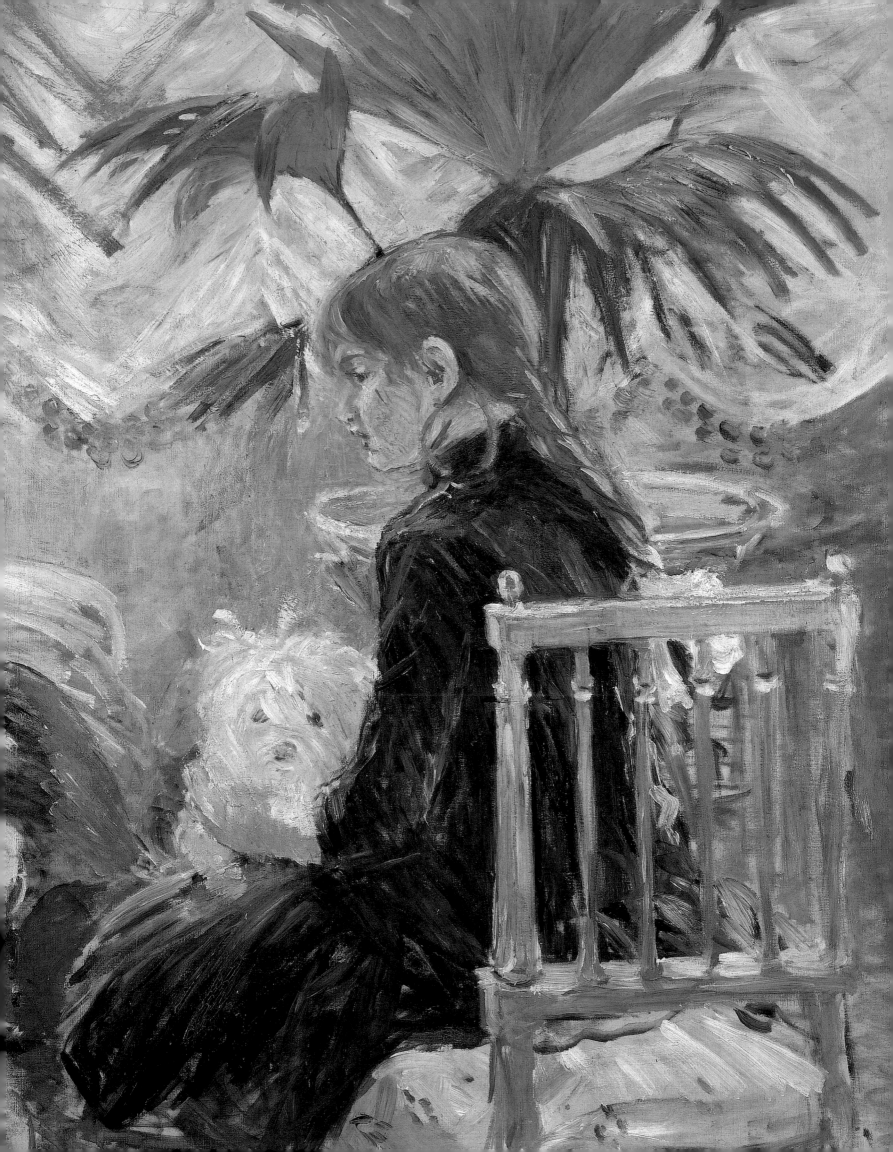

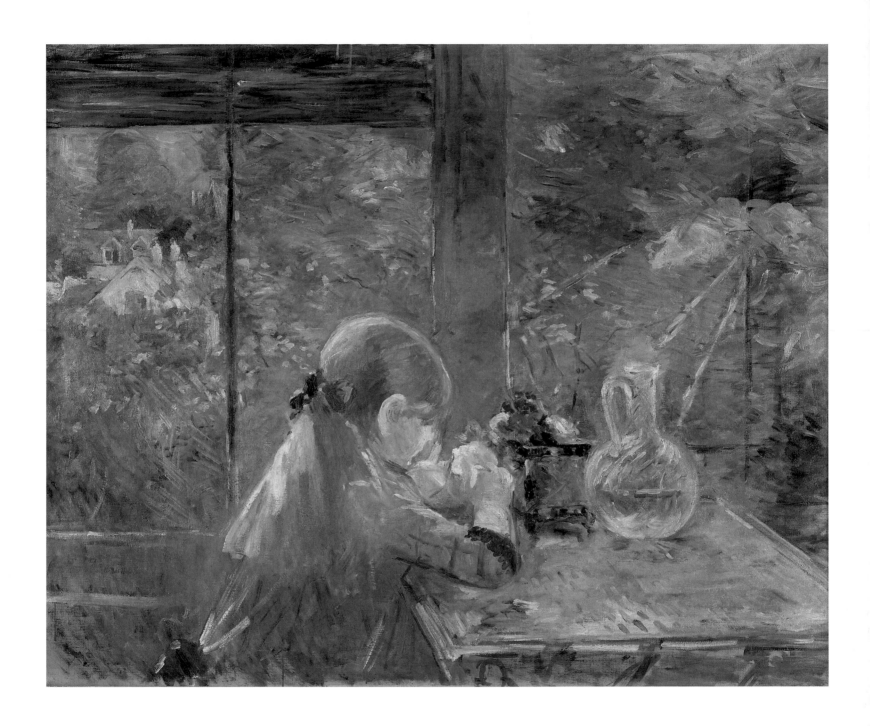

Fillette au chien (Little Girl with Dog), second fragment **1886.**
Oil on canvas, 36 ¼ × 28 ¾ in. (92 × 73 cm). Private collection, Paris.

*Initially, Berthe Morisot had painted the two cousins, Jeannie Gobillard
and Julie Manet, in the same picture. Not satisfied with the result,
she separated the work into two distinct pictures, of which this is the
second fragment.*

Dans la véranda (On the Veranda), 1884.
Oil on canvas, 32 × 39 ¼ in. (81 × 100 cm). John C. Whitehead Collection, New York.

years slipped from her grasp just as she reached it, and that many new discoveries were denied her by death.

Among the finest pictures of these years, we should note *Le Modèle au repos* (*Resting Model*), in which objects are suggested solely in terms of their appearance in the prevailing light. Surrounded by a mirror, a screen, and an armchair, a naked young woman half covers her body with a dressing gown held across her chest by her folded arms. The canvas seems to mark the beginning of a series of images of women notable for their supreme sensuality, subtly incorporated into the caressing brushwork. Here, we think for a moment of Toulouse-Lautrec: a Lautrec before his time—the canvas is barely covered, the brush hardly touches the surface. But a Lautrec more mellow and sophisticated than caustic; more sensual than risqué. And this fleeting evocation of Lautrec—the technique and appearance of his work—should not blind us to the fact that at that same moment, he had painted none of his key masterpieces. Still less so two years earlier, in 1885, when Berthe Morisot painted her self-portrait, on an unprepared canvas. Strangely, in these pictures—and this must have been felt by those who saw them for the first time—the lighter their touch, the greater their powers of suggestion.

But the most moving characteristic of the canvases painted in Berthe's last years remains the way in which their subtle sensuality seems to capture the essence of life, while at the same time allowing it to slip through their grasp, like water. The same sensuality is seen again in the supple line of the *Bergère nue couchée* (*Naked Shepherdess Lying on the Ground*), a red chalk drawing executed in Mézy in 1891, and a number of different canvases featuring Jeanne Fourmanoir, Berthe's favorite model during these years. We recognize her in *Sur le lac* (*On the Lake*) (**page 119**), sitting in a rowing boat, the swan's neck echoing the rhythmic movement of her dress; in *Le Cerisier* (*The Cherry Tree*), and, above all, in Berthe's two finest paintings of 1892, works which can, in a sense, be taken as the culmination of her oeuvre. One is the *Jeune fille endormie* (*Young Girl Sleeping*), with its echo of a line by Paul Valéry: "Sleeping girl, a gilded heap of shadows and abandon...." The other, *Jeune fille au chat* (*Young Girl with a Cat*), a blend of mauve and green, two facets of that allusive, discreet sensuality, fulfillment, and secret ardor.

With its swans, their contours erased and almost drowning in mist, *Sous-bois en automne* (*Undergrowth in Autumn*) (**page 149**), dating from the last months of 1894, seems like a farewell to life. The human figures, minuscule and scarcely identifiable, seem obliterated, too, by color; touches of paint among many others, already part of the play of colors rather than forms. Framed by the green

Le Cerisier (The Cherry Tree), 1891.
Oil on canvas, 57 ¾ × 35 in. (146.5 × 89 cm). Private collection, United States.

This is without doubt the tallest painting by Morisot—an even taller version (60 ½ in.) is kept at the Musée Marmottan Monet—and was created in the workshop after several studies in pencil, watercolor, and pastel.

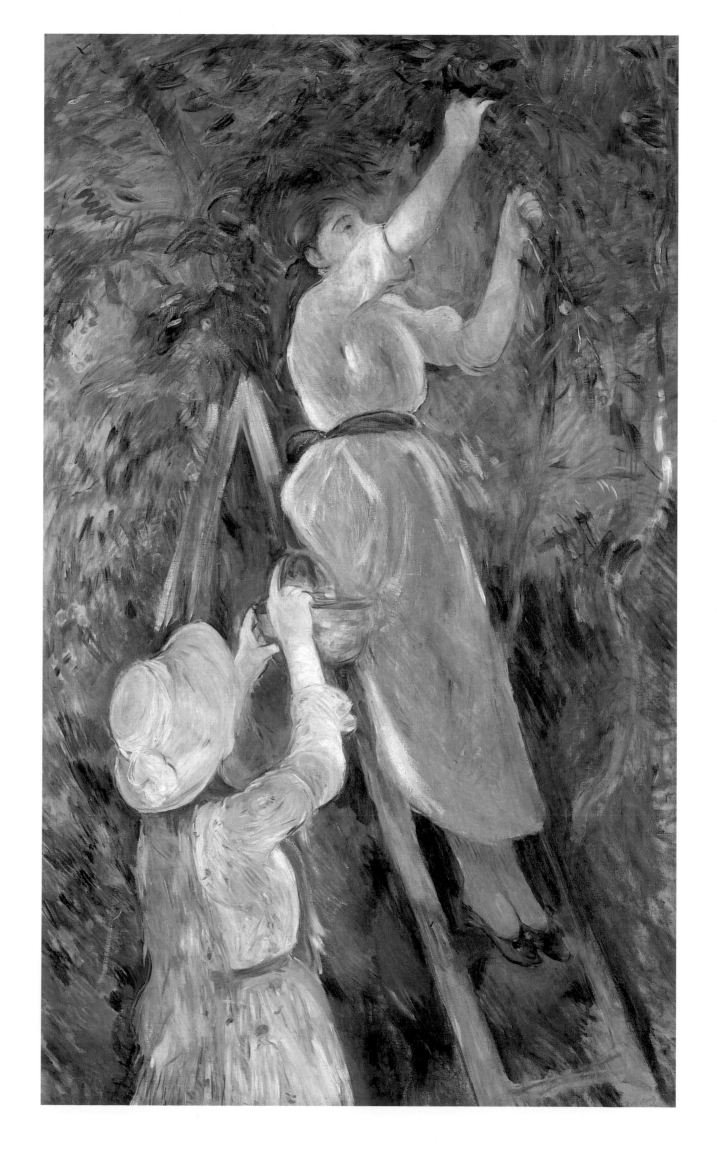

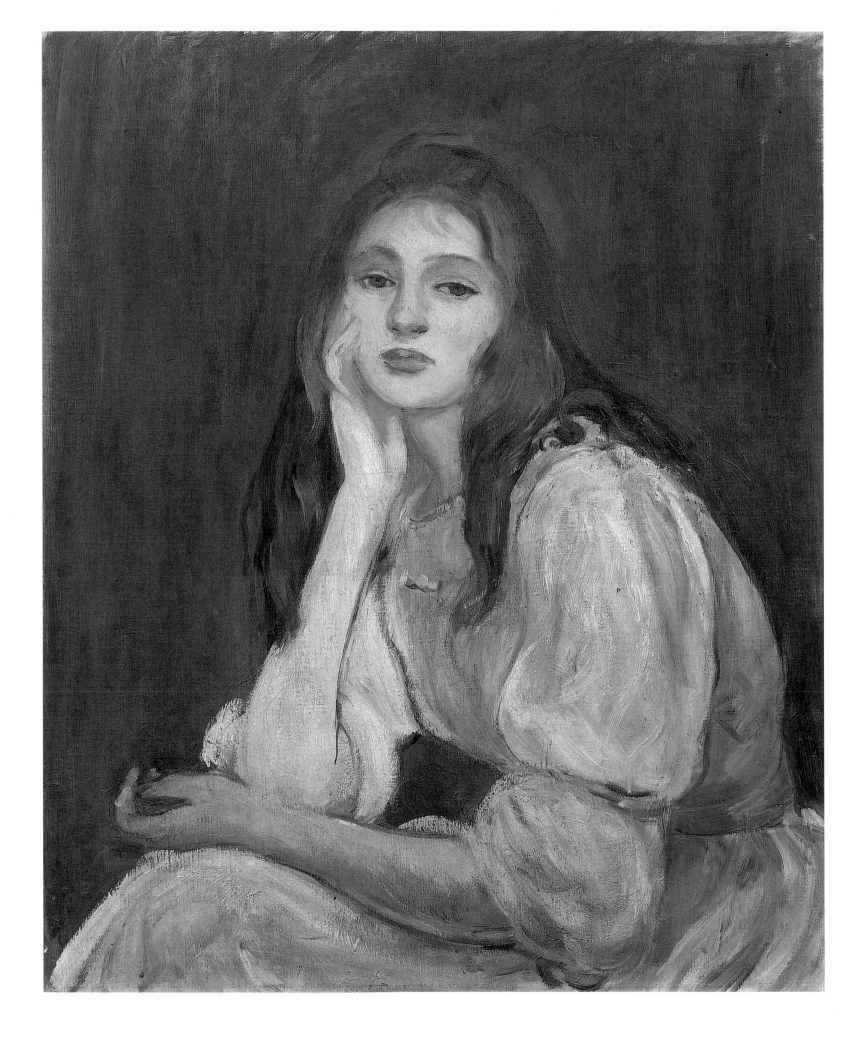

of the tree trunks and the pink of the carpet of leaves, a hint of blue in the center of the picture closes the horizon and opens itself to what lies beyond.

At the beginning of 1895, Berthe Morisot fell ill nursing her daughter, whom she had painted gazing dreamily a few months earlier at Rue Wéber, her last port of call. By early March, Morisot had died. On the eve of her death, her last written words were for her daughter: "My dearest little Julie, I love you as I lie dying; I shall still love you when I am dead. I beg of you, do not cry; this parting was inevitable."

So ended, at the age of fifty-four, a quiet existence whose intensity seems masked by diffidence, but whose many facets are revealed in an exceptional body of work. It is tempting to see Morisot's notebooks as her true testament: hastily jotted words that confirm what we sense in some of her self-portraits—that restless mix of doubt, renunciation, lucidity, passion, and discretion that animated her soul:

> With what resignation we arrive at the end of life, resigned to all its failures on the one hand, all its uncertainties on the other, for so long I have hoped for nothing, and the desire for glorification after death seems to me an overblown ambition; my own ambition has been confined to a desire to fix something of all that passes, oh! something, the least little thing, well! that ambition, too, is overblown.

The true depth of Berthe Morisot's character is revealed in this unassuming, disillusioned, diffident personal creed—a constant flame, wavering in a permanent draught of unfathomable melancholy. And yet, unbeknown to her as she wrote these lines, her work—unencumbered now by its creator's self-doubt—had already embarked on the long, sometimes hidden, road to the future. There are 423 oil paintings, 191 pastels, 240 watercolors, 8 prints, 2 sculptures, up to 300 hundred drawings: the sum total of the artist's work. A little less than Manet, much less than Degas, Monet, or Renoir. But let us not forget that Morisot died prematurely, at the age of fifty-four, and that she was the first of the founding family of impressionists to die.

At the end of this survey, it is fitting that we should return to one of the most persistent misunderstandings surrounding her work: the celebrated feminine charm with which it is both credited, and taxed. Its existence is undeniable; but her work cannot be reduced to the unchanging epithets that have accompanied it, endlessly rehearsed and repeated, for over a century. We have the advantage of distance and hindsight over the paintings' first viewers. And it falls to us to look beyond superficial appearances and to resituate the work in its proper perspective.

Pages 130–131:
La Bergère couchée (Shepherdess Lying on the Ground), 1891.
Oil on canvas, 13 ¾ × 22 in. (35 × 56 cm). Private collection, Paris.

Facing page:
Julie rêveuse (Julie Daydreaming), 1894.
Oil on canvas, 25 ¼ × 21 ¼ in. (64 × 54 cm). Private collection, Paris.

A painter of women, and a woman herself, Berthe Morisot imbued her female models with all the charm, all the sensuality, all the tender lightness of being that characterize her own vision, communicated through her work. But beyond that lightness, we are in the presence of paintings that stand proudly alongside the greatest, most inventive and creative painters of her day—Manet, Degas, Monet, Renoir—unsurpassed by them in quality, innovation, or emotional power. And let us remember, finally, that compared with the other female painters active in her own lifetime, and at the beginning of the twentieth century—with Mary Cassatt or Suzanne Valadon—she had the advantage of never falling into a kind of arid, overly muscular, spuriously virile hardening of her expressive means. It falls to us to recognize that beyond its tender charm and femininity, her work is well structured, constantly searching for greater subtlety of expression; and that its superficial appearance, however delightful and attractive, simultaneously hides and reveals a depth concealed from over-hasty eyes by discretion and diffidence alone.

When things have been too much reproduced, it behooves us to look at them afresh, from a new or forgotten standpoint. The same is true when we define reality too closely: we need to soften the contours, diminish its presence and, if the image is still strident and insistent, to dissolve it altogether. And so light succeeds form; dense, clearly defined volumes are supplanted by dabs and patches of color; explicit symbols by ellipsis and allusion. Morisot came to painting through Corot, forged her own path parallel to Manet—the upholder of a form of realism transfigured by invention and rich impasto—and devoted all her sensuality and feminine charm to the depiction of reality, with the power of her distinctive mix of lucidity and melancholy, progressively traversing that reality with fine splinters of color, trapping the light and, while not dissolving reality completely, gradually investing it with that luminous presence whose source is nowhere visible, but whose manifestation is everywhere apparent. She was tempted, by light, to turn back to a more assertive use of contour, and firmer modeling, but already her last canvases show that the journey was not at an end, that death interrupted its course too soon. And beneath the appearance of carefree happiness, this woman, who seemed to paint her whole life long "in her own way," was in truth pursuing an adventure—with passion, tenacity, lucidity—whose ethereal delicacy was its principal disguise, whose charm concealed so delightfully its underlying rigor, and who, while seeming merely to flit across the surface of the canvas, succeeded in gazing through and beyond it, dissolving the appearance of things and so distinctively enriching our own way of looking at the world.

Autoportrait (Self-portrait), 1885.
Oil on canvas, 24 × 19 ¾ in. (61 × 50 cm). Musée Marmottan Monet, Paris.
Denis and Annie Rouart Foundation.

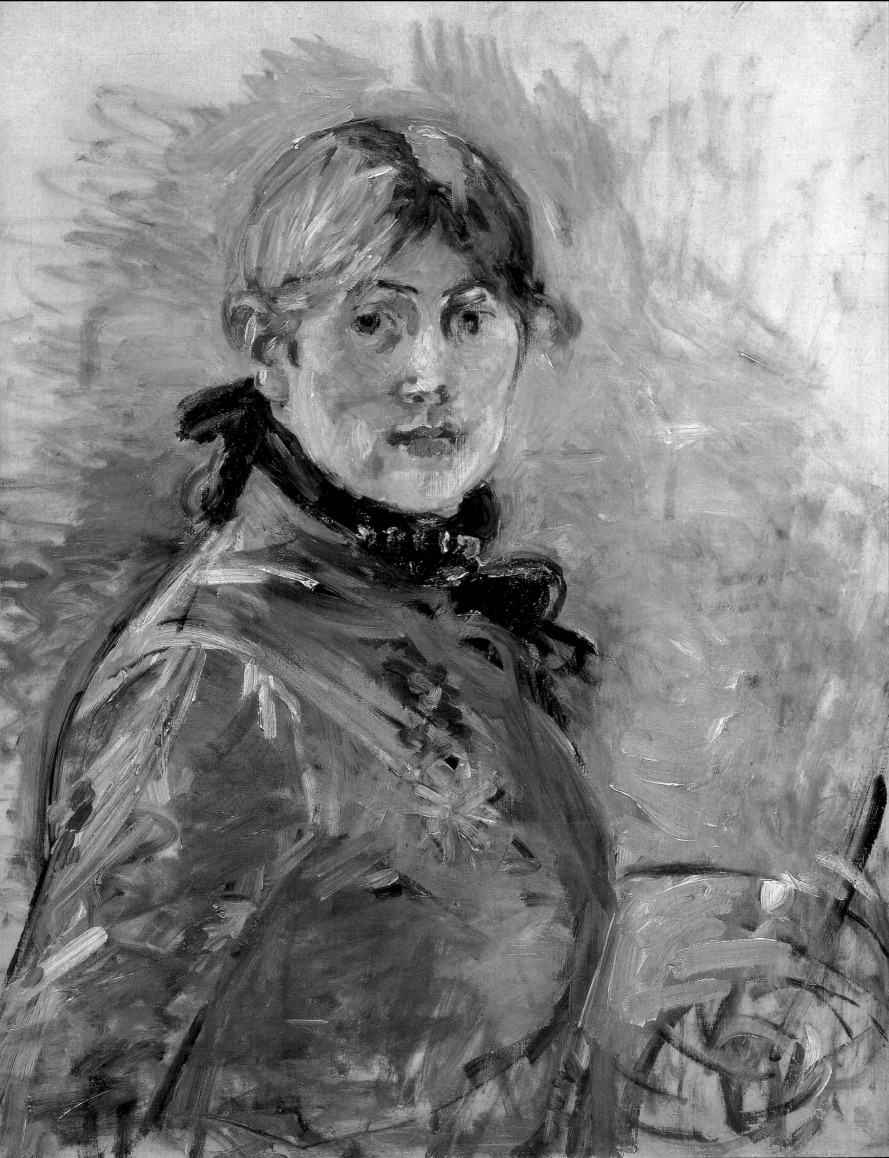

"My dear friend,
Do we see Le Mesnil from
the railway a little beyond
Gargenville? Twice, on
my way to Honfleur, and
on the way back, I jostled
through the carriage
and dashed to the door
to admire what is, indeed,
a grand façade."

LETTER FROM STÉPHANE MALLARMÉ TO BERTHE MORISOT
SEPTEMBER 23, 1892

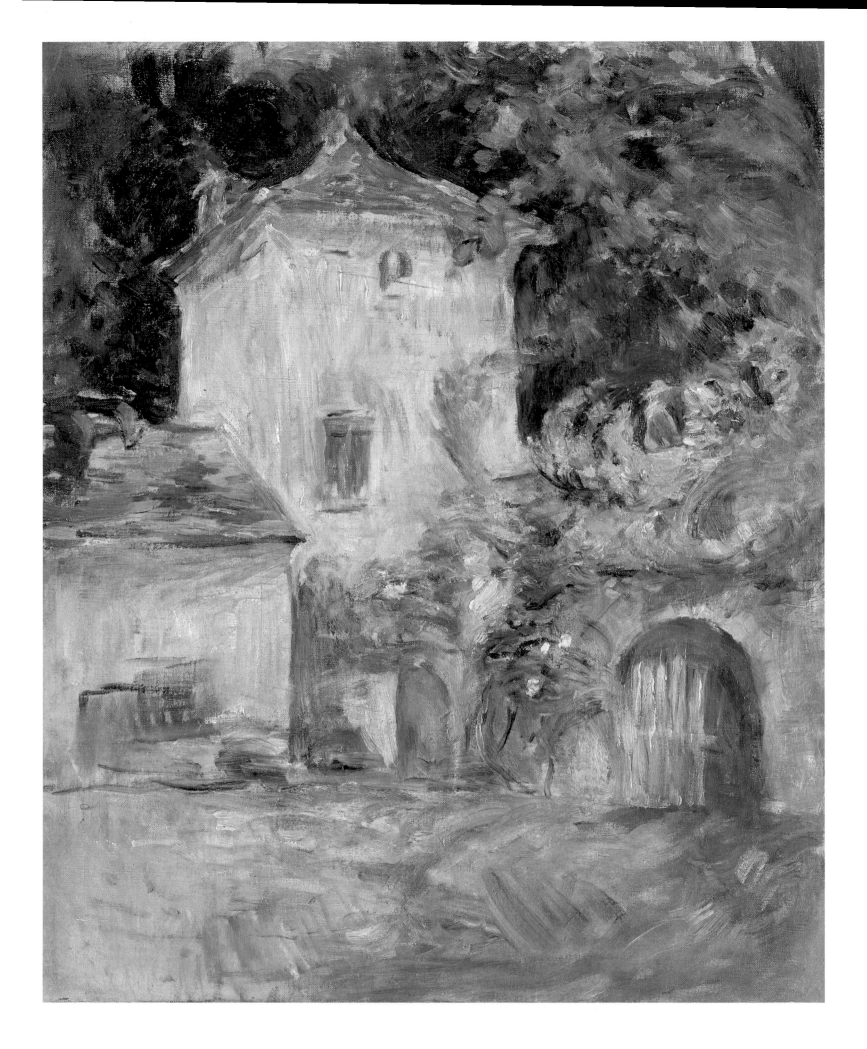

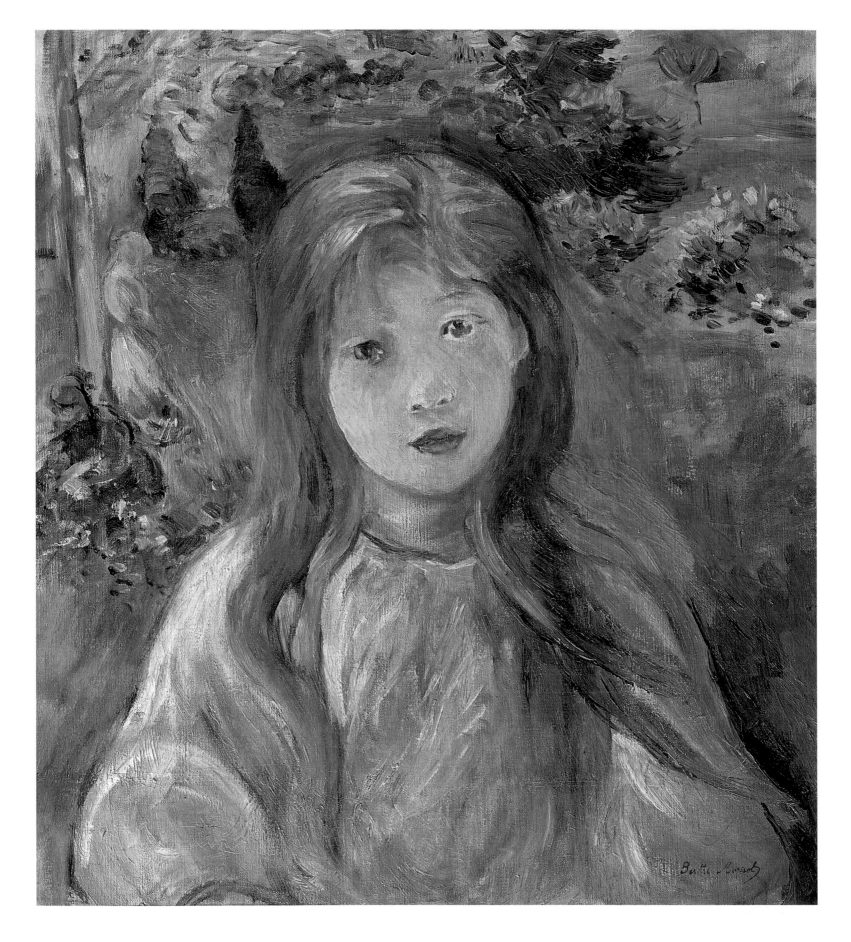

Fillette au Mesnil (Little Girl at Mesnil), 1892.
Oil on canvas, 18 ¾ × 16 ½ in. (47.7 × 42.1 cm). Private collection.

Fillettes à la fenêtre (Young Girls at the Window), 1892.
Oil on canvas, 25 ½ × 19 ¼ in. (65 × 49 cm). Private collection, United States.

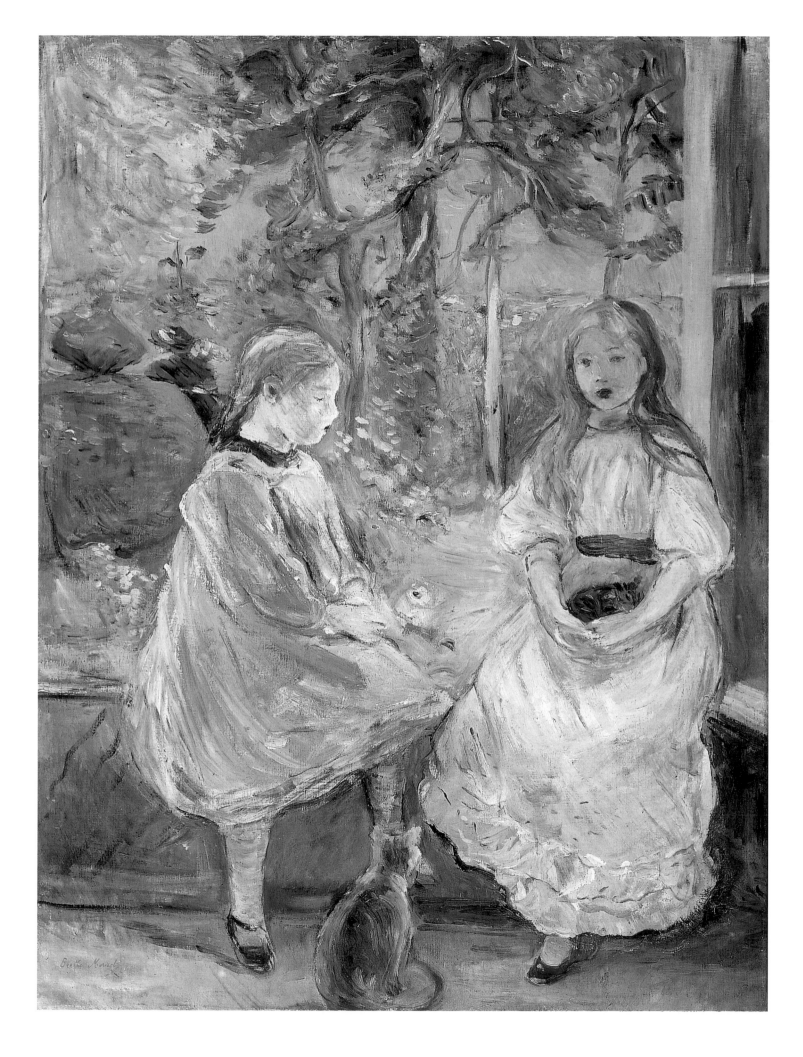

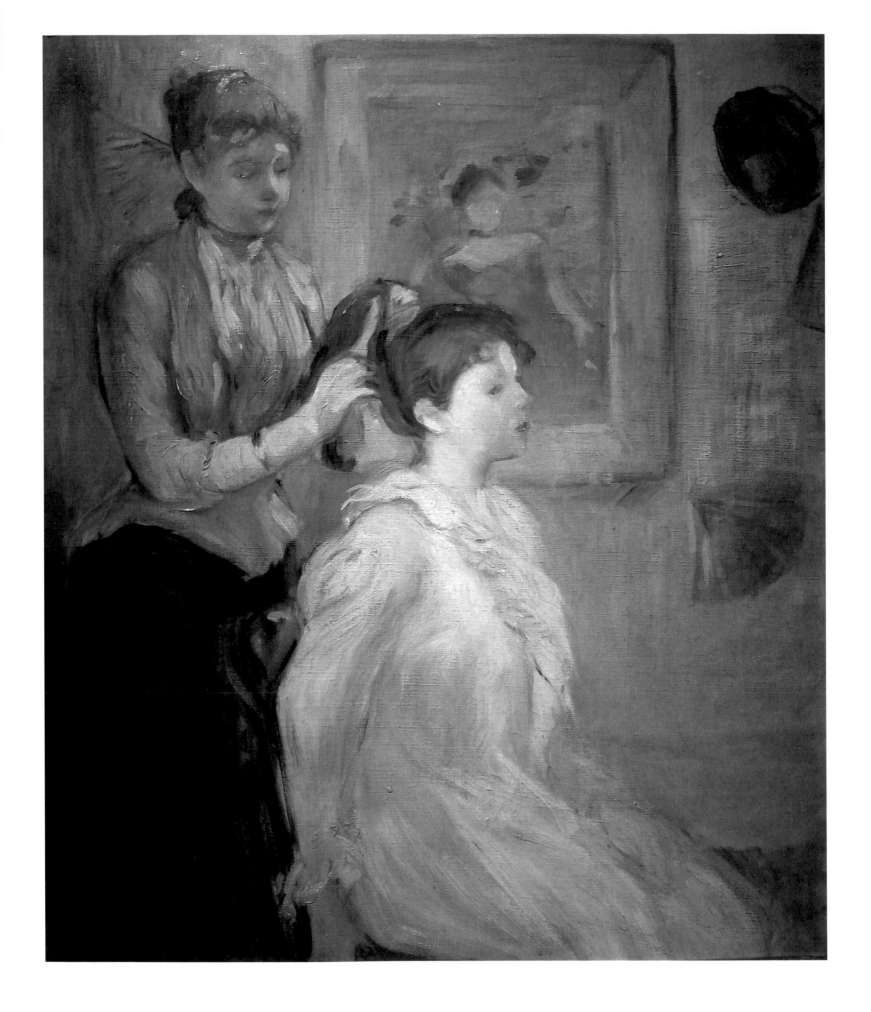

La Coiffure (The Hairdresser), 1894.
Oil on canvas, 21 ¾ × 18 in. (55 × 46 cm). Museo Nacional de Bellas Artes, Buenos Aires.

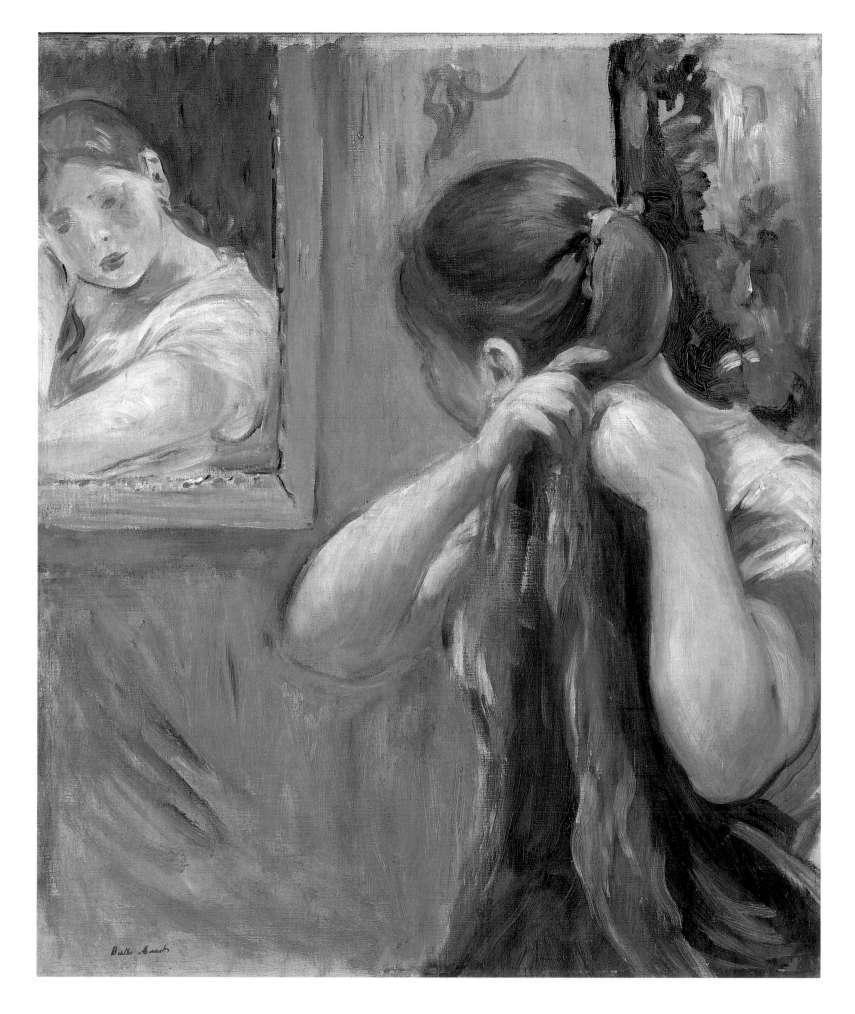

Devant la glace (Before the Mirror), 1893.
Oil on canvas, 25 ½ × 21 ¼ in. (65 × 54 cm). Private collection.

If *The Fable* owes its title to Mallarmé, this canvas painted at Bougival belongs to the Irish writer George Moore, friend of Manet, Degas, and Mallarmé who wrote of Berthe Morisot: "Her pictures are the only pictures painted by a woman that could not be destroyed without creating a blank, a hiatus in the history of art."

La Leçon de couture or **Julie et sa nurse (The Sewing Lesson** or **The Artist's Daughter with Her Nanny), 1884.**
Oil on canvas, 7 ½ × 8 ¾ in. (59 × 71 cm). Minneapolis Institute of Arts.

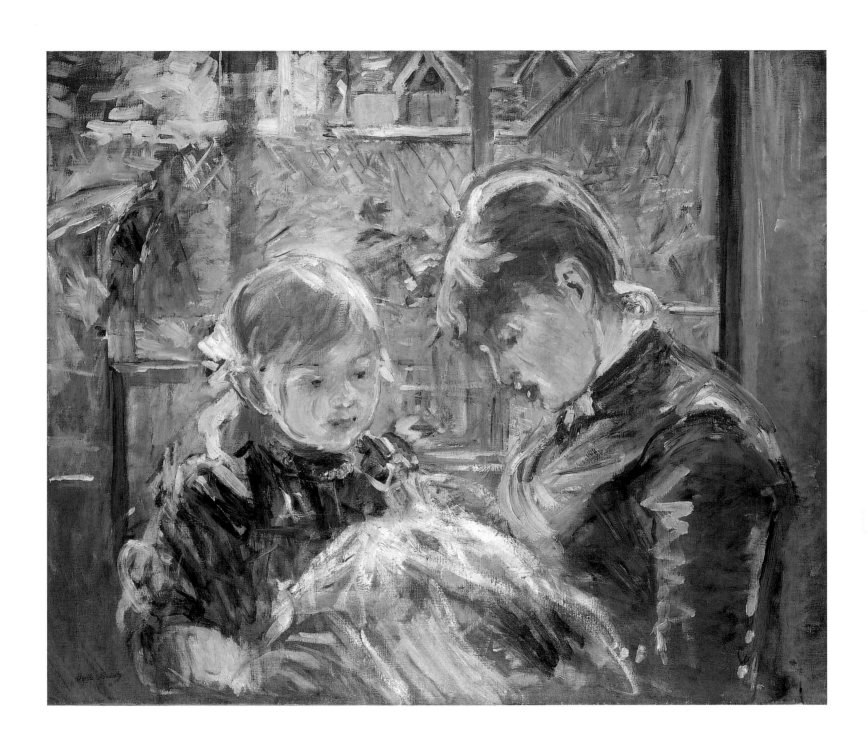

Poires (Pears), 1891.
Pastel, 16 ½ × 18 ¾ in. (42 × 48 cm). Private collection.

La Cueillette des oranges (Orange Picking), 1889.
Oil on canvas, 25 ½ × 19 ¼ in. (65 × 49 cm). Private collection, Switzerland. Courtesy,
Fondation Pierre Gianadda, Martigny.

After the death of her mother, Julie Manet offered this canvas to her tutor,
Stéphane Mallarmé, who had just penned the preface to her 1896 exhibition.

Arbre roux au bois de Boulogne (Red Tree in the Bois de Boulogne), 1888.
Watercolor, 11 × 7 ½ in. (28 × 19 cm). Private collection.

*This tree inspired a drypoint print that Berthe Morisot made for
an edition of* Le Nénuphar blanc (The White Water Lily) *by Mallarmé that
was never actually published.*

Sous-bois en automne (Undergrowth in Autumn), 1894.
Oil on canvas, 17 × 13 in. (43 × 33 cm). Private collection, Paris.

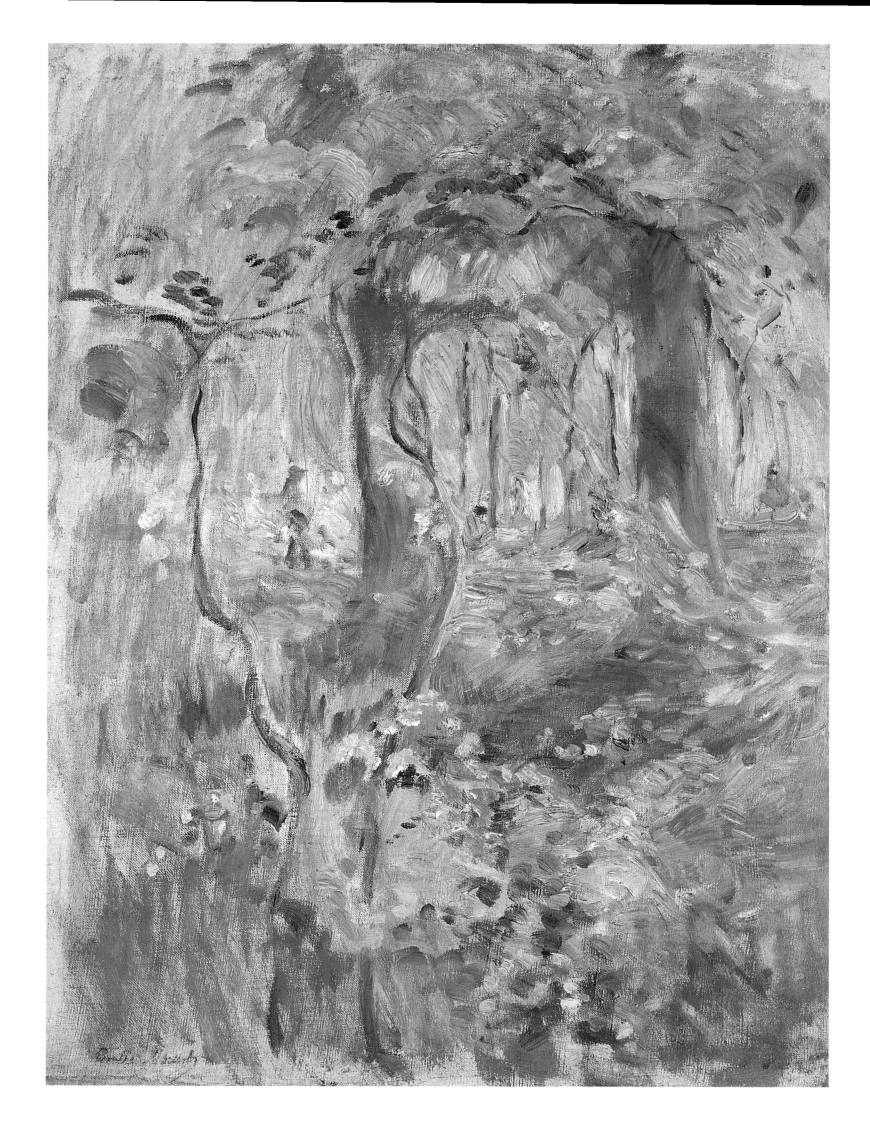

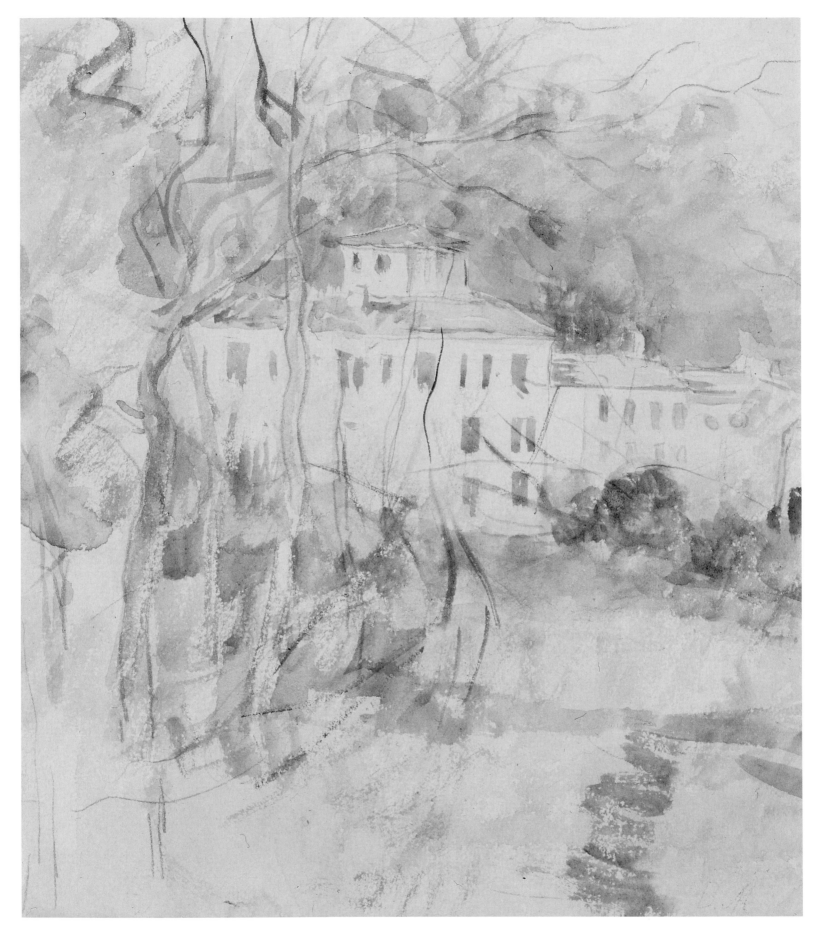

Villa dans les orangers (Villa with Orange Trees), 1882.
Watercolor. Private collection.

Villa dans les orangers, Nice (Villa with Orange Trees, Nice), 1882.
Oil on canvas, 21 ¾ × 17 in. (55 × 43 cm). Private collection.

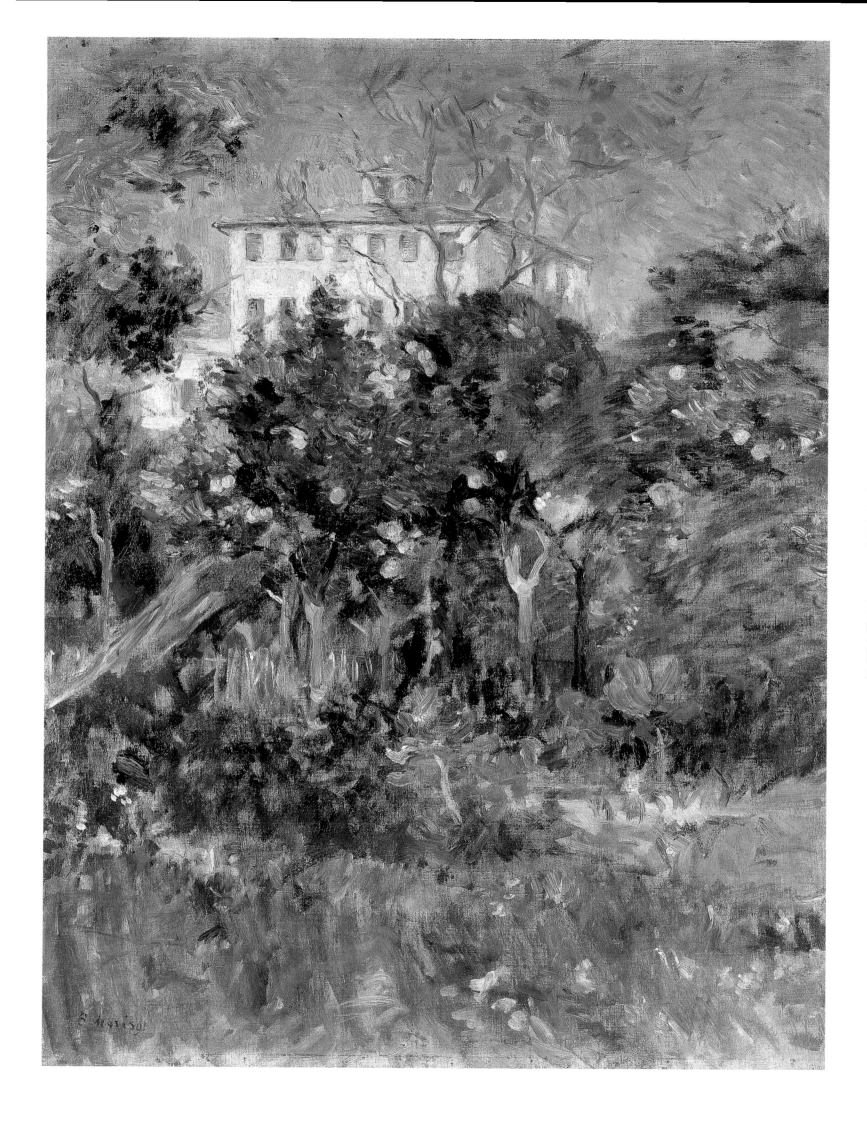

Study for **La Baigneuse (Bather), 1891.**
Red chalk drawing, 17 ¾ × 14 ½ in. (45 × 37 cm). Private collection.

La Baigneuse (Bather), 1891.
Oil on canvas, 21 ½ × 18 in. (54.5 × 45.5 cm). Private collection, Paris.

152

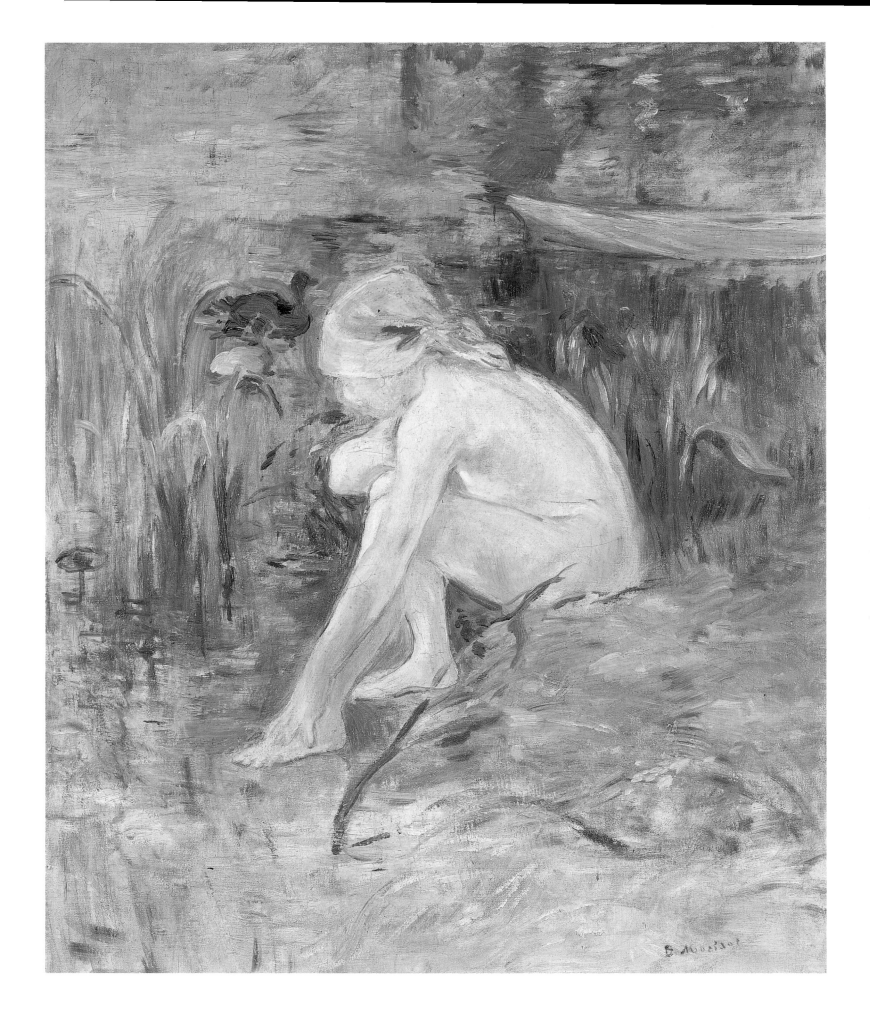

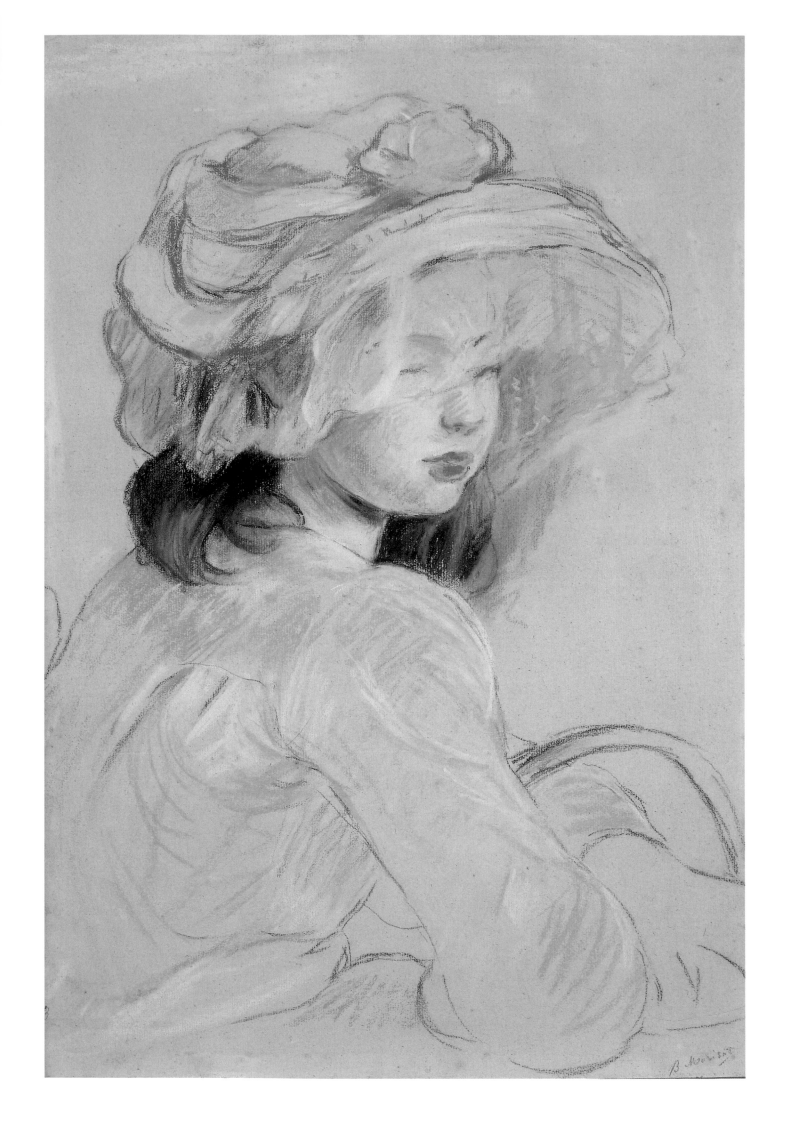

Pastels, Watercolors, and Drawings

As well as oil painting, Berthe Morisot excelled in the art of pastel, watercolor, and drawing. If Guichard made it known that she was the "leading watercolorist of her time," Philippe Burty compared her pastels to the work of the illustrious Rosalba Carriera. The 191 pastels and 240 watercolors she painted make up almost half of her oeuvre. The inventory of her drawings is yet to be completed, but they punctuate all her work and became particularly numerous in the last years of her life.

Jeune fille au panier (Girl Carrying a Basket), 1891.
Pastel, 22 ¾ × 16 ¼ in. (58 × 41 cm). Musée Marmottan Monet, Paris.

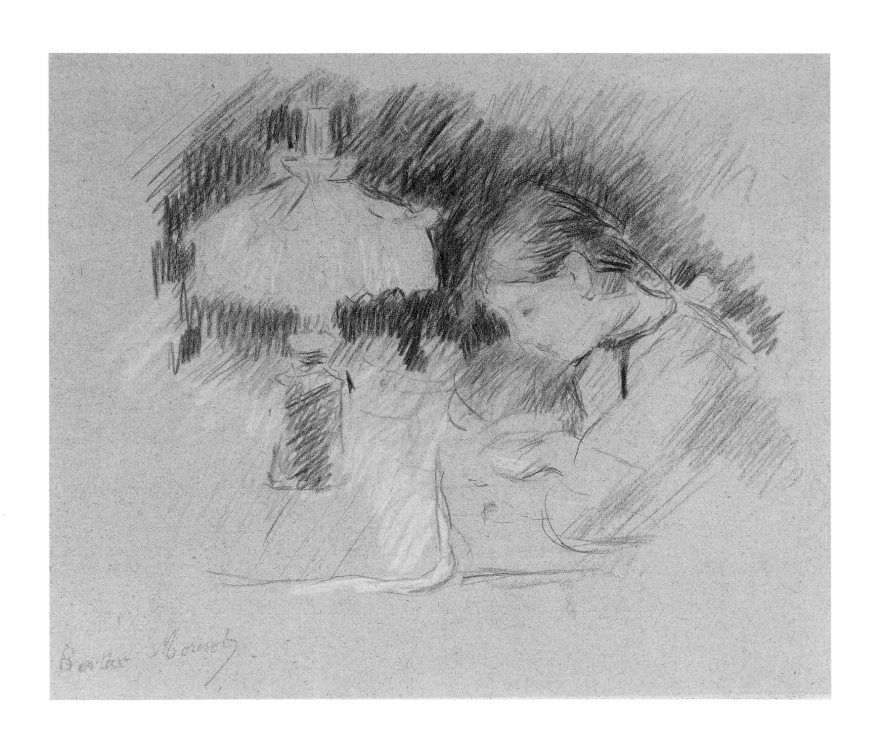

Le Travail à la lampe (Work by Lamplight), undated.
Pencil. Private collection. Paris.

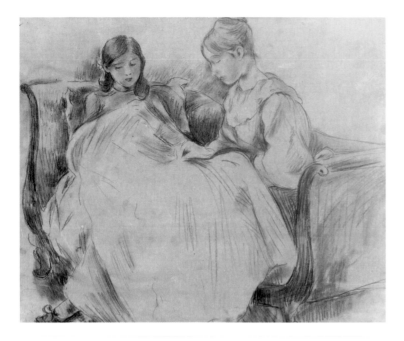

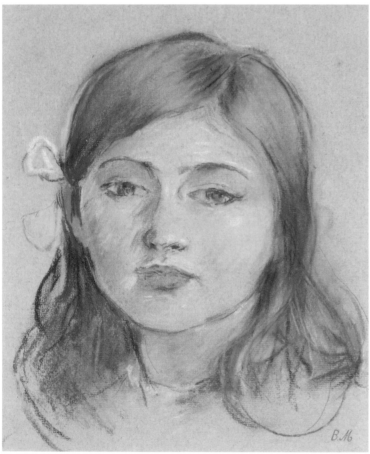

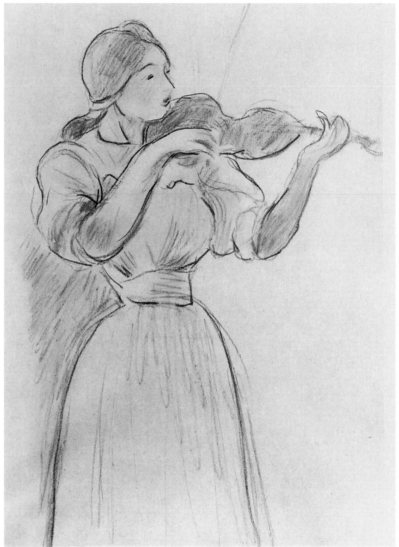

La Broderie (Needlework [Alice Gamby and Julie Manet]), 1889.
Lead pencil, 7 ½ × 8 ¾ in. (19 × 22 cm). Musée du Petit Palais, Paris.

Portrait de Julie (Portrait of Julie), 1889.
Pastel. Private collection, Paris.

Julie au violon (Julie Playing the Violin), 1893.
Red chalk, 15 ¼ × 11 in. (39 × 28 cm). Private collection.

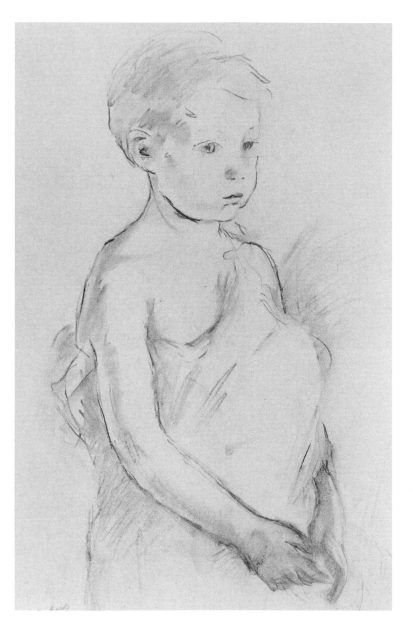

Le Petit Saint-Jean (The Little Saint John), 1890.
Pencil, 22 ¾ × 14 ¼ in. (58 × 36 cm). Private collection, Paris.

Page from a notebook, c. 1883.
*One of the first letters from Julie with sketches
by Berthe Morisot for* Jeune fille à la poupée
(Young Girl with a Doll).

Perroquet à la fenêtre (Parrot at the Window), 1889.
Color pencil on paper, 7 ½ × 8 ¼ in. (19 × 21 cm). Private collection.

Study for **Jeanne Pontillon, 1893.**
Pastel, 13 ¾ × 17 in. (35 × 43 cm). Private collection.

Study for **La Jeune Femme au repos (Young Girl Resting), 1889.**
Pencil, 18 ½ x 24 ½ in. (47 x 62 cm). Private collection.

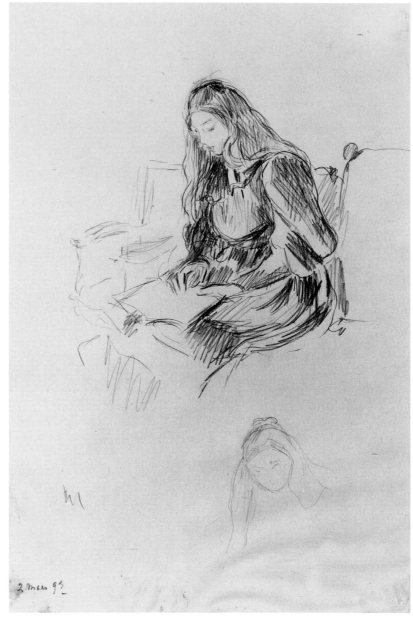

Les Aloès à Cimiez (The Aloes at Cimiez), 1889.
Lead pencil, 11 ½ x 9 in. (29 x 23 cm). Private collection, Paris.

Julie Manet lisant (Julie Manet Reading), 1892.
Pencil, 13 ¾ x 8 ¾ in. (35 x 22.5 cm). Private collection. Paris.

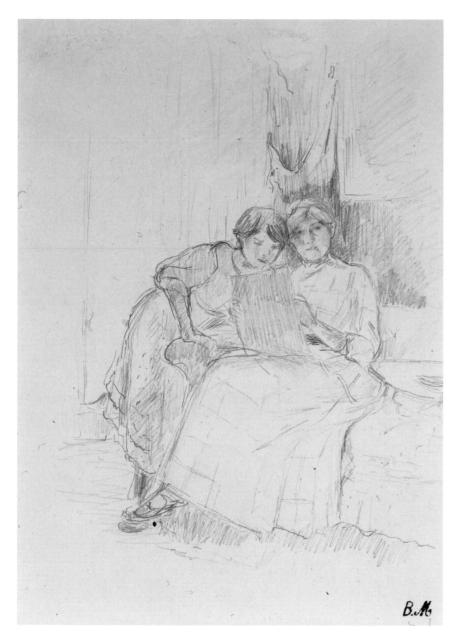

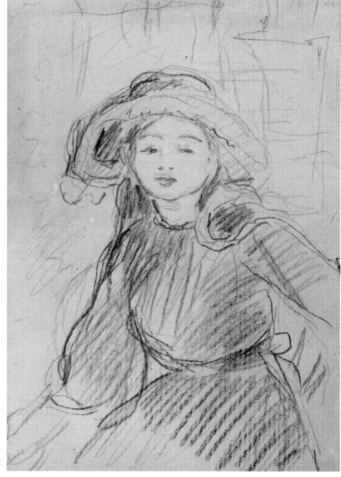

Portrait de Berthe Morisot et de sa fille Julie or
La Leçon de dessin (Berthe Morisot Drawing, with her Daughter), 1887.
Lead pencil, 10 ¼ × 7 ½ in. (26 × 19 cm). Private collection, Paris.

Julie enfant au chapeau (The Child Julie with Hat), undated.
Pencil, 6 × 4 ¼ in. (15 × 11 cm). Private collection, Paris.

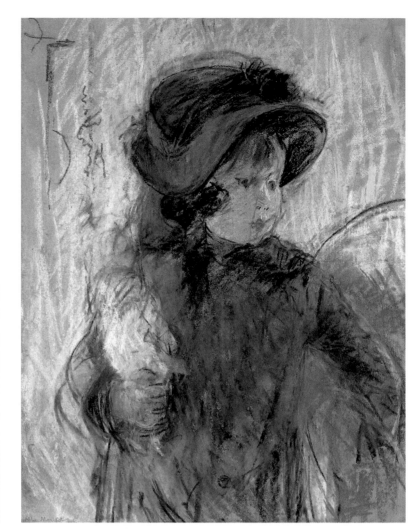

Intérieur à Jersey (Interior at Jersey), 1886.
Pastel, 15 ¾ × 23 ½ in. (40 × 60 cm). Private collection.

Petite fille avec sa poupée (Little Girl and her Doll), 1883.
Pastel, 23 ¾ × 18 in. (60 × 46 cm). Private collection.

La chaise de jardin (The Garden Chair), 1885.
Pastel, 15 ¾ × 19 ¾ in. (40 × 50 cm). Private collection, Paris.

Jeune fille en jersey bleu (Young Woman in a Blue Blouse), 1886.
Pastel on canvas. 39 ¼ × 32 in. (100 × 81 cm). Musée Marmottan Monet, Paris.

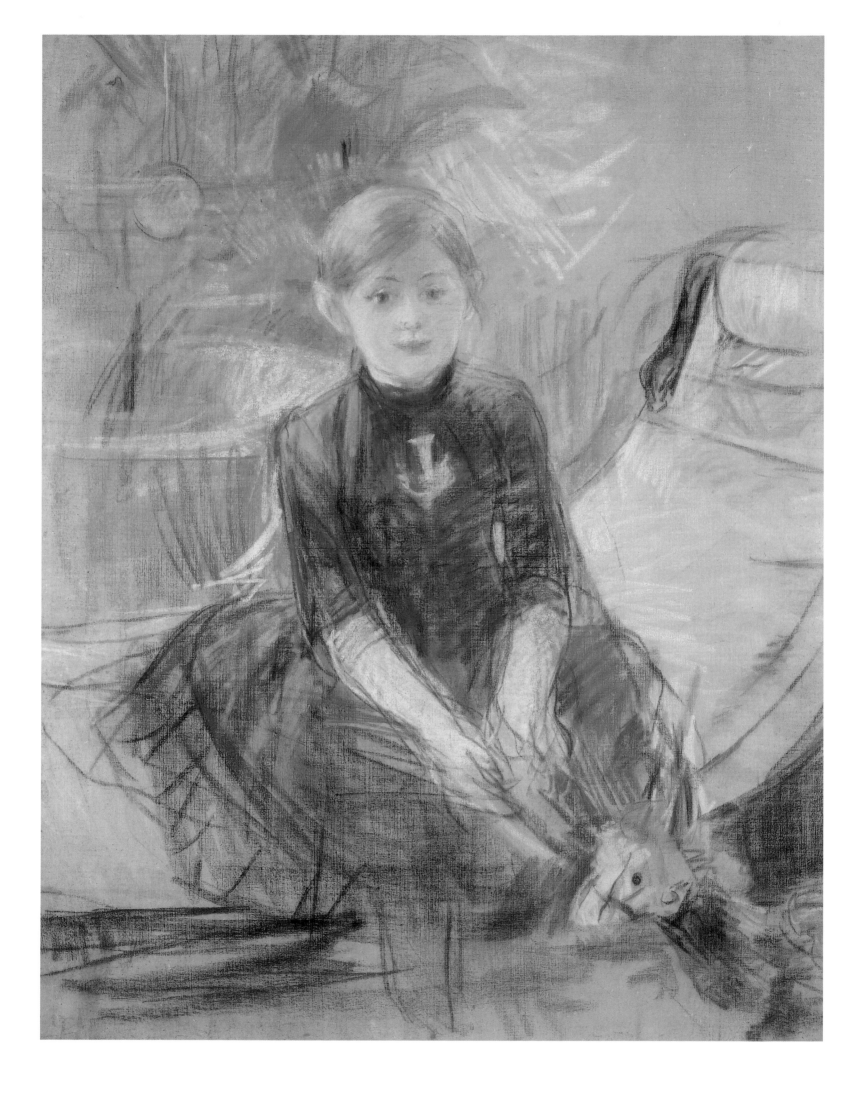

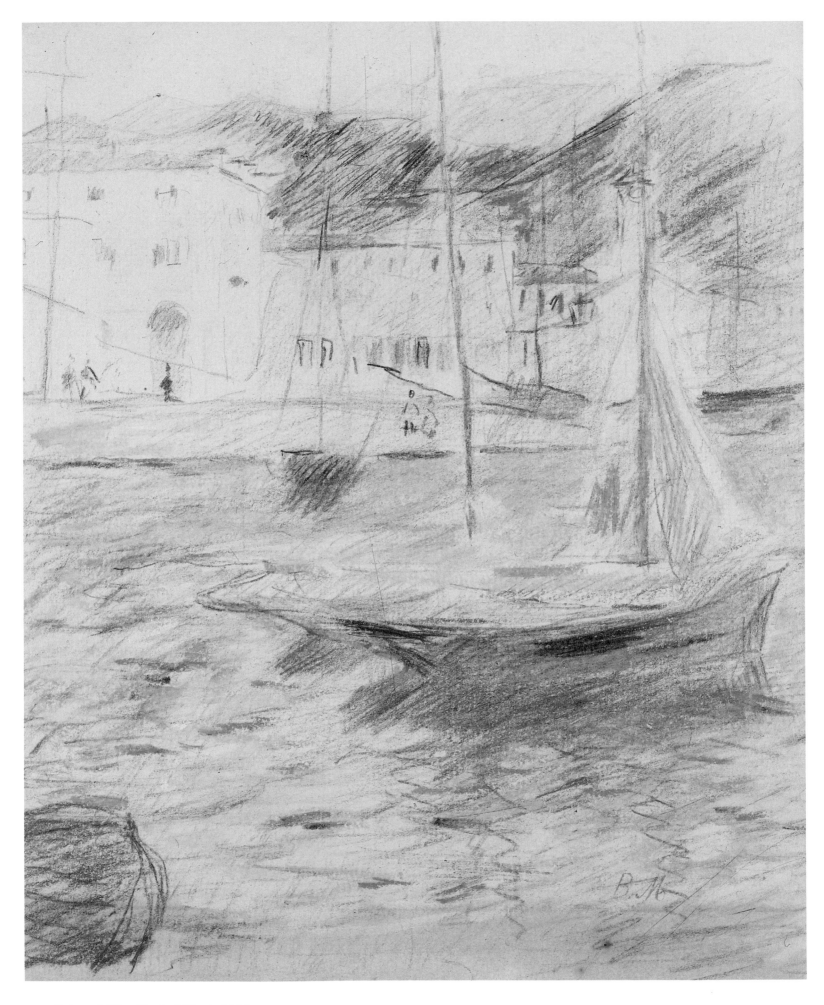

Bateau à Nice (Boat at Nice), 1881.
Pastel, 11 ½ × 8 ¾ in. (29 × 22 cm). Private collection.

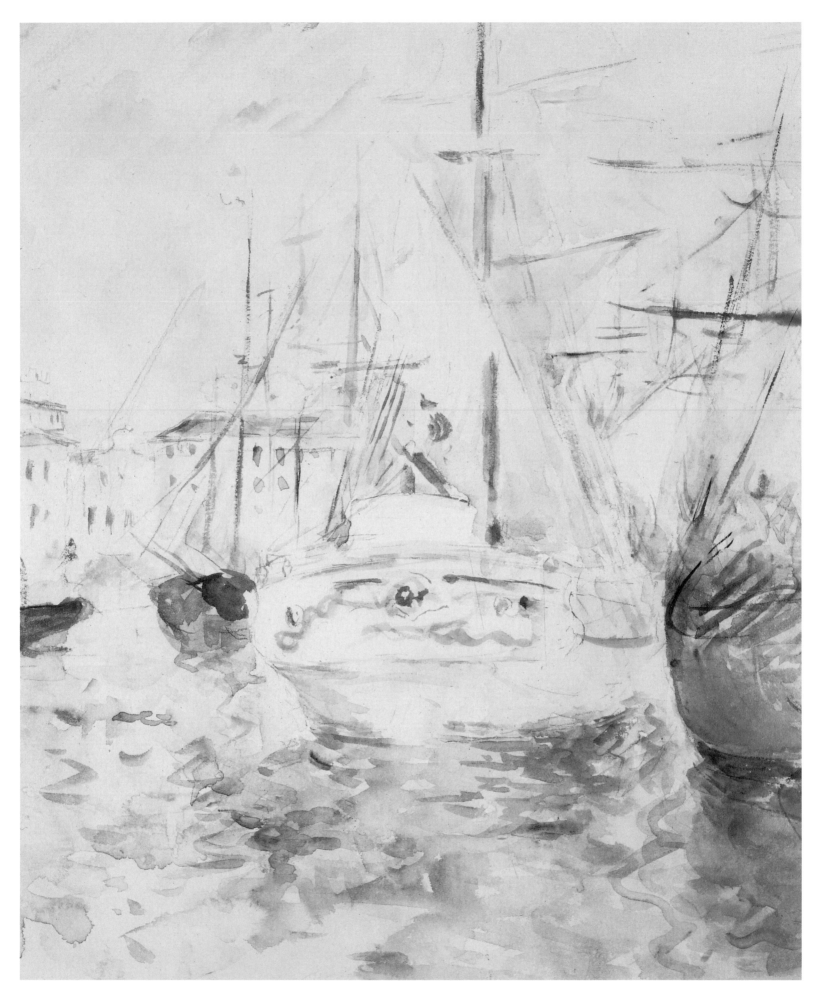

Le Bateau blanc (The White Boat), 1881.
Watercolor, 9 ½ × 7 ¾ in. (24 × 20 cm). Private collection.

Promenade au Bois de Boulogne (Walk in the Bois de Boulogne), c. 1886.
Watercolor, 9 ½ × 7 ¾ in. (24 × 20 cm). Private collection.

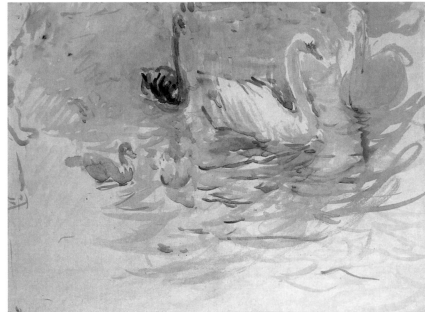

Gorey, 1886.
Watercolor, 6 ¾ × 9 ½ in. (17 × 24 cm). Private collection.

Julie et son bateau (Julie and Her Boat), 1884.
Watercolor. Private collection.

Cygnes (Swans), c. 1887.
Watercolor, 7 ½ × 10 ¼ in. (19 × 26 cm). Private collection.

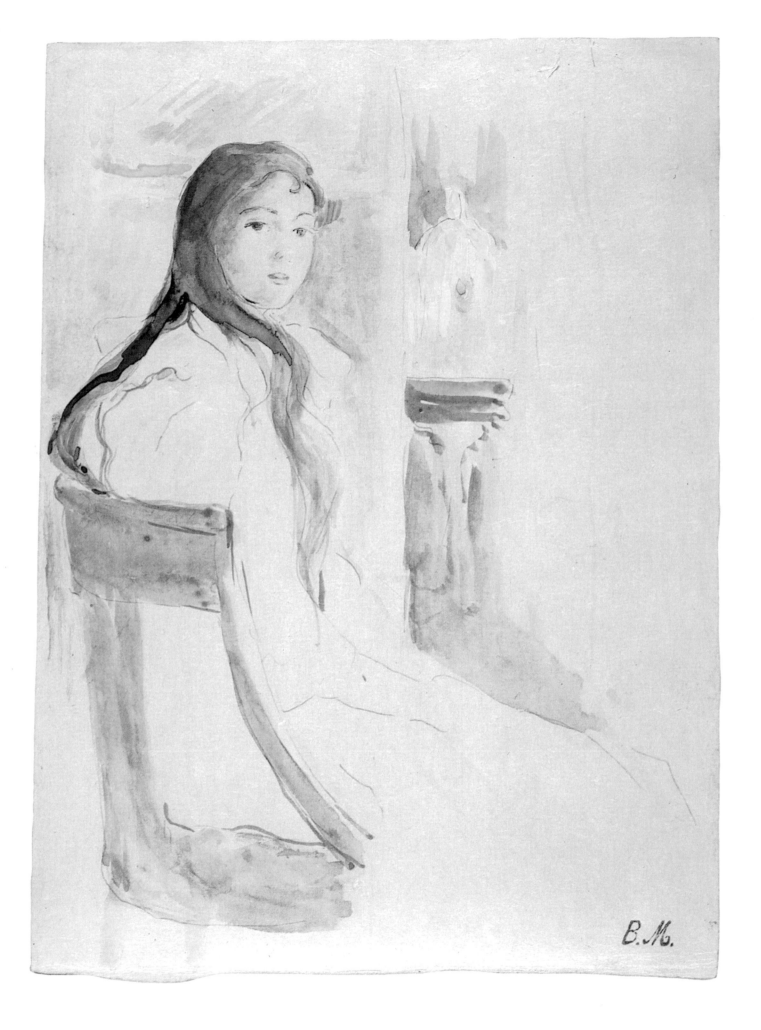

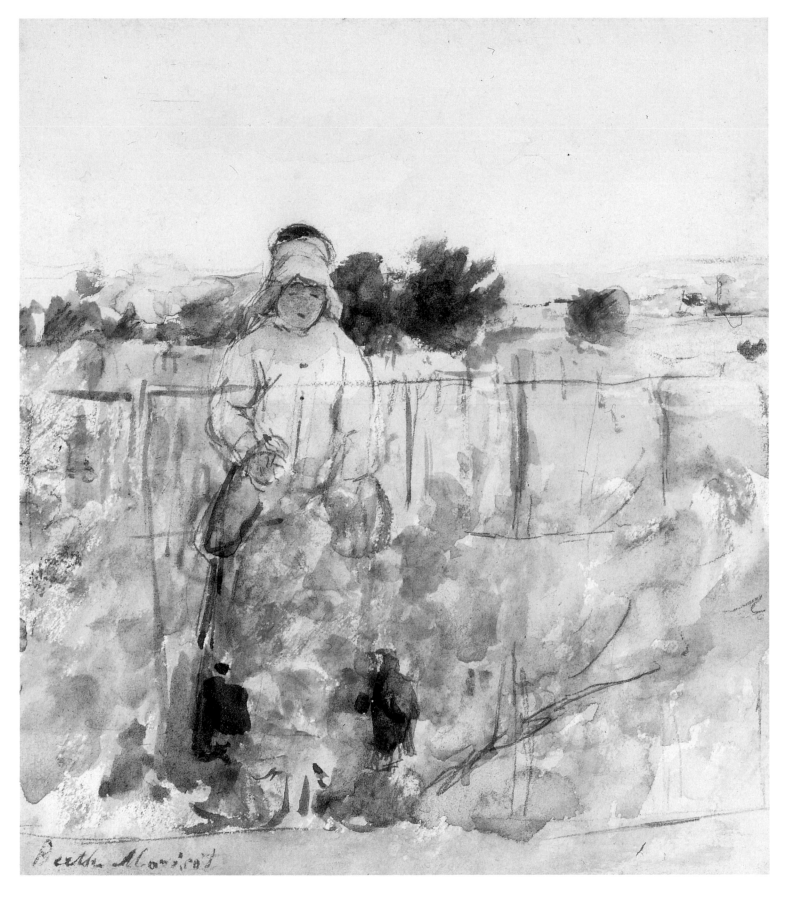

Modèle assis (Model seated), 1894.
Watercolor and pencil on paper, 9 x 6 ½ in. (23 x 16.8 cm).
Philadelphia Museum of Art. Louis E. Stern Collection.

Paysanne à Gennevilliers (Peasant Woman at Gennevilliers), 1875.
Watercolor. Private collection.

*Several months after getting married in 1875, Berthe Morisot stayed
at Gennevilliers, a family property of the Manets, and painted a stunning
series of watercolors.*

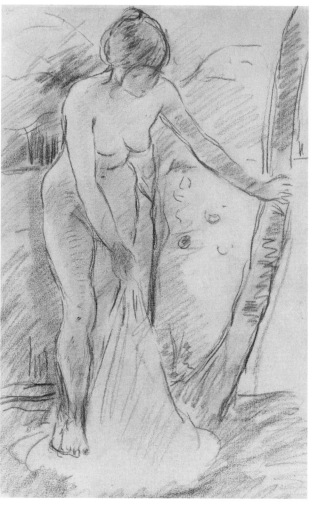

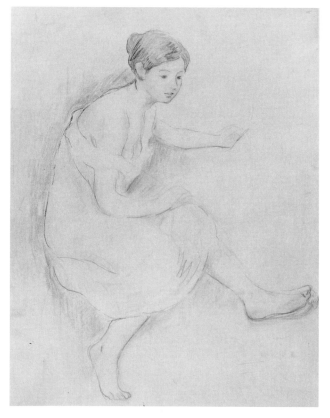

La Bergère nue couchée (Naked Shepherdess Lying on the Ground), 1891.
Pencil. Private collection, Paris.

Baigneuse en chemise (Bather in a Blouse), 1894.
Drawing highlighted in red chalk, 22 × 17 ½ in. (56 × 44.5 cm). Private collection.

Baigneuse debout: étude de Nu (Standing Bather), 1888.
Red chalk, 18 ½ × 11 ¾ in. (47 × 30 cm). Private collection, Paris.

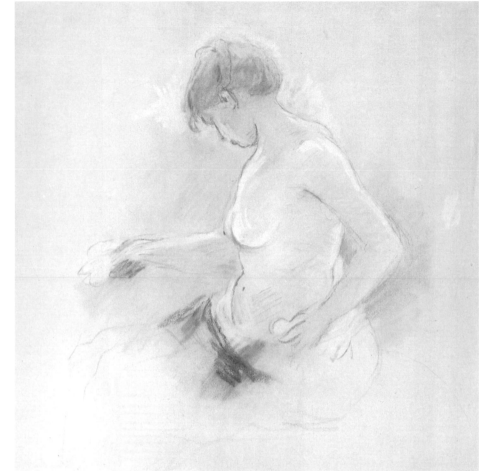

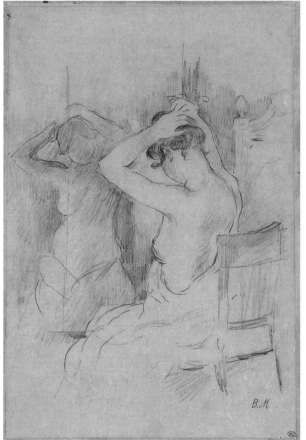

**Femme demi-nue de dos, se coiffant devant une glace
(Semi-nude Woman from Behind, Pinning up Her Hair
in a Looking Glass), undated.**
Lead pencil, 12 × 8 ¼ in. (30.5 × 20.7 cm). Musée du Louvre, Paris.

Jeune fille se séchant (Young Girl Drying Herself), 1886–87.
Pastel, 16 ½ × 16 ¼ in. (42 × 41 cm). Private collection.

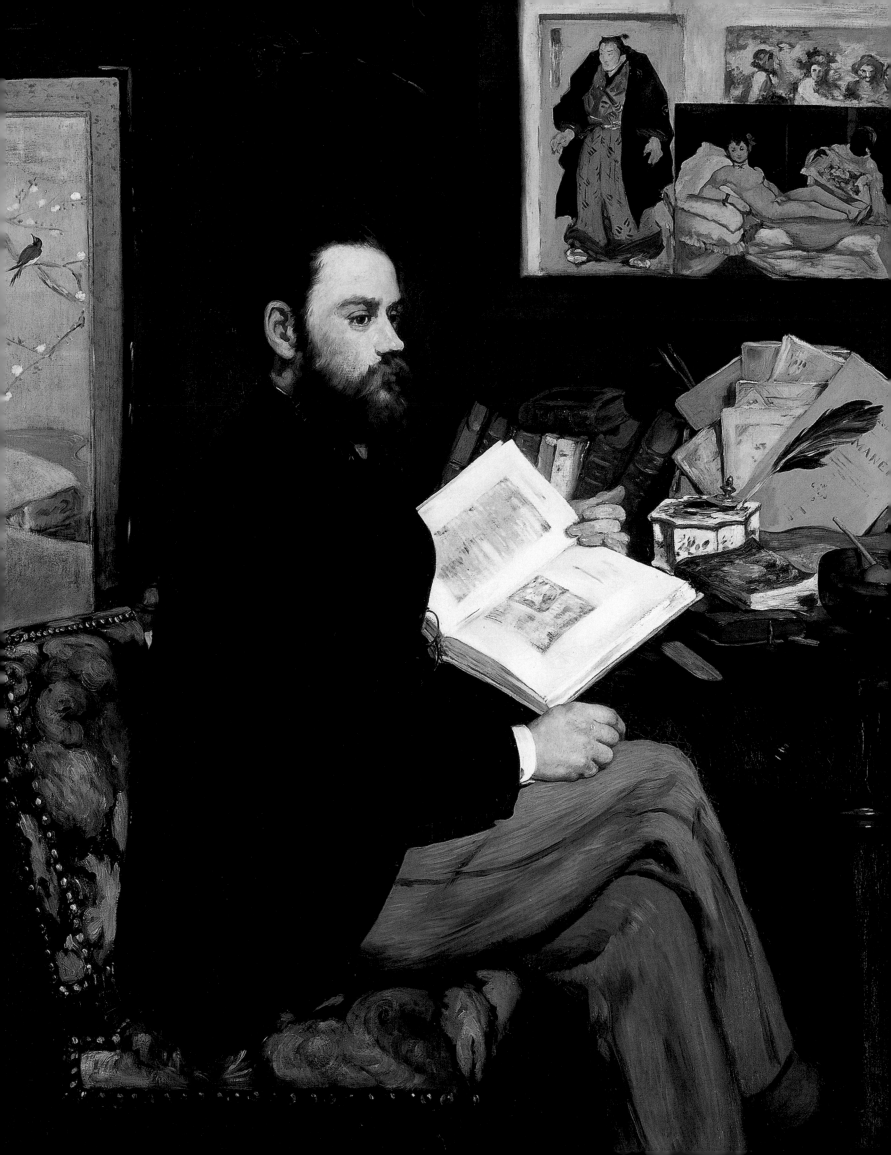

Writers in Morisot's Circle

Jean-Dominique Rey

Poets and musicians inhabit the world of sound, while painting finds extension in the written word. The writer finds in painting his echo, sometimes his metaphors, possibly the source of his descriptions or, better, of his evocations.

Due to her untimely death just as impressionism was beginning to gain recognition, Berthe Morisot's achievements remained—for a long time—little appreciated; but now her oeuvre has been celebrated by a constellation of writers, following its early success among her contemporaries. Her work is pure painting, and this is itself one of the possible definitions of impressionism, and might explain its appeal for writers. Morisot's work, like that of the impressionists as a whole, stands (albeit at some distance) between two major movements whose influence suffused the art world of the late nineteenth and early twentieth centuries: naturalism and symbolism. Can we imagine today a writer devoting a three-hundred-page work to the Paris Salon, to appear first in serial form, and then in a hardback edition published by Hachette in the same year? And yet, in 1864, this was what Edmond About did—he was the first in a long line of writers to discuss the work of Berthe Morisot, in conjunction with her sister Edma: "I will just mention quickly the pretty little sketches by Mesdemoiselles Berthe and Edma Morisot." Despite its occasional connivance with impressionism, naturalism seems utterly opposed to the poetic climate of Morisot's paintings. Yet it was Émile Zola who succeeded in defining Berthe Morisot's works with intelligence and delicacy over a number of years. At the Salon of 1868, he too noticed the sisters' work:

ÉMILE ZOLA

I would also point out two landscapes by Mesdemoiselles Morisot—doubtless two sisters. Corot is sure to be their master. These canvases show a freshness and naïvety of expression and atmosphere that provided some respite from the suave, mean-minded work lapped up with such enthusiasm by the crowds. The artists must have painted these studies quite deliberately on the spot, determined to reproduce what they saw.

Édouard Manet
Émile Zola, 1868.
Oil on canvas, 57 ¾ × 45 in. (146.5 × 114 cm). Musée d'Orsay, Paris.

175

In 1876, Zola encountered Berthe Morisot once again, alone this time: "Mlle Berthe Morisot has small pictures whose notation rings exquisitely true. In particular, I would cite two or three seascapes of great finesse, and landscapes, women and children walking through fields of tall grass." And lastly this, written the following the year: "The *Psyché* and the *Young Woman at Her Toilet* are two veritable pearls, in which the grays and whites of the fabrics play a most delicate symphony. I also noticed two delicious watercolors by the artist."

Berthe Morisot's paintings were soon to arouse the interest of the poet whose work corresponds most closely to her own in mood, sensibility, and spirit, and with whom she formed a lifelong friendship—Stéphane Mallarmé. In 1876, in a long article about Manet and impressionism, Mallarmé devoted a number of paragraphs to Morisot, recognizing her work and expressing their shared sensibility, their ultimate poetic complicity:

STÉPHANE MALLARMÉ

Drawn more to rendering the appearance of things with marked economy of means, infusing them with the fresh charm of a feminine vision, Mlle Berthe Morisot succeeds marvelously in capturing the intimate presence of a modern woman or child, in the quintessential atmosphere of a beach or grassy lawn.

And later:

The air of anxiety, the blasé quality, the private sorrows that generally mark scenes of contemporary life are nowhere more noticeable by their absence than here. We feel as if the charming woman and child are completely unaware that their pose, adopted unconsciously to satisfy an innate need for beauty, is being perpetuated in this charming watercolor.

Everything is suggested rather than openly stated, shaped by lack or absence—that Mallarméan principle—but at the same time, the essential spirit of impressionism is captured.

In his more substantial preface of 1896, written just after Morisot's death, but condensing two decades of friendship and artistic exchange, Mallarmé inaugurates and develops a form of writing on art that was relatively little used at the time, stamped with the seal of his own unique style—a mix of subtle, beautifully coined

Stéphane Mallarmé at Rue de Rome, Paris, 1895.
Photograph from the period. Bibliothèque Nationale de France, Paris.

Valvins, Mercredi

Les dames Manet ont montré du flair, grâce au grand nez de Laërtes.
Quel temps! On vit chez soi, avec du feu, méditant à l'ironie des derniers beaux jours.
Je n'ai jamais été moins à Valvins, que depuis, du reste, que vous n'y êtes plus.
Le soir j'ai été frapper à l'auberge close et j'y suis retourné le lendemain matin,
doutant de tant d'aptitude fugitive. Elle ne m'a été avérée que le dimanche, chez les Siguarat;
où l'on ne parlait que des dames Manet, qui y ont fait sensation.
La dame Loint les avait rencontrées sur l'avenue du chemin de fer, en flagrant départ,
Julie avec une boîte à violon. Nous nous évadons de ces jours noirs, à notre tour,
au commencement de la semaine prochaine. Au revoir.
Je flaire que vous n'irez pas dans le Limousin, ni peut-être à Tours.

Bonne amitié des dames.

Valvins, Wednesday

The Manet ladies have demonstrated great intuition, thanks to Laertes' good nose.
What weather! We stay at home with the fire lit, meditating on the irony of the last fair days.
I've never been less present at Valvins since, indeed, you are no longer here. In the evening
I knocked at the door of the closed inn and I went back there the next morning, unable
to believe one could run away like that. It was only confirmed to me on the Sunday,
at the Siguarats, where we talked about nothing but the Manet ladies, who have created a sensation.
Madame Loint had met them on the railway avenue and caught them just as they were leaving,
Julie with her violin case. We will be escaping these dark days, in our turn, at the beginning of next week.
Good bye. I sense that you will not be going to Limousin, and perhaps not to Tours either.

Best regards from the ladies.

Letter from Stéphane Mallarmé, 1895.
Bibliothèque Nationale de France, Paris.

Chère Madame,
Tous mes regrets, à partager
avec Manet. Je voulais venir
vous voir jeudi dernier, mais j'ai été
souffrant ; ce sera pour jeudi
prochain. Mille compliments d'ici là,
sur ce papier qui, déployé,
vous donne le format du fameux
livre, avant que la verdure
ne passe ; à tout votre pardon
de mon retard.

Leur lévrier industrieux
Aux Dames Manet va remettre
– Côtes-du-Nord, à Portrieux
La Roche Plate – cette lettre

Dear Madam,
My sincere apologies to you
and to Manet. I wanted to come
and see you last Thursday but I was
sick; it will have to be next Thursday.
All my compliments to you on
this note, which, unfolded, takes
the format of that infamous book,
before summer turns to autumn.
Please excuse me for the delay.
Stéphane Mallarmé

Their industrious greyhound
To the Manet ladies, will deliver
—Côtes-du-Nord, Portrieux
La Roche Plate—this letter

formulae and more esoteric-seeming expressions. This is the ultimate, ideal match between a painted work and its formulation in poetry, losing nothing of the painterly approach; a finely detailed portrait, hewn from his personal memories—a text that says all there is to say, virtually impossible to summarize here, but which opens with a prediction—"[these paintings] may wait with a future smile"—and which is characterized by delightfully apt turns of phrase: "Paris knew her only slightly," or, "a touch of the eighteenth century, exalted by the present." The essence of Morisot's work is defined. She is "a great artist with nothing of the banal." Mallarmé celebrates the distinctive character of this "delightful Medusa," conjuring up works like *La Véranda* (*The Veranda*) before our very eyes: "And amid the Eldorado pink brick, suddenly the appearance of some carafe, dazzlingly of the daylight, while, multicolored, its rays are scattered in sea greens and joyous tapestries of vegetation."

Joris-Karl Huysmans introduces a quite different style—sometimes heavy, often coruscating (one of his favorite terms)—into the literature on Morisot's work. But while he was soon to portray the quintessential aesthete in his novel *À Rebours*, his naturalism and undeniably artistic temperament, his rigor, and practiced eye steered him toward a more measured, complimentary style on his visits to art exhibitions. In 1880, he compared Mary Cassatt and Berthe Morisot, with a clear preference for the former:

Mlle Cassatt has, nonetheless, a curious appeal, a special attraction: highly strung female nerves are acceptable in her painting, which is more balanced, more serene, wiser than that of Mlle Morizot [sic].... Left as oil sketches, the works exhibited by this artist are a pretty froth of pink and white....

JORIS-KARL HUYSMANS

Huysmans returns several times to the apparently improvised character of the works: "pretty dabs of color that animate and radiate from elegant female presences," although he admits Morisot has an eye "that enables her to seize the finest, most dilute nuances of color imprinted by bodies on the surrounding air," before attacking once again: "She confines herself to excessively summary improvisations, too often repeated."

Théodore Duret was the first historian of impressionism, writing in 1878. Jules Laforgue was its first theorist, although his text was not published until 1895, after his death, in *La Revue blanche*. The too-brief article asserts the primacy and independence of the eye, free from tactile illusions, and defines the impressionist eye as "the most advanced, that which has up to now captured and rendered

Letter from Stéphane Mallarmé to Berthe Morisot, December 12, 1887.
Private collection, Paris

Envelope of letter addressed by Stéphane Mallarmé to the "Manet ladies" with a coded note to the postman in the form of a quatrain.
Private collection, Paris.

the most complex combinations of nuanced colors." In Berlin, in 1881, in a letter to Charles Ephrussi, he evokes hours spent in the latter's company, surrounded by the works in his collection, and especially "by Berthe Morisot, a deep, cool woodland scene, a seated woman, her child, a black dog, a butterfly net"—a reference to the pastel *Sur la pelouse* (*On the Lawn*)—"and again by Morisot, a maid with her infant charge, blue, green, pink-white, sunshine."

Writer or critic? In the case of Félix Fénéon, we are tempted to answer "an eye, but what an eye!" Mallarmé awarded him the title of "lapidary critic," and Jean Paulhan enshrined him as *the* critic, in his eyes the one and only. Here he is:

FÉLIX FÉNÉON

Mme Berthe Morisot is all elegance: broad, bright, alert handling; feminine charm devoid of sentimentalism; and— despite the appearance of improvisation—rigorous, finely judged values. These young girls in the grass, at their morning toilet, dressing their hair, are exquisite works; these expeditious drawings and watercolors are a joy.

We shall now turn to painters who were also writers—not the least of whom is Odilon Redon, a wholehearted devotee of fantastical symbolism in his paintings, but who embraced a wider range in his writings. In 1880, a passage on Berthe Morisot brims with restraint and high praise:

ODILON REDON

It is to be feared that Berthe Morisot may have already given us the full measure of her talent; she is like a flower that has surrendered its perfume and faded, alas, like every exquisite, transient blossoming. The only woman who showed, perhaps, a truly painterly quality. She has contributed a few charming, supremely distinguished notes to this concert of intransigents.... But she retains the imprint of an early artistic education that distinguishes her quite clearly, with Monsieur Degas, from this coterie of artists.... See these watercolors, so vividly produced, these extraordinarily subtle, feminine touches—underpinned by a suggestive, evocative line—that give her charming works a genuinely more refined accent, a more delicate expressive vocabulary than those of the others.

But for a bout of illness that prevented Huysmans from attending the Salon des XX in Brussels, in 1887, we might never have been granted a fine passage of writing by a great Belgian poet, deeply and actively involved in the artistic and literary life of France—the poet of the *Villes tentaculaires*, Émile Verhaeren:

ÉMILE VERHAEREN

Here is Mme Morisot, very modern, but who nonetheless evokes dreams of the charming art of the Fragonards, the Eisens, the Moreaux and Marilliers of this world—the mischievous, rather risqué art of the eighteenth century, that art of undress still beloved of collectors and refined, sensitive souls. Some canvases have a slightly glassy appearance, but what nonchalant grace, what lively improvisation in the brushwork! *Rising* rests on delightful, ultra-feminine qualities of execution. Like a conversation, or rather a babbling of the brush, and we come away charmed by the painter's spirit and intimate quality.

Verhaeren was one of the first to note the presence of the eighteenth-century painterly tradition in the work of Berthe Morisot. And *Le Lever* (*Rising*) won unanimous approval. This superb painting is well worth the praise it received from a writer who was soon to achieve great fame, who had recently decamped with all guns blazing from the defense of the accepted order to the defense of anarchy: Octave Mirbeau. Writing in *La France* on May 21, 1886, he noted: "A few strokes of the brush, two, three pale touches of watercolor wash, and we are filled with emotion, dreaming.... The portraits of young girls, and above all *Rising* have an enigmatic quality."

Before Mallarmé and his text of 1896, the catalog for Morisot's only solo exhibition during her lifetime was prefaced by Gustave Geffroy, a novelist and journalist, soon to be the biographer of Monet and Rodin. His introduction perfectly captures the quality of Morisot's depiction of light: "[It] seems to break as if by force through a limpid crystal glass or block of ice. It retains its tender blue, and its green embers, it acquires a fragile brilliance, it radiates with fresh palpitations, shimmering and sparkling."

Indeed, her distinctive handling of light emerges as the central theme of the preface: "The whole canvas is phosphorescent with the great brilliance of marine light pouring in from outside... this clear brilliance that traverses the walls, harmonizes the colors, animates vague forms with strange life, is rediscovered wherever Mme Berthe Morisot has left her personal mark."

Following pages:
Julie Manet, Jeannie Valéry, Stéphane Mallarmé, Paule Gobillard, and in the foreground, Geneviève and Madame Mallarmé, c. 1897.
Photograph from the period. Private collection, Paris.
Mallarmé, Julie Manet's guardian, often had her to stay at Valvins with her cousins.

And Geffroy concludes: "a delicious art of hallucination and vaguely fantastical reality, evoking the brilliant shades in the light of the forest, pure crystal," before going on to define Morisot's art as "the painting of reality observed and living—delicate, lightly brushed, utterly present."

In 1896 Thadée Natanson, editor-in-chief of *La Revue blanche*, journalist and collector, acknowledged that "she fixes the essence of fragility on her canvas, without stiffening or overloading. Her wizardry allows her to paint whatever is powder-fine, whatever sparkles, or blurs, or flows, whatever is mobile and light, without transfixing it." And again, "scattered across a few hundred canvases and works, this is the very flowering of the art of painting, silvery and iridescent."

The French writer and critic Georges Lecomte seems a very distant figure today. But this friend of Fénéon, a committed anarchist but (later) a member of the Académie Française, was the editorial director of the review *La Cravache*, an organ of the anarchist movement, to whose columns he invited both Huysmans and Fénéon to contribute. The opening of his text, devoted to Berthe Morisot, reads today like a classic anthology piece:

GEORGES LECOMTE

Mme Morizot does not paint chlorotic petals on screens, nor does she ever assemble formless compositions of bazaar-stall japonaiseries: and it is not to her studio that the cicerones of officialdom bring traveling grand dukes, exiled kings, and fallen highnesses. The artist in no way seeks to compete with operettists or sporting celebrities for their status as august curiosities.

But what follows is a better definition of the artist: "Conscious of the natural rhythms of lines and colors, she strives to recreate them without forcing the manner natural to her feminine temperament. Her work shows no violence, harsh bitterness, or easy vigor.... Mme Morizot is concerned with what lies beyond mere impressions; she paints the intimate life of beings and things."

Polyglot and Wagnerian, described by his friend Fénéon as a "Montmartre Oblomovist," Théodore de Wyzewa was introduced to Morisot by Mallarmé. A brilliant conversationalist and perceptive critic, he became a regular guest at the Morisots' Thursday dinners, with Renoir, Degas, and Mallarmé. His intelligence shines through his definition of Morisot's art: "To have consented to look at things with her own eyes is the first of Mme Berthe Morisot's merits.... But she knows, too, how to express her personal vision with the fittest, most perfectly adapted expressive means."

He does not hesitate to suggest that "only a woman could be permitted to apply the impressionist system to its most rigorous extreme... redeeming the invariably superficial aspect [of her impressions] with incomparable charm, gentility, refinement, and grace."

Throughout his life, he continually stressed that Morisot's "impressions" were those of "the eye most gifted to perceive them, most refined, most assured, and most practiced."

As may be seen, misogyny was not automatically de rigueur in the intellectual circles of the late nineteenth and early twentieth century. We should remember, too, that at the very same moment, writers connected with the anarchist movement supported the pictorial and painterly revolution led by the impressionists. Wyzewa continues (writing in 1903): "Mme Morisot is still almost completely unknown. The public barely recognizes her name."

Mauclair was a singular contemporary figure, gifted with the striking birth name Séverin Faust, which he later changed. A close associate of Mallarmé—whose daughter he hoped to marry and to whom he devoted a passably fine novel, *Le Soleil des morts*—he served as tutor to Julie Manet for a time, and took a close interest in impressionism, but his reputation foundered in the 1930s and (especially) 1940s, when he published a succession of uninformed vilifications of modern movements in art, notably *La Farce de l'art vivant* (1929–30). What matters here is his role, after Duret, as one of the first historians of impressionism. Of Morisot, he wrote that she would "remain the most fascinating figure of impressionism—the one who stated most precisely the femininity of this luminous and iridescent art," adding that "as great-granddaughter of Fragonard, Berthe Morisot... seemed to have inherited from her famous ancestor his French gracefulness, his spirited elegance, his svelte handling, his expert improvisation and spontaneity." And he rightly observes:

It is a woman's work, but it has a strength, a freedom of touch, and an originality which one would hardly have expected. Her watercolors, particularly, belong to a superior art: some notes of color suffice to indicate sky, sea, or a forest background, and everything shows a sure and masterly fancy for which our time can offer no analogy.

CAMILLE MAUCLAIR

There could hardly be two more contrasting personalities than Camille Mauclair and Guillaume Apollinaire. The latter gradually became a figurehead for the most

progressive modern movements in literature and art, inventing the term "surrealism," although he did not live to see it flourish. In 1912, under the somewhat provocative title "Les Peintresses" ("the *paintresses*"), Apollinaire wrote a column in the review *Le Petit Bleu*:

GUILLAUME APPOLINAIRE

It was in the nineteenth century that several veritable personalities began to emerge in France: such as Rosa Bonheur, Louise Abbema, Berthe Morisot, all three of whom have had some influence on painting, the last-mentioned being one of the most complete artists of her day, whose works are sure to last.

With Jacques-Émile Blanche—a renowned painter and portraitist whose love of society life somewhat curtailed his talent, although he was a capable memoirist—we are in the presence of a painter and writer who succeeded in evoking Berthe Morisot "from the life," with a portraitist's eye. In "Les Dames de la Grande Rue," a kind of verse letter addressed to Julie Manet in around 1919, he describes Berthe in the years before her marriage, when he would come across her in the streets of Passy, "a box of watercolors and a sketch block under her arm... her curious dress, always in black and white, her dark, burning eyes, her slender, angular, pale face, her quick, nervous, staccato speech," quickly adding: "Beneath her distant, cool manner, she was all energy, love, and passion." He is without doubt one of the few people to have watched her paint, and to have described the experience:

JACQUES-ÉMILE BLANCHE

Before my eyes, she made a charming portrait of Mlle Marguerite Carré in a pink dress, pale pink, the whole canvas was pale. Berthe Morisot was already very much herself, eliminating shadows and half-tones from the natural scene.... She touched her canvas like the bloom of a cheek, treating a millstone, a suburban poplar tree, a mouth, or a tulle scarf all alike.

Blanche was one of the first, and the very few, to identify Morisot's contribution to the work of others in the impressionist group:

I should like to believe that she perhaps suggested, to Claude Monet or Sisley, that a Parisian view or the landscape around Paris, a garden, a railway bridge, poppies

in a pale field of oats [...] were painterly motifs, and it seems that she sometimes furnished the models for the female figures in straw hats and bright skirts who ultimately replaced the peasant girls and woodlanders in the impressionist landscape.

Lastly, he gives a precise description of her studio and its orientation toward the light, reflecting the distinctive qualities of her painting:

She wanted it not facing north, but full south: the light is diffused through cream-coloured blinds; there is not a dark corner to be seen. The daffodils, tulips, and peonies in vases stand out against a bright background, with their transparent flesh, the flat, uniform modeling of objects and faces before a window. Lighting such as this reputedly drains a scene of color; but I do not believe that before Berthe Morisot, any artist deliberately, invariably painted in the absence of effect—by which I mean suppressing the oppositions of shade and half-tones and choosing to highlight a figure by the apposition of color of the same bright value.

Valery Larbaud was a multifaceted writer, the creator of the fictional poet, A. O. Barnabooth (a sensitive, millionaire traveler and aesthete), and the author of *Enfantines* and *Fermina Márquez*. It is perhaps in the latter guise that he found himself seduced by the work of Berthe Morisot. In a "Letter from Paris" written in 1914, Larbaud talks of the "innocent company of charming young girls painted by Berthe Morisot…," noting that "these portraits of children are, without doubt, the best part, the most original part of her work." And concluding: "We do not tire of contemplating such bright faces, such innocent eyes. In them the beauty and joy of morning and light find an intimate expression or feeling."

A skilled juggler and ambivalent provocateur, fascinated by the avant-garde, Jean Cocteau dated an article on Berthe Morisot to the nonexistent day of June 31, 1919. The piece attempts to picture what women painters are, what they can be, but sees only what its author wants to see—a pale reflection of the work of their male counterparts, paintings executed "with water from the watering can," although he does credit the works with their own "particular smile." Cocteau pictures "Mme Eugène Manet" as "a black-headed warbler sharpening her beak."

Other distinguished poets speak of Morisot in more apt terms, like Henri de Régnier, introduced to her by Mallarmé, and the author of what we might call a "looking-glass" portrait:

HENRI DE RÉGNIER

Tall and slim, with an extremely distinguished manner and mind.... Her face had retained its striking, enigmatic quality, its expression of quiet melancholy... she seemed aloof and distant, with an infinitely intimidating reserve... but her coolness also communicated a charm to which it was impossible to remain indifferent.... The tone of the house was, like its chatelaine's, discreet and reserved. Berthe Morisot listened more readily than she spoke, and her taciturn nature sometimes caused uncomfortable silences in the conversation.

Paul Valéry had only to walk up one flight of stairs to see the superb portrait of Berthe Morisot "with a bouquet of violets" painted by Manet. And at the same time, to take a look around the Morisot museum that was Julie Rouart's apartment. What better way to understand an artist's oeuvre than to live with it from day to day? Morisot's effusive canvas, *Le Cygne* (*The Swan*), hung in his office. His portrait of the artist proceeds in delicate touches: "her being... simple—pure—intimately, passionately hardworking, rather withdrawn, but elegantly so.... She was the rarest and most reserved of characters, the essence of distinction: comfortably, dangerously silent... she imposed an inexplicable distance... everything in her habits and looks spoke of careful *choice*." And Valéry was particularly keen to define her eyes: "Berthe Morisot inhabited her large eyes, whose extraordinarily attentive gaze and constant activity gave her that curious air, distant and distancing."

In 1941, he captured better still the figure of the artist, and her work, remembering "this woman who stood aloof," whose most striking feature was to "'live' her painting, and to paint her life, as if this was a natural and necessary function for her...." And of her painting he noted:

PAUL VALÉRY

It is made of nothing, a nothingness multiplied by the supreme art of her touch, the merest touch of mist, a hint of swans, the quick touch of a brush barely rubbing the fabric. This gentle brushing gives us everything: the

time of day, the season, and the knowledge, the promptitude which that confers, the great gift of reducing things to their essence, of lightening matter to the extreme and, through that, of taking the impression of the workings of the mind to its highest degree.

At the conclusion of this brief anthology, we are grateful to all of our writers for their service; those who, throughout Berthe Morisot's long years in limbo, were the "ferrymen" of her work: for contributing to reinstate her painting to its rightful place, and for their dedication to the continued assertion of its value.

Paul Valéry in 1926.
Private collection, Paris.

191

Appendices

Pierre-Auguste Renoir
Berthe Morisot et sa fille Julie Manet
(Berthe Morisot and her daughter Julie Manet), 1894.
Oil on canvas, 32 x 25 ¾ in. (81 × 65.5 cm). Private collection.

Illustrated Biography

1841

Birth, in Bourges, on January 14, of Berthe-Marie Pauline Morisot, third child of Edme-Tiburce Morisot and Marie-Cornélie, née Thomas. Her father was appointed prefect of the French department of Cher in 1840. Her two older sisters, Yves-Élisabeth and Edma, were born in 1838 and 1839, both in Valenciennes, where their father was sub-prefect.

1841–48

Edme-Tiburce Morisot is appointed prefect of the Haute-Vienne. Berthe spends her childhood in Limoges where she begins modeling in clay at an early age.
Tiburce Morisot is born, in 1848.

1849

The Morisot family settles in Caen.

1855

Berthe's father resigns and the Morisot family move to Rue des Moulins (now Rue Scheffer) in Passy. Berthe Morisot learns the piano with Camille-Marie Stamaty.

Berthe Morisot
Photograph from the period. Private collection, Paris.

Edme-Tiburce Morisot
Photograph from the period. Private collection, Paris.

1857

The three sisters, Yves, Edma, and Berthe, take their first drawing lessons with Geoffroy-Alphonse Chocarne on Rue de Lille, but are soon disappointed. Edma and Berthe continue their studies with a neighboring painter, Joseph Guichard, who is impressed by their talent and predicts they will "both become painters," taking them to the Louvre to study "before the Masters," copying Titian and Veronese. In 1859, Berthe paints *Ferme en Normandie* (*Farm in Normandy*), the first dated canvas in her catalog, earlier works having been destroyed by the artist herself.

1860–62

Confronted by the sisters' determination to paint in the open air, Guichard steps aside, telling them: "Now it's Corot you need!" The sisters continue working under the elderly master, in his studio, and out of doors at Ville d'Avray. Corot dines with the Morisot family every Tuesday evening.

1862

Edma and Berthe trek through the Pyrenees, riding on mules.

1863

Corot recommends the sisters to his disciple Achille Oudinot, with whom they paint in the countryside around Auvers-sur-Oise, meeting Charles Daubigny, Honoré Daumier, and Antoine Guillemet.

1864

The two sisters exhibit for the first time at the Salon: Berthe's painting *Vieux chemin à Auvers* (*Old Lane in Auvers*) is noticed by Edmond About. The Morisot family move to the painter Léon Riesener's house in Beuzeval for the summer. Through these new friends, Berthe meets Marcello, who makes a bust of her, and she works on sculpture in her own right, with Aimé Millet.

Edma Pontillon, née Morisot. Photograph from the period. Private collection, Paris.

Tiburce Morisot. Photograph from the period. Private collection, Paris.

Berthe Morisot. Photographs from the period. Private collection, Paris.

SOCIÉTÉ ANONYME

DES ARTISTES PEINTRES, SCULPTEURS, GRAVEURS, ETC.

PREMIÈRE

EXPOSITION

1874

35, Boulevard des Capucines, 35

CATALOGUE

Prix : 50 centimes

L'Exposition est ouverte du 15 avril au 15 mai 1874,
de 10 heures du matin à 6 h. du soir et de 8 h. à 10 heures du soir.
PRIX D'ENTRÉE : 1 FRANC

PARIS

IMPRIMERIE ALCAN-LÉVY

61, RUE DE LAFAYETTE

—

1874

1866–67

Visit to her sister Yves in Brittany, shortly after the latter's marriage to Théodore Gobillard, a tax inspector in Quimperlé. Berthe paints the river at Rosbras, near Pont-Aven.

1869

Her sister Edma gives up painting when she marries. Berthe stays with her in Lorient, painting portraits of her and their mother.

1868

Berthe meets Édouard Manet at the Louvre, through Fantin-Latour. Soon, she will pose for the celebrated *The Balcony*. At the Manets' home she meets Baudelaire, Cros, Zola, Chabrier, and Degas.

1871

Visits to Saint-Germain-en-Laye and Cherbourg.

1872

Berthe Morisot travels to Spain and Madrid with her sister Yves and the critic Zacharie Astruc.

Cover of the catalog of the first impressionnist exhibition in 1874.
Private collection, Paris.

Edgar Degas.
Photograph from the period. Private collection, Paris.

Édouard Manet.
Photograph from the period. Private collection, Paris.

Auguste Renoir.
Photograph from the period. Private collection, Paris.

1874

Death of her father, on January 24. On April 15, the impressionists open their first exhibition at Nadar's studio. Berthe Morisot shows four oils, including *Cache-cache* (*Hide and Seek*), two pastels, three watercolors. She marries Eugène Manet on December 22.

1875

Trips to Gennevilliers, Cowes on the Isle of Wight (returning with several new paintings), and London, where she meets James Tissot and makes studies of the Thames.

1876–77

Second impressionist exhibition, at Galerie Durand-Ruel: Berthe shows fifteen paintings, and five at the third exhibition.

1878

Birth of her daughter Julie, on November 14.

1879

Visit to Beuzeval.

1880

Fifth impressionist exhibition. Berthe Morisot shows ten paintings.

Edma Pontillon and her daughter.
Photograph from the period. Private collection, Paris.

Cover of the catalog of the exhibition of works by Morisot, Monet, Renoir, and Sisley, in 1875.

Julie Manet as a young girl.
Photograph from the period. Private collection, Paris.

Eugène Manet, Berthe Morisot, and their daughter Julie at Bougival around 1881.
Photograph from the period. Private collection, Paris.

1881

First visit to Bougival; trips to Nice and Italy.

1883

Death of Édouard Manet. Berthe moves to Rue de Villejust (now Rue Paul-Valéry). Impressionist exhibiton in London.

1884

Last visit to Bougival, where Berthe Morisot executes numerous paintings.

1885

A year of intense work. Travels to Belgium (Antwerp) and Holland, where she visits museums (Amsterdam, The Hague, Haarlem).

1886

Stays and works on the island of Jersey; shows eleven paintings at the eighth impressionist exhibtion.

1888

Stays at Villa Ratti in Cimiez.

1890

Settles in Mézy, in a house overlooking the Seine. Visits Monet in Giverny, accompanied by Stéphane Mallarmé.

Berthe, Julie, and her greyhound Laertes at Vassé
Photograph from the period. Private collection, Paris.

Paule Gobillard as a little girl.
Photograph from the period. Private collection, Paris.

Julie Manet at Vassé.
Photograph from the period. Private collection, Paris.

1891

From Mézy, where she paints
Le Cerisier (*The Cherry Tree*), Berthe
Morisot and her husband discover
and buy the house at Le Mesnil.

1892

Death of Eugène Manet on April 13.
In May, Morisot holds her first solo
exhibition, at Boussod et Valadon. The
catalog preface is by Gustave Geffroy.

1893

Moves to Rue Weber.
Her daughter Julie, Jeanne
Fourmanoir, and Lucie Léon serve
as her models.
Stays in Fontainebleau, from where
she visits Mallarmé and Alfred Sisley.

1894

Exhibits with the Libre Esthétique
groupe in Brussels.
Mallarmé arranges for Berthe's
painting *Jeune fille en toilette de bal*
(*Young Girl Dressed for a Ball*) to be
bought by the State. Visits Brittany,
traveling from Portrieux to Vannes
via Bréhat, Roscoff, and Brest.

1895

Berthe Morisot dies on March 2 after
a brief illness.

Auguste Renoir.
Photograph from the period. Private collection, Paris.

Julie Manet as a young girl.
Photograph from the period. Private collection, Paris.

Berthe Morisot at the end of her life.
Photographs from the period. Private collection, Paris.

Jeudi 2 Mars

Mon cher ami,

J'attendais une lettre de
pour vous écrire de nouveau
avec bien de l'impatience, car
vos deux dépêches me renseign...
mal, ou point, sur vous... enfin
de la recevoir ce soir avant le ...
Et me voici vous écrivant auss...
cette corvée terminée — Déli...
dans le lit de Guiguin et d...
dans son coin — elle est aus...
... elle ... possible depuis vo...

Correspondence

Paris, samedi

Ma chère Berthe,
Je viens d'avoir justement la visite du terrible Pissarro qui m'a parlé de votre exposition
prochaine. Ces messieurs n'ont pas l'airde s'entendre. Gauguin joue les dictateurs.
Sisley, que j'ai vu aussi voudrait savoir ce que doit faire Monet. Quan[d] à Renoir,
il n'est pas encore rentré à Paris.
Je suis étonné qu'Eugène ne se soit pas rappelé qu'il faisait très froid à Florence
nous y avons passé deux mois très froidementautrefois. Vous feriez bien à l'avenir
de ne pas trop effrayer ma mère avec la santé de Bibi cela la met dans des états effrayants.
Quand [sic] à moi, je me porte mieux depuis deux jours, j'ai mis de côté la canne.
Ce qui est une grande chose. Les affaires vont mal. Tous ces événements financiers ont un peu
touché tout le monde et la peinture s'en ressent.
Suzanne me charge de vous dire ses amitiés.
À vous
Édouard Manet

Pertuiset est à Nice au Grand Hôtel. C'est un homme très complaisant. Eugène peut aller le voir.

Letter from Édouard Manet to Berthe Morisot

Paris, Saturday

My dear Berthe,
I have indeed just received a visit from the dreaded Pissarro who spoke about
your next exhibition. The gentlemen don't seem to be able to agree. Gauguin is playing
the great dictator. Sisley, who—I also saw, would like to know what Monet should do.
As for Renoir, he hasn't yet returned to Paris.
I am surprised Eugène did not remember that it was very cold in Florence—
we shivered there for two months once before. You would do well in future not to
frighten my mother overly with Bibi's health, it puts her in a frightful state.
As for me, I have been feeling better for the past two days, I have put my walking
stick to one side. Which is something. Business is bad. All these financial events
have touched everyone to some extent, and painting is taking it hard.
Suzanne asks me to send her warm regards.
Yours,
Edouard Manet

Pertuiset is in Nice at the grand hotel; a very pleasant man. Eugène can go and see him.

Cowes, île de Wight

Cher Monsieur,

Édouard Manet m'a dit que vous aviez eu la gracieuseté d'apporter
l'esquisse que vous avez fait de lui.

Je n'ai pas eu le temps de vous en remercier avant de quitter Paris.
Je suis d'autant plus sensible à votre souvenir que j'attribue une grande
valeur à ce que vous faites. Mon mari et moi, en face de ces paysages
anglais si marins qui nous entourent, parlons souvent de votre talent
et du parti que vous sauriez tirer de ce mouvement [illegible].

Mille compliments, je vous prie, à Madame Monet et agréez, pour vous,
cher Monsieur, l'expression de mes meilleurs sentiments et tous mes
remerciements.

Berthe Manet

Cowes, Ile of Wight

Dear Sir,

Édouard Manet told me that you were kind enough to bring the sketch
that you completed of him.

I did not have the time to thank you before leaving Paris.
I treasure your gift all the more because I attribute much value
to what you do. My husband and I, when we look out at the English
seascapes which surround us, often speak of your talent and
what you will achieve from this movement.

My best compliments to Madame Monet and to you, dear Sir, please
accept my sincere regards and thanks.

Berthe Manet

Facing page: **Letter from Berthe Morisot to Claude Monet, summer 1875.**

Claude Monet
Photograph from the period. Private collection, Paris.

A descendant of Fragonard, Berthe Morisot nonetheless chose in 1884 to copy a painting by Boucher, *Venus at Vulcan's Forge*, of 1755, held at the Louvre. She intended this copy to be placed above the large mirror in her salon on Rue de Villejust whilst waiting for the painting that had been promised to her by Claude Monet, that "famous painting that will never arrive," he wrote to her in 1885.

Vénus va demander des armes à Vulcain (Venus at Vulcan's Forge), 1884.
Oil on canvas, 44 ¾ × 54 ¼ in. (114 × 138 cm). Private collection. Paris.

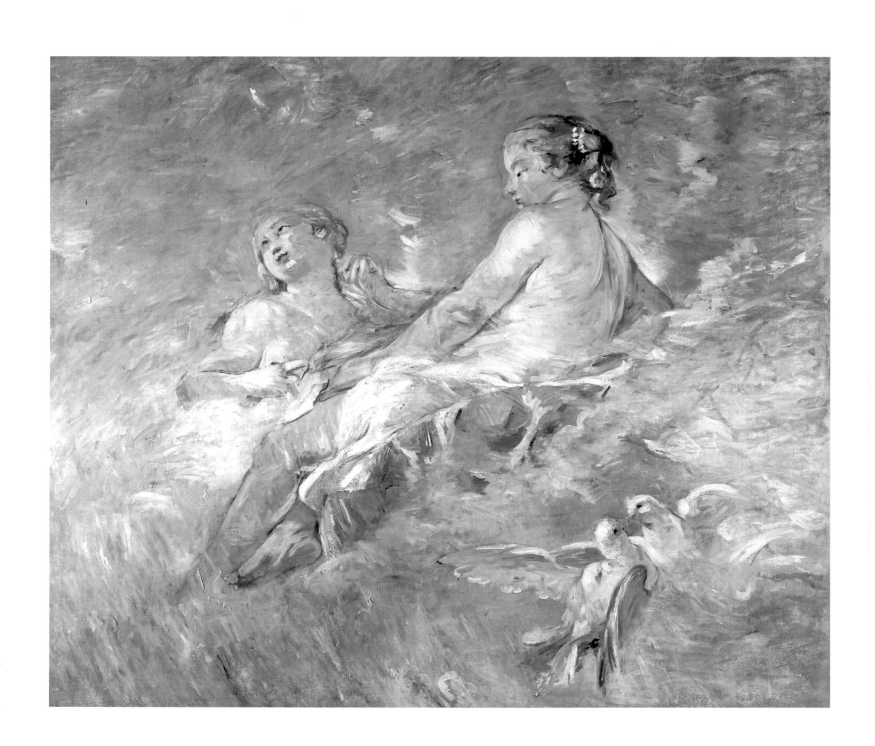

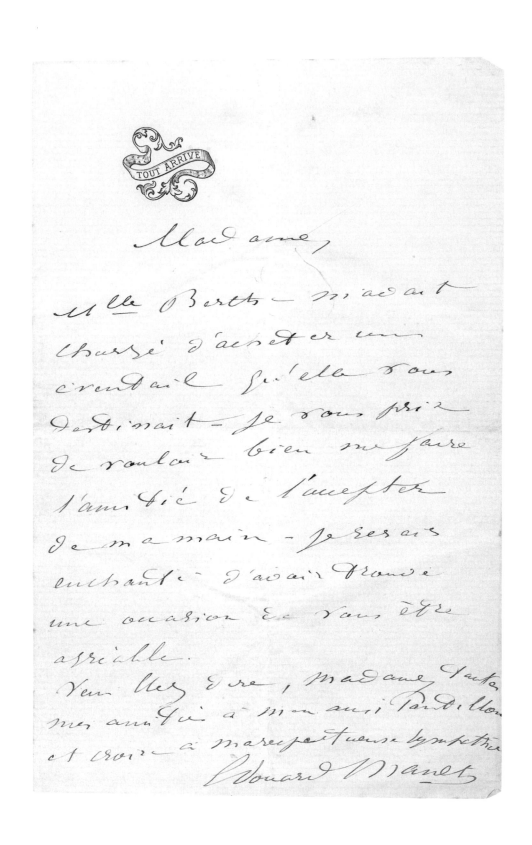

Madame,
Mlle Berthe m'avait chargé d'acheter un éventail
qu'elle vous destinait, je vous prie de vouloir bien me faire l'amitié
de l'accepter de ma main. Je serais enchanté d'avoir trouvé
une occasion de vous être agréable.
Veuillez dire, Madame, toutes mes amitiés à mon ami Pontillon
et croire à ma respectueuse sympathie.
Édouard Manet

Madam,
Mlle Berthe asked me to buy a fan that she intended for you,
will you be so kind as to accept it from me.
I would be delighted to find an opportunity to please you.
Please give my regards, Madam, to my friend Pontillon and
accept my best wishes.
Édouard Manet

Letter from Édouard Manet to Edma Pontillon.

Apporte ce livre, quand naît
Sur le Bois l'Aurore amaranthe,
Chez Madame Eugène Manet
Rue au loin Villejust, quarante

Take this book, when violet Dawn
Rises over the Wood
To the house of Madame Eugène Manet
To the road of far-away Villejust, number 40

Envelope of letter from Stéphane Mallarmé to Berthe Morisot, c. 1880. Private collection, Paris.

Ma petite Julie,

Je t'aime mourante, et je t'aimerai encore morte. Je t'en prie ne pleure pas,
cette séparation était inévitable, j'aurais voulu aller jusqu'à ton mariage –
travaille et sois bonne comme tu l'as toujours été, tu ne m'as pas donné
un chagrin dans ta petite vie. Tu as la beauté, la fortune, fais en bon usage.
Je crois que le mieux serait de vivre avec tes cousines rue de Villejust,
mais je ne t'impose rien. Tu donneras un souvenir de moi à ta tante Edma
et à tes cousines, à ton cousin Gabriel les bateaux en réparation de Monet.
Tu diras à M. Degas que s'il fonde son musée il choisira un Manet –
un souvenir à Monet à Renoir et un dessin de moi à Bartholomé.
Tu donneras aussi aux deux concierges.
Ne pleure pas je t'aime encore plus gaie je t'embrasse
Jeannie je te recommande Julie.

Last letter from Berthe Morisot to her daughter Julie.
Private collection, Paris.

*et un dessin de
moi à Bartholomé. Jeannie je te
Tu demeureras avec recommande
tes concierges
Ne pleure pas Julie
je t'aime encore
plus grande
J'emporte...*

My dearest Julie,

I love you as I lie dying; I shall still love you when I am dead. I beg of you, do not cry;
this parting was inevitable. I would have liked to be with you until you married…
Work hard and be good as you have always been; you have never caused me a moment's
sorrow in your little life. You have beauty, good fortune; use them well. I think the best
thing would be to live with your cousins in the Rue de Villejust, but I do not wish to force
you to do anything. Give a memento of me to your aunt Edma, and to your cousins too;
and give Monet's Bateaux en réparation to your cousin Gabriel. Tell M. Degas that
if he founds a museum he is to choose a Manet. A keepsake for Monet; one for Renoir,
and one of my drawings for Bartolomé. Give something to the two concierges.
Do not cry, I love you more than I can tell you
Jeannie, I commend Julie to your care.

Solo Exhibitions

1892
Paris, Galerie Boussod et Valadon
(catalog preface by Gustave Geffroy).

1896
Paris, Galerie Durand-Ruel
(catalog preface by Stéphane Mallarmé).

1902
Paris, Galerie Durand-Ruel.

1905
Paris, Galerie Eugène Druet.

1907
Paris, Salon d'Automne.

1919
Paris, Galerie Bernheim Jeune.

1922
Paris, Galerie Marcel–Bernheim.

1926
Paris, Galerie L. Dru (catalog preface
by Paul Valéry).

1929
Paris, Bernheim Jeune.

1930
London, The Leicester Galleries.

1936
London, N. Knoedler and Co.

1941
Paris, Musée de l'Orangerie
(catalog preface by Paul Valéry).

1947
Paris, Galerie André Weill.

1948
Paris, Galerie Durand-Ruel.

1949
Copenhagen, Ny Carlsberg Glyptotek
and Stockholm, Nationalmuseum.

1950
London, The Arts Council.

1951
Geneva, Galerie Motte.

1952
Limoges, Musée Municipal (catalog
preface by Denis Rouart).

1952–54
Toronto, Art Gallery; Montréal, Musée
des Beaux-Arts; New York, Metropolitan
Museum of Art; Toledo, Museum of Art;
Washington, The Phillips Collection;
San Francisco, Portland Museum of Art.

1957
Dieppe, Musée de Dieppe.

1958
Albi, Musée Toulouse-Lautrec.

1960
Boston, Museum of Fine Arts; New York,
Wildenstein Galleries.

1961
London, Wildenstein Galleries;
Minneapolis, Institute of Fine Arts;
Paris, Musée Jacquemart-André.
Vevey, Musée Jenisch.

1962
Aix-en-Provence, Galerie Lucien Blanc.

1972
Birmingham, Alabama, Museum of Art.

1987
Paris, Galerie Hopkins Thomas.

1987–88
Washington, National Gallery of Art;
Dallas, Kimbell Art Museum;
Mount Holyoke, College Art Museum.

1990–91
London, JPL Fine Arts.

2002
Retrospective.
Lille, France, Palais des Beaux-Arts;
Martigny, Switzerland, Fondation
Pierre Gianadda.

2006
Lodève, France, Musée des Beaux-Arts.

2007
Seigi, Japan, Togo Memorial Sompo
Museum of Art.

List of Illustrations

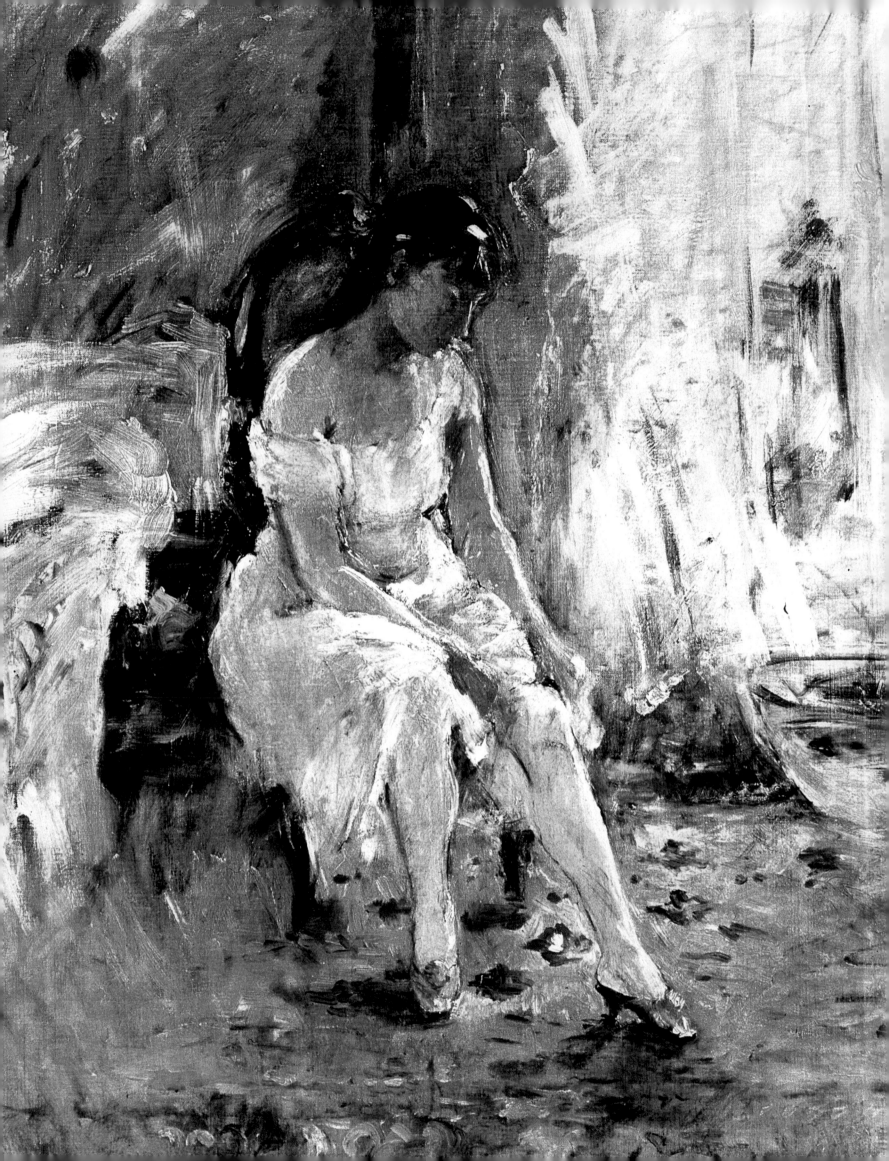

Bibliography

Any exploration of the work of Berthe Morisot begins with three pivotal studies:

BATAILLE, M. L., AND G. WILDENSTEIN. *Catalogue Raisonné of the Oil Paintings, Pastels and Watercolors of Berthe Morisot*. Catalog preface by Denis Rouart. Paris: Les Beaux-Arts, 1961.
CLAIRET, A., D. MONTALANT, AND Y. ROUART. *Berthe Morisot, Catalogue raisonné*. Paris: CERA-nrs Éditions, 1997.
ROUART, DENIS (ED.). *The Correspondence of Berthe Morisot*. London: Camden, 1986 / Kingston, R.I.: Moyer Bell, 1989.

Another essential text:

Julie Manet, Growing Up with the Impressionists: The Diary of Julie Manet, translated, edited, and with an introduction by Rosalind de Boland Roberts and Jane Roberts. London: Sotheby's Publications, 1987.

Works entirely devoted to Berthe Morisot include:

ADLER, K., AND T. GARB. *Berthe Morisot*. Oxford: Phaidon, and Ithaca, New York: Cornell University Press, 1987.
ANGOULVENT, M. *Berthe Morisot*. Paris: Éditions Albert Morancé, 1933 [the first attempted catalogue raisonné of Berthe Morisot's work].
BONA, D. *Berthe Morisot*. Paris: Grasset, 2000.
FOURREAU, A. *Berthe Morisot*. Paris: F. Rider, 1925.
HIGONNET, A. *Berthe Morisot: A Biography*. New York: Harper and Row, and London: Collins, 1990.
HUISMAN, P. *Berthe Morisot*. Lausanne: International Art Book, 1962.
REY, J.-D. *Berthe Morisot*. Paris: Flammarion, 1982, second revised edition 1989.
ROUART, L. *Berthe Morisot*. Paris: Plon, 1941.
ROUART, D. *Berthe Morisot*. Paris: Brown & Company, 1949.
STUCKEY, C.F., W.P. Scott, S.G. Lindsay, *Berthe Morisot: Impressionists*. Manchester, UT: Hudson Hills Press, 1987.

Major studies of impressionism that give prominence to Berthe Morisot's oeuvre include:

CLEMENT, R.T., C. ERBALATO – RAMSEY, A. HOUZE, *The Women Impressionists: A Sourcebook*. Westport, CT: Greenwood, 1989.
COGNIAT, R., *The Century of the Impressionists*. New York: Crown, 1960.
DURET, T., *Les Peintres impressionnistes*. Paris: Heymann et Pérois, 1878 and H. Floury, 1906.
FÉNÉON, F. *Les Impressionnistes en 1886*. Geneva: Droz, 1970.
MAUCLAIR, C. *L'Impressionnisme*. Paris: Librairie de l'Art Ancien et Moderne, 1904.
MONNERET, S. *L'Impressionnisme et son époque*. Paris: Laffont, 1987.
REWALD, J. *The History of Impressionism*. New York: Museum of Modern Art, 1973.
RUBIN, JAMES H. *Impressionism* ("Art and Ideas"). London: Phaidon, 1999.

Jeune fille enfilant ses bas (Young Woman Putting on her Stockings).
Oil on canvas. Private collection.

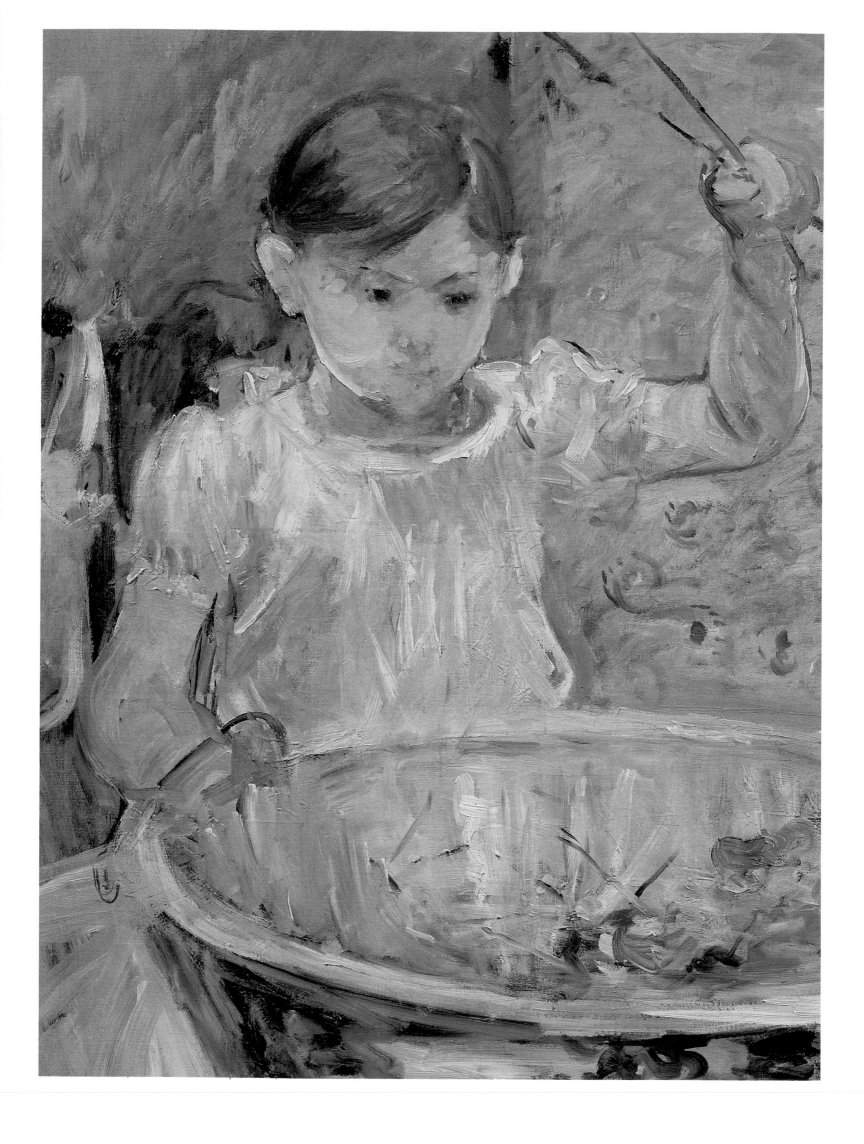

Studies of Berthe Morisot also appear in the following works:

BLANCHE, J.-E. *Propos de peintre, 2e série*. Paris, 1923.

GEFFROY, G. *La Vie artistique, 3e série*. Paris, 1894 and *6e série*, Paris: E. Dentu, 1900.

HUYSMANS, J.-K., *L'Art moderne*, Paris, 1883, reissued 1975.

MARX, R. *Maîtres d'hier et d'aujourd'hui*. Paris: Calmann Lévy, 1914.

WYZEWA, TÉODOR DE. *Peintres de jadis et d'aujourd'hui*. Paris: Librairie académique Perrin & Cie, 1903.

Of the texts, prefaces, or articles listed in detail up to 1996 in the 1997 catalogue raisonné, the following are particularly worthy of mention:

BAILLY-HERZBERG, J. "Les Estampes de Berthe Morisot." *Gazette des Beaux-Arts* 93 (1979): 215–27.

JAMOT, P. " Manet et Berthe Morisot." *Gazette des Beaux-Arts*. Jan–June 1927.

MALLARMÉ, S. Preface to the exhibition catalog of 1896, reprinted in *Divagations*. Paris: Fasquelle, 1897.

ROUART-VALÉRY, A. "De 'Madame Manet' à 'Tante Berthe.'" *Arts*. March 1961.

SCHUHL, P. M. "L'œuvre de Berthe Morisot, un art de vivre" *Rivista di estetica*, 1961.

SCOTT, W. P. "The Enchanting World of Berthe Morisot" *Art and Antiques*, 1981.

VALÉRY, P. "Tante Berthe," preface to the exhibition catalog of 1926, reprinted in *Pièces sur l'art*. Paris: Gallimard, 1934; and "Au sujet de Berthe Morisot," preface to the exhibition catalog of 1941, reprinted in *Vues*. Paris: La Table Ronde, 1948.

Detail of **Children with a Bowl,** (page 33).